PALESTINE IN PIECES

PALESTINE IN PIECES

GRAPHIC PERSPECTIVES ON THE ISRAELI OCCUPATION

Kathleen and Bill Christison

PLUTO PRESS
www.plutobooks.com

First published 2009 by Pluto Press
345 Archway Road, London N6 5AA and
175 Fifth Avenue, New York, NY 10010

www.plutobooks.com

Distributed in the United States of America exclusively by
Palgrave Macmillan, a division of St. Martin's Press LLC,
175 Fifth Avenue, New York, NY 10010

British Library Cataloguing in Publication Data
A catalogue record for this book is available from the British Library

ISBN 978 0 7453 2930 7 Hardback
ISBN 978 0 7453 2929 1 Paperback

Library of Congress Cataloging in Publication Data applied for

This book is printed on paper suitable for recycling and made from fully managed
and sustained forest sources. Logging, pulping and manufacturing processes are
expected to conform to the environmental standards of the country of origin.
The paper may contain up to 70 percent post-consumer waste.

10 9 8 7 6 5 4 3 2 1

Designed and produced for Pluto Press by
Chase Publishing Services Ltd, Sidmouth, England
Typeset from disk by Stanford DTP Services, Northampton, England
Printed and bound in the European Union by
CPI Antony Rowe, Chippenham and Eastbourne

To Ahmad

To Jeff Halper

To Rachel Corrie

Who each in a different fashion showed us the way

CONTENTS

ACKNOWLEDGMENTS

We have dedicated this book to our Palestinian friend Ahmad, without whom we would not have been able to discover half as much about the West Bank as we have; to Jeff Halper, a wonderful friend and human being who taught us more about the occupation and about how to fight it than we could have learned anywhere else; and to Rachel Corrie, a courageous young American who, although we never knew her, taught us what activism and standing up to oppression really mean.

There are myriad others who in one way or another have taught us and helped us along the way and continue to do so: those countless Palestinians and numerous Israelis who talked to us freely, answering our endless questions; who showed us the occupation in all its obscene detail, hiding nothing; who welcomed us and welcomed our desire to learn; who helped us understand not only the occupation but, just as important, its connection to 1948. They are too numerous to credit individually and, sad to say, often too vulnerable to reprisal to name.

There are some we can name. Our deep thanks go to Sandra Place, an artist with a wonderful eye for composition and for seeing the story that a picture can tell, for giving us the idea of reproducing some of our photographs and, simply by her encouragement, for giving us the confidence to think this project might work. Special thanks go to Joe Mowrey and Janice St. Marie, a talented husband-wife team who themselves are extraordinarily determined Palestinian rights activists and who helped immeasurably with the maps,

designing one and making certain that those from other sources were formatted properly for high-quality reproduction. Thanks also to Amjad Yaghmour, a mapping specialist with OCHA-oPt who made certain that the highly descriptive map from OCHA that is reproduced here as Map 3 came through perfectly.

We owe a debt to several people who read all or parts of the manuscript and offered suggestions and very apt comments. One friend in particular who is knowledgeable of the situation, Lynne Withey, read the entire initial draft and saw the first selection of pictures and gave us some excellent suggestions for sharpening the text and sorting, and in some cases eliminating, pictures. We also owe thanks to the excellent peer reviewers selected by Pluto Press, who read parts of the manuscript and offered some particularly cogent comments. Although we took all comments and suggestions very seriously and adopted virtually all of them, any remaining gaps or errors are ours alone.

At Pluto Press, we particularly thank the publisher, Roger van Zwanenberg, who encouraged us and worked very hard to be certain this book was published. We would also like to thank Melanie Patrick and Robert Webb at Pluto and Ray Addicott at Chase Publishing Services for their consistent patience and attention to detail in dealing with our many, many nagging demands regarding the presentation of the book and its photographs and maps.

PREFACE

Millions of American adults today, perhaps the majority, know the story of Israel through Leon Uris's bestselling 1958 novel *Exodus*, the 1960 movie spinoff, and the images that these romantic fictions projected of heroic Jewish pioneers and Holocaust survivors struggling against terrible odds—a tragic history, a hard land, marauding bands of barbaric Arabs—to build a refuge and a nation after centuries of persecution. President Barack Obama, despite having been born after the book and the movie emerged, has credited Uris among other Jewish writers with "shaping his sensibility" with respect to Israel. In an interview in May 2008, before he was elected president or had even won the Democratic Party primaries, he enumerated all the old sentimental stereotypes about Israel: an uprooted people coming home, "overcoming great odds," playing out a courageous "commitment to carving out a democracy and prosperity in the midst of hardscrabble land," the land itself as "a metaphor for rebirth," but through everything a perpetual insecurity—everything "plagued by this notion that this could all end at any moment." Palestinians, on whose land this nation of Israel was built, do not appear to have entered Obama's thoughts at all.[1]

As younger adults, the two of us imbibed the same fictions and the same stereotypes of innocent Israelis and hate-filled Arabs, and 40 years ago we regarded Israel and the Palestinians the way Obama and most other politicians still do. But seeing is believing, and having dealt, both in our careers as CIA political analysts and

in recent years through frequent travel to Palestine, with the realities on the ground unencumbered by the emotional haze that surrounds so much about Israel, our eyes have been opened in a way few politicians feel they can afford.

Our awakening has been gradual. Although the years at the CIA stripped away the halo around Israel, we did not—in the rush of analyzing urgent day-to-day political developments around the world and in the realpolitik focus on what were believed to be US national interests—gain an adequate understanding of Zionism's true meaning or its inevitable impact on the Palestinians. The events of 1948, particularly the dispossession and expulsion of the Palestinian people, hovered in the background as a tragic period but not one, we thought, that had much impact on today's events or on US interests. The occupation of 1967 seemed merely an example of Israeli aggressiveness that would soon, we thought, have to end. We had a sense of Palestinians as a political factor but not specifically as an oppressed, colonized people or of the real meaning and the real human impact of their dispersal.

After leaving the CIA in 1979, we did other things unrelated to Palestine-Israel for several years, but we always came back to this haunting problem. By moving away from the insular Washington bubble, we were able to gain a broader perspective—on US policy, on American society, on our own moral compass. Then, over more years, we began to read and learn much more about Palestine-Israel, to write articles, to meet Palestinians. We examined broad policy issues and human issues in two books written in the late 1990s, and finally we traveled regularly to Palestine—where seeing is indeed believing, where Zionism's human consequences are visible across the land, and not merely inside Israel.

We have visited Palestine multiple times, most particularly seven times since 2003, and have been able to witness close up the vast changes that Zionism is constantly bringing to the land and to the people, none for the better. You cannot, in fact, possibly come away from even a single trip around the West Bank without realizing that Zionism is no mere abstract political philosophy but is an aggressive, exclusivist movement of Jewish redemption intended from the beginning to sweep everything non-Jewish from its path. You can actually see this Jewish implantation across the land—the whole land of Palestine—in concrete form, actually see that Zionism has no room in its thinking, and Israeli leaders have no room in their policies, to accommodate any non-Jews at all, any Palestinians, living in Palestine in freedom and equality.

There are Israelis who believe in greater justice for Palestinians and in a just peace, but unhappily they have little influence. Gideon Levy, a correspondent for the Israeli newspaper *Haaretz* who has reported for years from the occupied territories and knows the Palestinians well, has bitterly declared the death of Israel's peace camp because of the Israeli public's apathy and the peace camp's own lack of commitment. The occupation enterprise, Levy wrote in late 2008, has never been so prosperous,

sweeping up in its whirlpool all of Israeli society.... Everyone, absolutely everyone, is implicated. They speak peace, but make war; oppose the settlements, but take part in their construction; say "two states," but vote Likud; close their eyes, hide their faces and wrap themselves in the most dangerous of blankets: blankets of apathy.[2]

Over many years, all these realizations moved the two of us a long way from the images projected by *Exodus* and quite a long way too from the images harbored by US and other Western politicians and

much of the public. Very few Americans or Europeans, in government or among the public, truly comprehend the scope of the occupation's horrors—horrors that are daily enabled by the United States itself, through its unquestioning support for almost everything Israel does, and by the silence of European governments. It is our hope that this book, because it is brief, because it is filled with photographs and highly illustrative maps, will help to educate readers—more rapidly than we were educated—in the realities of the occupation and the unpleasant truth of Zionism's long-term objectives.

<center> C3 80</center>

As this book goes to press in the early months of 2009, three seminal events are evolving that will profoundly affect the future of Palestine-Israel. As the year began, Israel was in the midst of a brutal three-week assault on Gaza that destroyed virtually the entire civil, economic, and governmental infrastructure of the small territory—including roads, electric grids, sewage and sanitation facilities, government buildings, hospitals, schools, United Nations relief distribution sites, manufacturing plants, even agricultural land, as well as homes and apartment buildings. Over 1,300 people, the majority civilians and children, were killed, and thousands were injured. The Israeli assault, launched ostensibly as "self-defense" in response to a barrage of rockets fired by Hamas into Israel, was in fact the latest, most destructive phase of an escalating cycle of violence and counter-violence that has been raging since Israel captured and occupied Gaza in 1967.

In the United States, on 20 January, only days after Israel unilaterally halted the Gaza operation, President Obama was inaugurated as the first black president in the nation's history,

promising substantial change in US foreign policies and in the sensibility and tone of US relations with the world and particularly the Muslim world. Obama's initial policy decisions on Palestine-Israel, however, appeared to demonstrate clearly that on this issue there would be little if any change. In his first public statement on the conflict, only two days into his presidency, Obama defended Israel and, accusing Hamas of terrorism, placed virtually the entire blame for the Gaza fighting on Hamas. He gave no sign that he recognized any Palestinian right to resist Israel's occupation, no indication that he viewed the 100-to-1 Palestinian-to-Israeli kill ratio during the Gaza war, and indeed for years before this attack, as disproportionate in any way, and no sign that he recognizes Israel as an occupying power totally dominating the Palestinian territories. As a candidate, Obama had made his political commitment to Israel quite clear, but when as president he had an opportunity to demonstrate an ability to separate politics from the substance of a critical foreign policy issue, he balked. He began his presidency sounding precisely as he had when as a candidate he hailed Israel in emotional terms as vulnerable and courageous and indicated no interest in the Palestinians who live under Israel's control.

Three weeks after Obama's inauguration and the conclusion of Israel's Gaza operation, on 10 February, Israel elected a new parliament that is strongly rightwing, composed of a majority of parties utterly opposed to making territorial concessions to accommodate an independent, sovereign Palestinian state. The new government will lean decidedly to the right and will resist any pressure to end Israel's occupation, probably even more strongly than has been true of the last three Likud- and Kadima-led governments since 2001.

The conjunction of the Gaza assault and the Israeli election with the beginning of Obama's presidency has essentially placed the Palestinian-Israeli conflict at a standstill. The Gaza slaughter and the ascendancy of the extreme right in the Israeli election clearly showed, for any who could not already see the trend or who had hoped to resist it, that Israel has no intention of relinquishing its control over all of Palestine and, moreover, that it is actually bent on destroying Palestine as a nation through killing or expelling its people, appropriating its land, and strangling its economy. Obama shows no inclination to confront or try to alter this reality and would undoubtedly face nearly insurmountable obstacles even if he were inclined to try. Israeli leaders have been working closely with the pro-Israel lobby and the military-industrial complex in the United States to envelop the US in a tight partnership with Israel and to ensure that US political leaders, including Obama and Congress, cannot see Israel's occupation as an intolerable violation of Palestinian human and political rights.

The events of early 2009 have placed tight psychological strictures on any progress toward resolving the conflict: after Gaza, large numbers of Israelis are increasingly explicit in expressing their absolute hatred of Arabs and Palestinians, a reaction reflected in the rightward tilt in the election; despite years of clinging to a commitment to living peacefully in a small independent state alongside Israel, large numbers of Palestinians are now deeply disillusioned and have moved away from desiring any reconciliation with their occupiers; and in the United States, many sectors of public discourse, influenced by the Israel lobby and by a disturbing increase in anti-Arab and anti-Muslim sentiment, have become more stridently supportive of Israel and blind to any concern for or even awareness of the human and the national consequences

for the Palestinians of Israel's ever-strengthening occupation and the relentless devastation wrought by assaults such as the one on Gaza.

The critical question for the future concerns whether Obama will confront the roadblock placed before him by the Gaza operation and Israel's move to the right, or will simply back down in the face of these obstacles to progress. An absence of any pressure on Israel to move toward a resolution will lead inevitably to continued Israeli consolidation of the occupation—more settlements, more impediments to Palestinian growth, more of the dismal realities laid out in this book. As one US commentator wondered several days before the Israeli election, "Will Obama, too, indulge Israeli rejectionism?"[3]

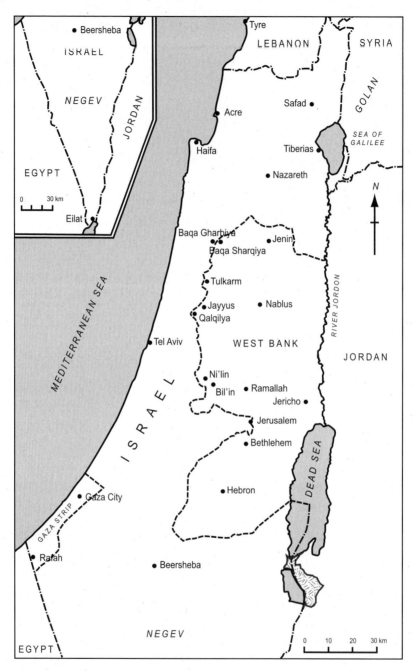

Map 1
Palestine–Israel

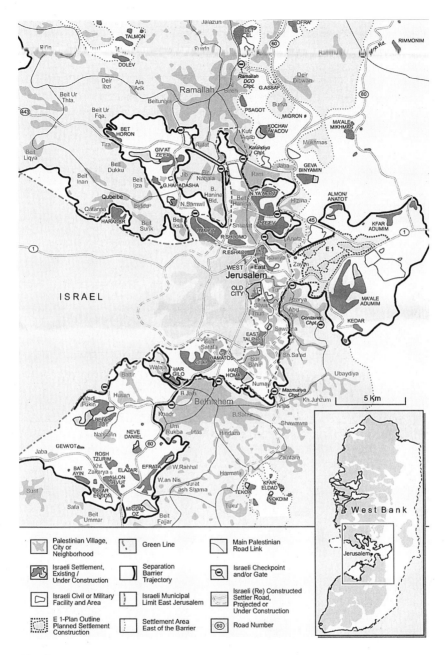

Map 2
Metropolitan Jerusalem—August 2008

Source: Foundation for Middle East Peace/Jan de Jong

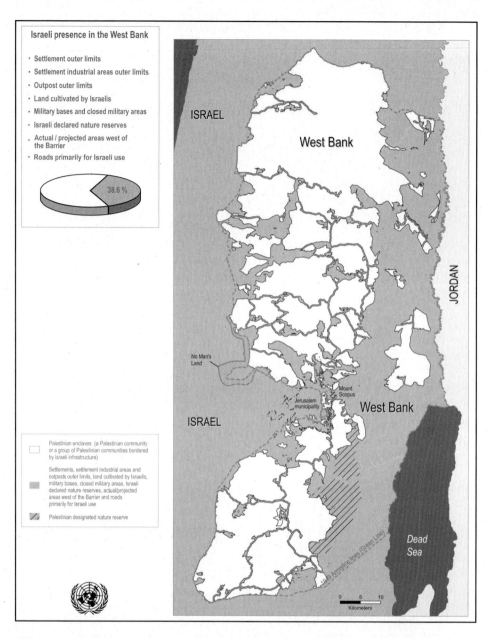

Israeli presence in the West Bank

- Settlement outer limits
- Settlement industrial areas outer limits
- Outpost outer limits
- Land cultivated by Israelis
- Military bases and closed military areas
- Israeli declared nature reserves
- Actual / projected areas west of the Barrier
- Roads primarily for Israeli use

38.6 %

Palestinian enclaves (a Palestinian community or a group of Palestinian communities bordered by Israeli infrastructure)

Settlements, settlement industrial areas and outposts outer limits, land cultivated by Israelis, military bases, closed military areas, Israeli declared nature reserves, actual/projected areas west of the Barrier and roads primarily for Israeli use

Palestinian designated nature reserve

ISRAEL

West Bank

JORDAN

No Man's Land

Mount Scopus

Jerusalem municipality

West Bank

ISRAEL

1949 Armistice lines (Green Line)

Dead Sea

0 5 10
Kilometers

Map 3
Palestinian enclaves in the West Bank

Source: Office for the Coordination of Humanitarian Affairs

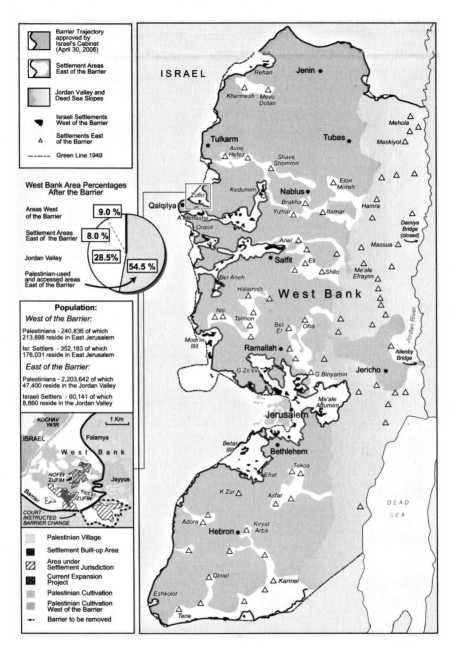

Map 4
West Bank Separation Barrier—April 2007

Source: Foundation for Middle East Peace/Jan de Jong

INTRODUCTION
THE SUPPRESSIVE POWER OF SILENCE

What totalitarian regimes do is to ... look at you and say, "You are not." Or, "You are something else." Or, "This event didn't exist." This power, that is only God's power. If a regime, or some people, think they are God, they can ... create you or kill you. And this is unbearable. So the only thing you can do—and the most subversive thing you can do—is to tell the truth. This is devastating because each time you come back with the truth, you deny their prerogative of creating a fictitious world where they can say whatever they want.

<div align="right">

Ladan Boroumand
Iranian exile, speaking to
US Holocaust Museum
7 June 2007[1]

</div>

There is a considerable irony in Ladan Boroumand's words. Although her statement addresses the plague of anti-Semitism and was made in a talk to a museum dedicated to remembering the most horrific anti-Semitic event in history, most Palestinians would contend that the power to say "You are not"—that "unbearable" power to deny a people's existence, to "create you or kill you"—has actually been turned against them throughout the century and more since Zionism, speaking for those victims of anti-Semitism whom Boroumand and the Holocaust Museum honor, began the displacement of Palestine's native population.

The effort to deny the Palestinians' existence and deny their right to a place and a homeland in Palestine began at the very start of the Zionist enterprise as one of its central aspects and has continued, in varying forms, until today. We have made a small effort for several years to bring the reality of Palestinian existence to public attention, and this book is an attempt to counter the widespread view, deliberately promoted by those who have the power to do so, that the Palestinians "are not"—do not exist as a people, do not suffer at Israel's hands, do not deserve independence.

We have followed the Arab-Israeli and particularly the Palestinian-Israeli situation in a professional way for almost 40 years and first saw Jerusalem and the spectacular hills around that city close to half a century ago. There are few places on earth more breathtaking than the steep hills and deep *wadis* around Jerusalem and running up and down the spine of Palestine. Jerusalem and Palestine's central range of mountains and hills mark the break between a fertile area spilling down to the Mediterranean Sea on one side and an arid desert wilderness of honey-colored escarpments and bottomless ravines descending in the east to the Jordan Valley and the Dead Sea, the lowest place on earth.

In the midst of this austere beauty, Palestinians who have lived on the land for millennia are fighting for their collective lives against the encroachment of Israeli settlers representing an Israeli government and society that want all of this land, this last remaining part of Palestine not taken in 1948, for themselves. We had visited Palestine several times over the years at irregular intervals until in 2003 we began what has become an annual, and in some years a more frequent, pilgrimage—a political rather than a religious pilgrimage to witness and record the progress of Israel's expansion across the

land, the pillage of Palestinian land, the plight of the Palestinians themselves. There is no better word than "pillage" for what is happening to the Palestinians and to their land—not merely for what has happened already but for what is continuing to happen every day as more walls and enclosures are built for the Palestinians, more life-giving land is taken from them, more Israeli settlements and roads spread across that land. Some of the stories here are personal tales of our experiences with the occupation. But we have been mere voyeurs. The real story is not ours, but the Palestinians'.

The principal theme of their story thus far has been great loss.

<p align="center">ϩ ʅ</p>

That loss has a long history. Early Zionist leaders essentially ignored the Palestinian presence in the land—despite the fact that at the start of the twentieth century this land said to be a "land without people" was inhabited by over 550,000 Palestinian Arabs, both Muslims and Christians, who made up over 90 percent of the total population. Both Britain's 1917 Balfour Declaration and the League of Nations instrument that confirmed the British Mandate over Palestine in 1922 advanced the Zionist cause by treating Palestinian Arabs as if they were not there, failing to mention the words "Arab" or "Palestinian Arab" at all and referring to Arabs, then still comprising 90 percent of the population, simply as "non-Jews."

The massive displacement of the Palestinians in 1948, when Israel was established and between 700,000 and 750,000 native Palestinians were forced to flee their homes and land, was ignored by most of the international community. Israeli historian Ilan Pappe has characterized this huge societal disruption as an "ethnic

cleansing," deliberately planned and carried out by Zionist leaders to ensure Jewish majority dominance over the area that became Israel.[2] Israeli leaders refused to allow the Palestinians to return, the refugees languished in camps in neighboring Arab countries, deliberately ignored by Israel and largely forgotten by the rest of the world, and Israel succeeded in erasing knowledge of the dispossession from its own public mind and its own psyche. Pappe notes that "if you look at Israeli textbooks, curricula, media, and political discourse you see how this chapter of Jewish history—the chapter of expulsion, colonization, massacres, rape, and the burning of villages—is totally absent."[3]

Even after Israel captured more Palestinian territory in the West Bank, Gaza, and East Jerusalem during the 1967 war—the remaining one-quarter of Palestine not already under Israeli control—the Israeli strategy continued to be denial of the existence of Palestinians. In a now famous statement, then Israeli Prime Minister Golda Meir explicitly told a newspaper interviewer in 1969, "It was not as though there was a Palestinian people in Palestine considering itself as a Palestinian people and we came and threw them out and took their country away from them. They did not exist."[4] Any remembrance of Palestinians as a native people dispossessed from their land and with a legitimate claim to any part of it was deliberately suppressed as Israel laid claim to and actually began taking physical possession of all remaining parts of Palestine. More than one expert on the Palestinian-Israeli situation has seen a direct link between 1948 and 1967, seeing the territorial gains made in 1967 as completing the assertion made in 1948 of Jewish dominance in a "Greater Israel" encompassing all of Palestine.[5]

Western complicity in the effort to ignore and push aside the Palestinians today takes the form of a general silence among US and, increasingly, other Western policymakers, the media, and the general public about Israel's policies and actions toward all Palestinians and the situations in which they live. This complicity applies to the fate of the four and a half million Palestinians registered as refugees in camps throughout the Arab world, to the second-class status of Palestinians living as unwelcome non-Jewish citizens in a state formally declared to be Jewish, and to the precarious situation of Palestinians living under Israeli occupation in the West Bank, Gaza, and East Jerusalem. The silence and widespread ignorance of the true Palestinian situation prevailed to a large extent even during the years of the active peace process in the 1990s. In the few cases in which the political and media mainstream in the United States and elsewhere in the West do consider the Palestinians, they are treated almost exclusively as obstacles to Israeli control and dominance.[6]

Writing shortly after the Israeli occupation began and a quarter century after the Palestinians' dispossession, referring to what he called "a peculiar and continuing state of mind" in the West that persistently ignored the realities of the Palestine issue, Palestinian intellectual Walid Khalidi wrote poignantly that Palestinians were "in the unique position where not only is their catastrophe ruled out of the Western court as being irrelevant to their reactions against its perpetrators, but where these very reactions are held to incriminate them."[7] The situation has changed little today, 60 years after the catastrophe, the *Nakba*, of their dispossession and more than 40 years into the occupation.

"The most subversive thing you can do," Boroumand said to her Holocaust Museum audience, "is to tell the truth ... because

each time you come back with the truth, you deny [to those who attempt to silence and deny] their prerogative of creating a fictitious world where they can say whatever they want." This book is a small attempt to show the truth of the Israeli occupation—to deny to Israel and the West their ability to "create a fictitious world" where Palestinians do not matter and can be discarded and denied at will. The book is an attempt to break the silence and show clearly, through maps and photographs rarely seen by the US public, just how permanent this system of Israeli control is intended to be and what the occupation means for the daily lives of Palestinians and for their prospects of ever achieving freedom and independence.

In the Palestinian story, maps have often been used—manipulated— to impose a silence and create a different, distorted story. A biblical map hangs in a classroom in a synagogue in our hometown, showing the entirety of the territory between the Mediterranean and the Jordan River to be "Israel." No borders are marked between Israel and the West Bank or between Israel and Gaza; no Palestinian area is noted at all. Similar maps hang in other synagogues around the country, teaching numbers of American Jewish children that Palestine does not exist.

Maps such as these, which represent a denial of a Palestinian presence in the land and an affirmation that all of Palestine is Israel, are not a phenomenon confined to religious institutions or to the United States but indeed reflect Israel's official position since Palestinian territories were occupied in 1967. Within days of the conclusion of the 1967 war, Israel's foreign minister ordered that maps produced by his ministry no longer show either the borders of the British Mandate or the 1949 armistice lines, which effectively form the border between Israel and the West Bank—often called the

"1967 lines" or the "Green Line." Before the year 1967 was over, the name "West Bank" had been replaced by the biblical moniker "Judea and Samaria" in all official Israeli documents.[8]

As a result, most maps available in Israel and the United States since the beginning of the occupation have failed to delineate any border between Israel and the occupied territories. An occasional map produced since the Oslo peace process began in the 1990s has shown some parts of the West Bank as "Palestinian autonomous areas," but these are most often quite limited areas. The major Israeli mapmaker Carta has produced a detailed physical map, entitled *Israel (and Autonomous Areas)*, that marks a few small, disconnected areas as "Palestinian autonomous areas," but these do not cover more than a fraction of the West Bank, and the West Bank itself is not delineated by a border of any sort.[9] Israeli tourist maps still commonly fail to show any border.

Israeli anthropologist and activist Jeff Halper, who has described what he calls Israel's Matrix of Control over the occupied territories and its efforts to integrate the territories with Israel, points out that in exerting this control Israel has almost totally erased the so-called Green Line between the West Bank and Israel, not only on maps but psychologically as well. In a striking reflection of Pappe's description of the erasure of memory in the wake of Israel's ethnic cleansing of Palestinians in 1948, Halper notes that since 1967 the Green Line has been erased "not only from the maps of children's school books or the TV weather reports, not only in the public's consciousness, but from any barrier or sign on the ground." The concrete manifestation of this psychological attempt to mould thinking and erase Palestinians in the public's mind by negating their presence on maps, is that, as Halper observes, Israelis are

able to "travel from place to place, routinely visit friends, receive public or private services and decide on where they would live with no regard for any border." The occupation has been routinized and made invisible in this way, so that what Israelis call Judea and Samaria—the West Bank—has become just another part of Israel, no different from the Galilee area inside Israel.[10]

The Israeli settlement of Modi'in Illit provides a dramatic illustration of this integration of the West Bank with Israel. The settlement actually straddles the Green Line northwest of Jerusalem. One of the largest Israeli settlements, with a population of approximately 37,000, Modi'in was declared an Israeli municipality in early 2008—an example, in the words of the general director of the Israeli peace organization Peace Now, of "the way Israeli governments have obliterated the green line and de facto annexed territory while simultaneously proceeding with peace negotiations."[11]

The maps appearing in this book clearly show how Israel's capture of territory in Palestine in 1948, its occupation of the West Bank, Gaza, and East Jerusalem since 1967, and its imposition since the 1990s of increasing restrictions on Palestinians in the occupied territories have squeezed Palestinians into ever smaller, more disconnected cantons with little possibility for political or economic viability and virtually no hope of true national independence and sovereignty.

In a very real sense, maps and pictures tell a personal story of Palestinian lives. Jean Zaru, a strong Palestinian woman who serves as presiding clerk of the Ramallah Friends Meeting, has observed that personal stories "reveal the complexity of our truth," and by telling them—as well as by showing those stories in pictures— "we resist watering down our truths into vague and generalized abstractions; we maintain the urgency and intensity of the concrete."

Her own story, she notes, like so many others, "reflects a narrative of exclusion: the denial of basic human and community rights."[12] With this book, we hope to make the occupation of Palestine an urgent and intense concrete reality for those who never hear the stories or see the pictures or see the real maps.

ം ഔ

Our hope is that this book and particularly its graphics will open the eyes of readers who have no true conception of what Israel's occupation of Palestine is like for Palestinians. The utter failure of the media, in the West in general and particularly in the United States, to tell the story of the occupation and of Israel's severe oppression of Palestinians is striking. A group of media analysts from Glasgow University conducted a content study of British television coverage of the conflict during the first two years of the second *intifada*, 2001–02, and augmented this with an analysis of the public impact of this coverage based on an extensive canvass of television audiences. Their conclusion was that, for a variety of reasons, coverage was inadequate and slanted toward Israel, emphasizing the Israeli perspective, providing very little of the Palestinian perspective, and giving the viewer little history of the conflict and virtually no context against which to judge Palestinian behavior. As a result, the study found, viewers exhibited considerable ignorance of all aspects of the conflict and minimal understanding of the issues involved, including why Palestinians were resisting Israel's occupation. Among a group of British students polled in 2001 and 2002, for instance, only 9 percent and 11 percent respectively could correctly answer the question, "Who is occupying

the occupied territories and what nationality are the settlers?" The study group drew the obvious conclusion that, given the pervasive lack of knowledge that an Israeli military occupation even existed, it was not surprising that there was so little understanding of the impact of the occupation on Palestinians.[13]

A second detailed study, concentrating on coverage of the conflict by the *New York Times* during the period 2000–06, was produced by media analyst Howard Friel and noted international law scholar Richard Falk. Writing from the perspective of international law and the critical need to hold the parties accountable for their actions under international law, the authors conclude that the *Times* consistently fails to consider the relevance of Palestinian rights as defined by this law and that this failure has a bearing on what readers perceive to be the shape of "a fair and sustainable solution." Judging that the Palestinian-Israeli conflict has for decades been the most misrepresented foreign policy issue, Friel and Falk conclude that the *Times*'s "unwillingness to view the conflict through the lens of international law has contributed significantly to both an anti-Palestinian bias and an inflated sense of Israeli entitlements."[14]

We have gained a sense of the impact photographs and maps can have—photos and maps that Americans and Europeans rarely if ever see—through the surprised reactions of our own friends to some of these graphic representations. Several years ago a friend saw a map showing the locations of Israeli settlements throughout the West Bank and was astonished at the numbers and extent of these foreign colonies. The size of the settlements also comes as a surprise to most people; another friend, looking at one of our pictures of the massive settlement of Ma'ale Adumim to the east of Jerusalem,

was amazed that this "little settlement" was no small, temporary encampment but a full-fledged city.

Palestinian author and human rights lawyer Raja Shehadeh tells a similar story of ignorance on the part, of all people, of a functionary of the Palestine Liberation Organization (PLO) who grew up in Beirut and saw the West Bank for the first time in the 1990s when Israel allowed Yasir Arafat and other PLO officials to come to the occupied territories from Tunis as part of the Oslo peace agreement. This Palestinian woman, who worked as a translator for Mahmoud Abbas, later to succeed Arafat as Palestinian Authority (PA) president, arrived with an idealized view of a "new re-created Palestine" arising from the Oslo agreement, but when Shehadeh drove her past the settlement of Ma'ale Adumim, she exclaimed that she had "never thought the Jewish settlements we heard so much about would be like this." She had thought they would be "temporary dwellings just to mark a presence, not like these stone houses with gardens and trees." She was chagrined that "they look so permanent and huge." By the time this woman arrived in the West Bank, the die had been cast: Arafat—undoubtedly just as ignorant as she was of the real scope of the settlements—had signed the Oslo accords in 1993 and in the process, as the price of securing Israeli recognition of the PLO, had signed away any right to PA jurisdiction over the settlements.[15] It is intriguing, although at this point heartbreakingly futile, to imagine what the outcome of the Oslo process might have been had Arafat and his PLO colleagues ever seen pictures of the large Israeli settlements that were absorbing so much of the land where they hoped to establish a state.

With very little media coverage of Israel's actions in the occupied territories, being able to witness what is happening on the ground

is often the only way to take it all in—to fathom the full extent of it, actually see the destruction, and understand the massive scope of the settlements and the strangulation imposed by the checkpoints. We had a bit of an epiphany ourselves after seeing the extent of the Israeli settlements from the air in March 2003. For complicated reasons, rather than traveling by land from Amman to Jerusalem via the Allenby Bridge across the Jordan River, we flew from Amman to Tel Aviv on a small Royal Jordanian Airlines commuter plane that followed a path across the middle of the West Bank at an altitude of only about 8,000 feet. Seeing the settlements, easily distinguishable by their Swiss-chalet-style red-tiled roofs, on the tops of practically all hills shocked us in a way we had never anticipated. We had thought we knew the reality intellectually from having followed developments for years, and we had seen settlements from afar on previous visits, but the full impact of their pervasive presence did not hit us until we gained this bird's-eye view.

During this and succeeding visits, we attempted to understand and convey the Palestinians' perspective on the oppressive measures under which they live. We do not claim to have understood fully, and we cannot claim any credit for doing the hard work of witnessing, protesting, and helping Palestinians in myriad ways that so many of the heroic activists of the International Solidarity Movement, Anarchists Against the Wall, the International Women's Peace Service, the Israeli group Machsom (Checkpoint) Watch, and many other activist organizations and individuals have done. But we have gained some sense of what life under occupation is like from walking the streets of villages, refugee camps, and towns under siege, from helping rebuild destroyed Palestinian homes, from watching others be demolished, from talking year after year to Palestinians who

endure this. Not infrequently, the more emotional one of us has felt an impulse to sob—upon rounding a corner to see the devastated center of the Jenin refugee camp, upon watching bulldozers demolish a small home, upon remembering the untouched hills of Jerusalem from half a century ago while traveling the asphalt byways of that city and its environs today, past modern settler metropolises that have destroyed the pristine beauty of the majestic hills of Palestine.

All of us who seek to help Palestinians in small or large ways— helping with annual olive harvests when farmers are unable to reach their own land, acting as human shields to stop the bulldozing of homes, protesting the Separation Wall, assisting in refugee camps, bringing relief supplies to Gaza—take satisfaction from the knowledge that, no matter how insubstantial our help, our mere presence gives the Palestinians hope that they are not totally alone in the world, that their virtual abandonment by the world's powers does not mean that civil society throughout the world has forgotten their plight. But the important thing to remember is that this is not by any means a one-way street; if outsiders give the Palestinians some reason for hope, the Palestinians return inspiration many times over simply by their resilience.

ᠵ᠖ ᠖᠕

Through the years, we have found Palestinians growing increasingly distressed, even depressed, over what appears to be the hopelessness of their situation: continued and increasingly oppressive occupation; continued Israeli expansion across the occupied territories; a continuing high death toll; the crippling embargo imposed on

Gaza; a Palestinian leadership increasingly seen to be betraying its people's interests; a disastrous split in Palestinian ranks and increased intra-Palestinian fighting; diminishing hopes that they will ever see the fulfillment of what are regarded as fundamental Palestinian rights to genuine independence in a viable, contiguous state, to the return of refugees displaced in 1948, to sovereignty over some part of Jerusalem. But few are prepared to leave, to surrender those rights, or to give up a long-term resistance to Israel's occupation. As our friend Ahmad, who accompanied us on almost all of our recent travels, is fond of saying, although there are some Palestinians who "think only about money and business, who only think about themselves and don't help the Palestinians, the people in general are still surviving, they still have a little bit of a smile, and this really annoys the Israelis."

In recent years, Palestinian society has indeed split, often quite severely, along lines more or less defined by Ahmad's two broad categories. Although he differentiated the two groups generally according to levels of economic prosperity, in fact the breakdown usually tends to be more political than economic, having to do with, on the one hand, an inclination to give up resistance—to make substantial compromises on Palestinian rights in the hope that ultimately the United States will defend Palestinian interests—versus, on the other hand, a determination to continue resisting all Israeli and US political pressures when these are so clearly intended merely to facilitate the occupation.

From our discussions with many Palestinians, we would place in one group those who might be characterized as being of the establishment—who are connected directly to or are at least politically invested in the PA and its political alignments, who tend

to be Fatah loyalists, are absolutely hostile to Hamas because of its Islamic character, and put considerable faith in the PA's policy of cooperating with Israel and the United States. These people tend often to be economically comfortable despite the occupation and to live in areas of Jerusalem or Ramallah where they can avoid the in-your-face aspects of checkpoints and roadblocks and the Separation Wall, although economic status is by no means the primary determinant of their political views.

The second group is composed broadly of the populace at large—people who tend not to be directly connected to political factions but who do have a clear political viewpoint and who by the time of the 2006 Palestinian legislative elections had become so dissatisfied with the Palestinian leadership's widespread corruption and particularly its utter failure to lead the Palestinians out of the occupation that they voted against Fatah, putting Hamas briefly in control of the legislature and the government (until Israel arrested most of the legislators and the Fatah-led PA pushed Hamas out of the cabinet). These are the people who face the occupation every day, who are vulnerable to being killed by Israeli forces, who have been directly affected by the Wall running through their land and the checkpoints that separate their homes from their workplaces. They showed their dissatisfaction and impatience by voting in large numbers for Hamas, which has had a reputation for incorruptibility and for providing social services in areas where it is ascendant and which promised to resist Israeli and US pressures for capitulation in peace negotiations.

Although this population is generally less economically prosperous, economic status, again, is not by any means the only factor determining political views. Nor is religious affiliation; large

numbers of those who voted for Hamas are secular Muslims and Christians who made their choice on the basis of politics rather than religion or economics. We talked at some length with a Christian couple that regards Hamas as, in their words, "the Palestinian national movement" because it is not prepared to relinquish Palestinian rights. These are the people of whom our friend Ahmad said that they are surviving "with a little bit of a smile" and a quiet resistance that annoys the Israelis. They are determined to resist Israel's occupation, US pressure for great concessions, and, most particularly, their own leadership's apparent inclination to make those concessions.

The split in Palestinian ranks came to a head in June 2007 when serious fighting between Fatah and Hamas led to Hamas's takeover of Gaza and, in retaliation, its expulsion from the government run by PA President and Fatah leader Mahmoud Abbas. During a visit of ours in November 2007, which came just before the summit in Annapolis, Maryland, called by President George W. Bush—an ultimately fruitless meeting over-advertised as restarting the dormant peace process—we found emotions running high among partisans of both sides. There was a general sense of desperation among everyone, highlighted by shame and dismay that Palestinians had begun killing each other and a sense that the factional fighting had severely weakened the Palestinians and marked a deep political failure. Some few have left Palestine altogether or would do so if they had the means. Among "establishment" people, we found despair seeking refuge behind a blind hope, against all rational calculations, that US policymakers understood Palestinian needs and would somehow pull out a decent, just solution. They expressed deep anger with Hamas. But underlying the expressed hope was a

sense that the Palestinians had no choice but to go along with Israeli and US schemes and ultimately to surrender. "Maybe we should just surrender," one man, well placed in the Palestinian hierarchy, told us over drinks one evening, after having just spoken of his faith that US Secretary of State Condoleezza Rice understood the Palestinian plight and would work for a good solution. "Perhaps in 50 years we could renew the struggle," he said forlornly, "but not now."

Most ordinary Palestinians are shocked at such defeatism. The "people in general" of whom Ahmad spoke are facing their own despair and depression, but generally this is directed at the leadership and at people like the man above for precisely the reason that they are ready to surrender. Palestinians have been lamenting for years that Abbas has shown such a readiness to put "all his eggs in the US basket," and in the run-up to the Annapolis summit, large numbers expressed deep fears that Abbas and his PA colleagues were being lulled into ceding basic Palestinian rights in return for nothing more than the uncertain promise of a so-called "state" that could not possibly be viable or truly independent. These Palestinians have begun to refer to the leadership as "collaborators" and "quislings," and they express a determination, despite the political split and the Palestinians' current political weakness, to continue the struggle, continue resistance to Israel's occupation and oppression.

It is from here that the resilience of Palestinian society emerges. "We have existed despite history," Palestinian journalist Khalid Amayreh told us in the days leading up to the Annapolis summit, "despite everything Zionism has done to us and despite Zionism's goals." Other Palestinians speak in similar terms about how society has endured and survived various phases of history. Hanan Ashrawi, a prominent Palestinian political leader who served for several

years in the 1990s as spokesperson of the Palestinian negotiating delegation, told us in March 2003, at the height of what she termed the efforts of then Israeli Prime Minister Ariel Sharon to "break" the Palestinians, that she did not believe Palestinians could be broken or brought to the point of surrendering or fleeing Palestine. Palestinians tend to regard their current difficulties as simply another historical phase that will pass, she said. "There's a social cohesion and an identification with the land that are very important. Originally we're all peasants who are completely bound to the land. The source of our self-value is tied to land." After the flight of over 700,000 Palestinians when Israel was established in 1948, Ashrawi said she believed Palestinians know the price of leaving, and the majority "are staying."[16]

Ahmad put it in simpler terms several years later. Palestinian resistance, he said in the wake of the Hamas-Fatah split, "is like a spoon or a fork. When you're eating, you don't put down your spoon in between bites or someone else will pick it up and take it." Palestinians may stop using the spoon for a while—may stop active resistance for a time—but "they won't put it down because someone will take the resistance away from them." They are not giving up. The journalist Khalid Amayreh believes that Palestinian discouragement at their current prospects, including their own internal discord, is breeding not defeat or a readiness to retreat or surrender but what he calls "frozen rage," a rage that sits quiet for a while, but "can go off at any moment"—as has occurred twice already with uprisings, *intifadas*, sparked by frustration in 1987 and in 2000 and, in a more benign way, with the breakdown of the wall enclosing Gaza in January 2008, when frustrated Palestinians simply burst out, spending weeks enjoying the freedom of escape in

Egypt before the wall was reimposed. People are able to adapt to the oppressive measures of the occupation for a while, Amayreh said—despite checkpoints and walls, "they go to school, have weddings; they go on because of their resilience"—but eventually Palestinians know they have the demographic advantage, and "we don't allow ourselves to have a minority mindset."

Our pictures clearly show the oppressive measures of Israel's occupation, but they cannot explicitly show the Palestinian will to resist. The pictures do nonetheless give clear evidence of why Palestinians are frustrated and angry, why they are filled with frozen rage, why they would want to resist the humiliation and oppression imposed on them.

<div align="center">☙ ❧</div>

Those who try to speak out in the United States about their experiences in Palestine, frankly describing the Palestinian situation, are often denied a venue or, having gained a venue, are accused of anti-Semitism or "Israel-bashing" because they are not "balanced" and do not present the "Israeli side of the story." But international law scholar Richard Falk, who was appointed in 2008 as UN special rapporteur on human rights in the occupied territories, has cogently addressed the question of objectivity in discussion of this conflict. In answer to criticism that both he and his predecessor, South African John Dugard, have been "one-sided" in their criticism of Israel's human rights violations, Falk maintains that if the facts "as they are" indicate "the persistent violation of international rules, then their legal interpretation is bound to be one-sided and critical of the violator." It is a dodge, he believes, to reject criticism of behavior

such as Israel's on the basis that such criticism is not "balanced." "If the reality is unbalanced, so must its assessment be."[17]

We have frequently been accused of "bashing" Israel, told by audience members that they agreed with what we described but that they objected because we failed to explain Israel's reasons, Israel's excuse, for taking harsh steps. "Security" is always the stated Israeli reason for taking these measures. But in fact security is not an adequate or an appropriate excuse for wanton killing, for expropriating massive tracts of Palestinian land, for imprisoning millions behind walls and razor wire, for bulldozing thousands of homes belonging to innocent people never charged with or even suspected of terrorism. What exactly is the reason for spilling sewage from Israeli settlements onto the land of neighboring Palestinian villages? What indeed is the security excuse for planting Israeli settlements on Palestinian land in the West Bank in the first place? What is the reason for dropping 1,000-pound bombs or lobbing artillery shells onto homes and apartment blocs in the middle of the night when it is a certainty that the vast majority of the casualties will be civilian?

The hypocrisy of the demand for sympathy for Israel's position, when Israel is the human rights violator and the brutal oppressor, is stunning.

1

THE OCCUPATION IN MICROCOSM: AN OVERVIEW

"Trapped without status in a never-never land"

Ahmad makes a U-turn in front of the Israeli guard tower, after a fruitless conversation with a Border Policeman, who will not let us through the adjoining gate in the Separation Wall. He pulls alongside two young Palestinian men standing across the dusty road from the tower. Having just been denied entry to the tiny Palestinian village of Numan on the other side of the guard tower, Ahmad asks the men if they think there is any way of getting in. They mutter something to him in Arabic but will not look at any of us, keeping their eyes pinned on the Israeli police across the road. Ahmad understands immediately and drives off, explaining to us that these young men are residents of Numan waiting to get back in to their village, and they fear that the Israeli police will penalize them further if they are seen to be talking to us. The Israelis are already making them wait at this checkpoint in the hot sun, for no particular reason, before allowing them to return home.

It is October 2006, and we are trying, with our Palestinian friend Ahmad, to return to Numan to talk to the residents about their precarious situation. We previously visited in September 2005, before the Wall was finished, but the barrier around the village was completed in the intervening year. In urban areas, the Wall is a concrete barrier 26 feet high, but in rural areas like this it consists of an electronic fence rigged with sensors and paralleled on each side by one or more patrol roads, another fence, a trench, and coils of razor wire—in total covering a section of land an average of 75 yards wide and usually destroying large swaths of cultivated Palestinian agricultural land.

Numan is a village of only 170 people[1] located in the southeastern corner of Jerusalem's expanded municipal boundaries,[2] northeast of Bethlehem and just east of the large and growing Israeli settlement of Har Homa. (On Map 2, showing East Jerusalem and the surrounding area, Numan is on the northeastern outskirts of Bethlehem, but on the Jerusalem side of the Wall, at the Mazmuriya Checkpoint. The Jerusalem municipal limits are shown in a dotted line.) Although the village has technically been a part of Jerusalem since Israel expanded the city limits after it captured East Jerusalem in 1967, almost all Numan residents have West Bank identity cards—an anomaly of no particular consequence until 1993, when at the start of the Oslo peace process Israel imposed a system of closures that bars West Bankers from entering any part of Jerusalem without difficult-to-obtain Israeli-issued permits. As a result, because they live in Jerusalem but have no permits to be there, most Numan residents exist in a Kafkaesque situation that renders living in their own homes technically illegal, by Israeli occupation law.

In addition to being cut off from Jerusalem to the north because of the lack of permits, the village is now also cut off from Bethlehem

and all neighboring West Bank villages by the Wall. Because it is so small, Numan has always depended on neighboring localities for all services, from groceries to medical care. Numan has no stores, no mosque, no school, no medical clinic, but until the Wall isolated the village, residents were easily able to access these services in Bethlehem or in a village on a nearby hilltop. Now Numan is completely cut off, surrounded by forbidden territory in Jerusalem, by the advancing Israeli settlement of Har Homa to the west, and by the Wall on the east and south. The only exit is at the guard tower where we and Ahmad encountered the two young men who were too intimidated by Israeli police to speak to us.

Residents' names, along with those of ten service providers allowed to enter the village, are on a list kept by the Israeli police at the checkpoint. No one else is allowed in. Passage through the checkpoint in either direction is permitted only on foot, except for five vehicles, bearing yellow Israeli license plates, that are owned by residents who happen to have Jerusalem identity cards. The heart of the village is approximately a mile from the checkpoint. Social and family ties with other nearby villages are essentially cut off. A UN mobile medical clinic that once came to the village weekly has been barred. Children must walk several miles over rocky terrain to schools in nearby villages. Any large commodities purchased from outside, such as 50-kilogram sacks of flour or animal feed, must be poured into small containers so that Israeli Border Police can inspect the contents. Israeli municipal authorities in Jerusalem cut off electricity and water to Numan in the 1990s after closure was imposed, but the inhabitants have been able to get water from wells and, at least until the Wall was built, hooked up to Bethlehem's electric grid. Because of these restrictions and because no livestock

may be brought into this agricultural village, its economy has been crippled.[3]

Numan, a village of settled Bedouin who have lived there at least since the 1930s, faces other difficulties that threaten its very existence. Virtually every one of the approximately 20 houses in the village has either been demolished by Israeli bulldozers or been issued a demolition order. These are so-called administrative demolitions, having nothing to do with terrorism or other Israeli security concerns; no Numan resident has ever been involved in or charged with participating in terrorism. But Israel wants Numan's land, primarily for the expanding Israeli settlement of Har Homa and, in a bit of bureaucratic sleight of hand, has declared that the homes in Numan are illegal because built without an Israeli-issued residential building permit. Numan has existed in this location, of course, since well before Israel captured and occupied the West Bank and indeed since before Israel itself was established.

Har Homa is one of the newest but most notable of the several Israeli settlements built on occupied territory inside the expanded Jerusalem municipal limits. Land was first cleared in 1998 for construction of the settlement on a hilltop in the southern reaches of East Jerusalem directly adjacent to Bethlehem and dominating its landscape. In 2007, Har Homa included approximately 1,500 housing units, and another 3,700 units were planned.[4] The settlement gained media attention in December 2007 when Israel defiantly issued construction tenders for 307 new housing units just weeks after the summit convened in November by President George W. Bush at Annapolis, Maryland, among himself, Palestinian President Mahmoud Abbas, and Israel's prime minister at the time, Ehud Olmert, intended to restart the peace process and reaffirm the US request for a freeze on Israeli settlement construction.[5]

Following publicity surrounding the issuance of the new construction tenders, Israeli government spokesmen contended that, because Har Homa is within the Jerusalem city limits in an area annexed by Israel, it is a "neighborhood" over which Israeli law applies and is not subject to the settlement freeze. In fact, according to international law, Israel's annexation of eastern Jerusalem is illegal. In a commentary following the Annapolis summit, Israeli columnist Akiva Eldar called Har Homa "the first test in the spirit of Annapolis." Noting that President Bill Clinton protested when Har Homa's construction was first announced a decade earlier but eventually backed down and had to "eat his words," Eldar quoted Olmert, then the mayor of Jerusalem, as declaring at the time that the settlement's construction was "the most substantive test of the government's ability to withstand pressure and demonstrate leadership." Eldar predicted that, despite protests by the Bush administration over the new construction plans, Olmert would again ignore the protests and proceed with construction. In a comment that accurately captures the tenor of the US-Israeli relationship and the ineffectiveness of US "demands" regarding Israeli settlement construction, Eldar wrote, "So the gentiles say these things—and thousands of Jewish residents laugh all the way to Har Homa."[6]

Residents of Numan have been told that their village land will be taken for Har Homa's expansion. Already, its demolished homes sit as piles of broken concrete and twisted metal in the shadow of the settlement, looming on the next hilltop. Some parcels of Numan's cultivated land have been expropriated for a new road, accessible only to Israelis, leading from Har Homa to another Israeli settlement south of Bethlehem.[7]

All Israeli actions against the village and its residents—the restrictions on entry to Jerusalem, the cutoff of water and

electricity, the demolitions, the Wall and the system of closures, the land confiscations, the settlement construction—are illegal under international law. The Fourth Geneva Convention, adopted in 1949 in the wake of World War II specifically to prevent the kinds of atrocities committed against civilians by Nazi Germany as an occupying power, prohibits collective punishments, transfers of a native population out of its own territory, settlement of the occupier's population in an occupied territory, and destruction of real or personal property belonging to the occupied population, among other practices. The 1907 Hague Regulations, which also regulate the behavior of a belligerent occupier toward a civilian population, prohibit the confiscation of private property.[8]

In July 2004, the International Court of Justice (ICJ) in The Hague ruled by a vote of 14 to one—the US judge being the only negative vote—that construction of the Separation Wall in occupied Palestinian territory in the West Bank, specifically including "in and around East Jerusalem," was "contrary to international law." Israel, the ICJ ruled, was obliged to terminate its breaches of international law, stop construction of the Wall, dismantle sections already built, and make reparation for all damage caused by this construction.[9]

Israel has rejected and ignored this body of international law, including the ICJ decision, and in fact completed construction of the Wall around Numan well after the decision was issued. Like all other Palestinian localities, Numan has little legal recourse against Israeli actions. The ICJ and the United Nations have no ability, and the international community little inclination, to enforce international law. Numan has twice appealed to Israel's High Court of Justice for some kind of relief from the restrictions imposed by the Wall, but to no avail. A petition in 2004 requested either dismantlement of the Wall around the village or recognition of the villagers as legal

residents of Jerusalem. Israel decided to proceed with construction of the Wall but promised to establish a committee to investigate giving villagers resident status in Israel. When nothing came of this agreement, beyond completion of the Wall around the village, residents petitioned the High Court again in 2007. In July 2008, the court rejected this second petition, leaving the residents of Numan, in the words of a *Jerusalem Post* article on the court decision, to live without relief "in their never-never land, trapped without status between the West Bank and Jerusalem."[10]

When we visit Numan in 2005, before the completed Wall blocks off the village, we hear its story from Fatma, the mother of the village council leader, and her nephew Yussuf, who is also a leading figure in the village.[11] The two describe Numan's untenable situation, including the land confiscations, the cutoff of water and electric services from the Jerusalem municipality, the house demolitions, the expansion of Har Homa, the middle-of-the-night arrests of young village men.

The two speak matter-of-factly, with surprisingly little emotion, our friend Ahmad interpreting. Near the end of our meeting, however, Fatma begins to tell a long story that we do not at first understand, until tears begin to roll down her cheeks as she talks. As Ahmad explains the story, one of Fatma's sons is married to a woman who has a Jerusalem identity card. Both are lawyers. Approximately a year ago, their then five-year-old daughter became ill, and Fatma's son went into Jerusalem, carrying his West Bank identity card, to buy medicine for the girl. He was arrested for illegally being in Jerusalem and was held for six months, under Israel's occupation regulations—a holdover from British Mandate days—which permit it to detain anyone for renewable six-month periods without bringing charges. The day before Fatma's son was

to be released, the Israelis imposed a second six-month sentence, and only two days ago, at the end of that sentence and after the family had prepared a welcome-home celebration for him, her son was sentenced for a third six-month period.

While we sit somewhat mute, unable to react adequately to this sad, although not particularly unusual, example of how Palestinians live under Israeli occupation, Fatma's nephew Yussuf strikes a hopeful note. Noting that Numan, and the Palestinians in general, have neither airplanes nor tanks nor large guns, he says they will fight non-violently. Numan's story, he thinks, is getting out—a Swedish film crew has been in the village this very day—and "maybe this will give us power."

Numan made the news in Israel a few months after we visited, but not in the way Yussuf was hoping. In December 2005, *Haaretz* correspondent Gideon Levy recounted the story of a Numan resident, Mahmoud Shawara, found near death, being dragged by his donkey down a rocky dirt road outside the village. He had last been seen several hours earlier driving his donkey cart to a neighboring village, inside the Jerusalem city limits, in search of work, when he and his brother were stopped by Israeli Border Police, who detained them for being inside Jerusalem without proper identity cards. The Border Police forced Shawara's brother into their jeep, but Shawara refused to get in himself because he feared leaving his donkey unattended. The brother was driven away and briefly detained, while Shawara remained surrounded by Border Police. Hours later a neighbor found him tied by one hand to the donkey, unconscious, his face battered, his donkey panicked. He died several days later in a hospital without ever regaining consciousness. Although the Border Police denied any culpability, others from Numan and nearby villages who had survived after

similarly being tied to their donkeys, which the Border Police then deliberately spooked, told Levy that the practice was common. They called it "the donkey procedure."[12]

Levy attended Shawara's funeral. "The funeral is restrained, difficult," he wrote, except for one brief anti-Jewish outcry. "The villagers are convinced that Shawara was killed by the Border Police. But when a Border Police jeep suddenly shows up in the middle of the funeral, for a quick, provocative look, the restraint is maintainedThe Border Police are here every day and people are afraid to talk."[13]

<center>ᴄ₰ ₰ᴅ</center>

Numan's horror story represents the Israeli occupation in microcosm. Hundreds of other villages and towns are experiencing similar fates—cut off from sources of employment, schools, medical care, and other services by walls, checkpoints, roadblocks, and onerous permit requirements; their access to vital necessities such as water and sanitation services severely compromised by the demands of large, urbanized Israeli settlements; their olive groves and other agricultural land expropriated or razed for construction of the Separation Wall or to be incorporated into Israeli settlements; their rural roads blocked or cut off altogether by a 1,000-mile network of highways, generally accessible only to Israeli cars, that connect the Israeli settlements.[14]

The network of Israeli settlements throughout the West Bank and East Jerusalem—numbering over 230, with a population of approximately 475,000 as of the end of 2007—is the very embodiment, the most visible symbol, of Israel's intention to perpetuate its dominance over all of Palestine by absorbing the land

for Jewish settlement, extending its physical presence throughout the land, and cleansing the land of as many Palestinians as possible, confining the remainder in multiple small, disconnected, non-viable, and essentially unlivable cantons. The Separation Wall is drawing a definitive line for much of this segmentation in the west of the West Bank. It preserves the bulk of the Israeli settlements, home to almost 90 percent of the settlers, by clearly placing them on Israel's side; it separates Palestinians from Jews (and very often from other Palestinians as well) through labyrinthine twists winding through urban and rural landscapes; it cantonizes Palestinian areas by separating one from another and squeezing Palestinian inhabitants into ever smaller spaces.

In the east, in the Jordan Valley, which makes up fully one-quarter of the West Bank, Israeli settlements, closed military areas, and designated nature reserves are erasing Palestinian agricultural and grazing land. Since 2005, a severely restrictive permit system generally prevents any Palestinian who does not already live in the Jordan Valley or does not have an Israeli-issued work permit from entering; four major checkpoints control entry to the area.[15]

Throughout the West Bank, a draconian system of closures, consisting of checkpoints, gates, roadblocks, trenches, and earthen mounds, blocks the movement of Palestinians and further ensures their cantonization. When they can travel at all, Palestinians are restricted to using usually narrow, unpaved or barely paved and potholed country roads. While Palestinians are confined, Israel is connected seamlessly with its settlements in the West Bank and East Jerusalem by the extensive network of high-speed, limited-access settler roads that bypass Palestinian towns and villages as if they did not exist.

In July 2007, the UN's Office for the Coordination of Humanitarian Affairs—Occupied Palestinian Territories (OCHA-oPt) produced a major study of the occupation that graphically depicts the extent of Israeli control and oppression.[16] The study, which was produced in book form and has been briefed repeatedly to international leaders and visitors to Jerusalem, includes a series of maps that chart the progression of Israeli control, as exerted through settlements and outposts, lands severed from the West Bank and incorporated into Israel by the Separation Wall, Israeli military areas, Israeli-designated nature reserves, and roads limited to Israeli use. The OCHA presentation—specifically entitled *The Humanitarian Impact on Palestinians of Israeli Settlements and Other Infrastructure in the West Bank*—is so powerful that rumor around Jerusalem has it that Tony Blair, who after stepping down as British prime minister took on the role of special international representative in the occupied territories in mid 2007, left a briefing prepared for him ashen-faced and in shock.[17]

The OCHA maps—adding Israeli-controlled lands on top of Israeli-controlled lands, all effectively barred to Palestinians— show a progression of Israeli domination that reveals a clear Israeli intention to negate any sustainable presence in the land by the Palestinians as a nation.[18]

Map 3 aggregates all this data into a single map showing what little is left to the Palestinians. It is a truncated "Palestine," a Palestine in pieces, which together comprise a mere 61 percent of the West Bank and no more than 13 percent of original Palestine. This broken land is, at present, the totality of what Israel might permit to be formed into a Palestinian "state"—an entity that would be powerless and completely engulfed by Israel, a non-viable, non-sovereign so-called state with no capital and no possibility of building a real economy,

each of its cantons surrounded by Israeli territory, no part having an international border.

Jeff Halper has traced Israel's strategy from 1948, when it was established as a specifically Jewish state in three-quarters of Palestine, through 2007, when it had occupied the remaining one-quarter for 40 years. He charts the changing tactics employed over the years to guarantee continued Israeli control over all of Palestine. Halper uses the Hebrew word *nishul*, meaning "dispossession," to characterize the driving force that has from the start dictated Israel's exclusively Jewish national claims and the extension of what Halper terms Israel's "ethnocracy" over all of the land. After 1948, the methods of accomplishing *nishul* shifted from expulsion of Palestinians to their containment in ever smaller, easily controllable enclaves. Former Israeli Prime Minister Ariel Sharon ultimately conceived the notion of "a cantonized Palestinian state separated from a greater Israel yet posing no challenge to its control of the entire country as the most do-able form of *nishul*." Separation, Halper writes, "became the main vehicle of dispossession and permanent Israeli control."[19]

This strategy has progressed to such an extent that it is now clearly discernible on maps, and the elements of containment— the elements of oppression—can actually be photographed. The following chapters picture what this situation looks like on the ground and describe the restricted situation of Palestinians in towns and villages throughout the West Bank and in parts of Gaza.

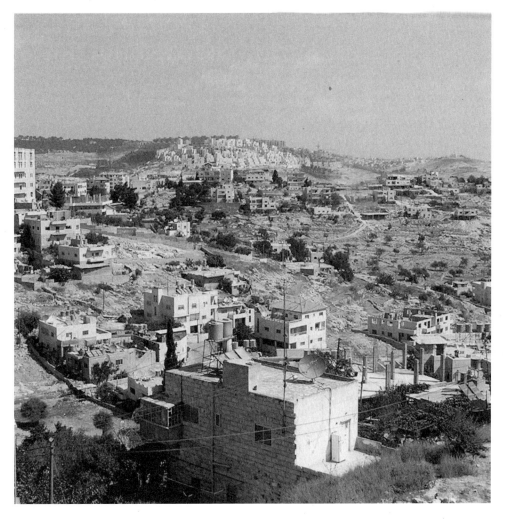

Picture 1
Har Homa, still expanding in 2005, sits on a promontory, known in Arabic as Jabal
Abu Ghnaim, in the southern reaches of municipal Jerusalem, overlooking Bethlehem.
Before settlement construction began, the hill was entirely tree-covered.

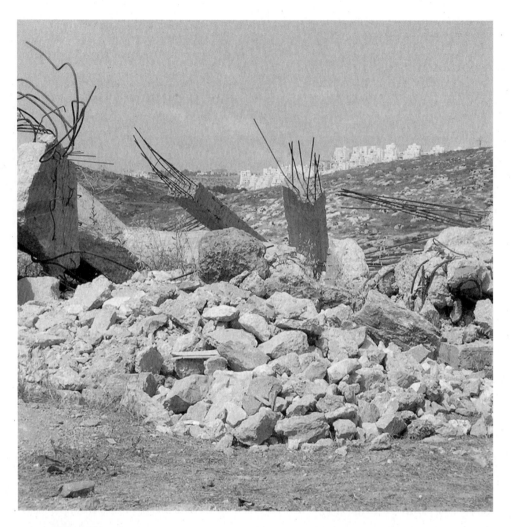

Picture 2
The demolished remains of one Numan house sit in the foreground. Har Homa is in the middle distance, Bethlehem in the background, to the left.

Picture 3
Fatma, mother of the village leader of Numan, wears a long black *thob*, the traditional Palestinian dress, with a bodice intricately embroidered in purple. Her face bears the faded traces of Bedouin face-painting.

2

SETTLEMENTS AND THE SEPARATION WALL

"A horrid, stifling jail"

As we stop in the Palestinian village of Qatanna, northwest of Jerusalem (see Map 2), to take a picture of an Israeli settlement hovering over the village, we are immediately approached by several curious young boys. Two of the boys, very friendly, talkative teenagers, speak to Ahmad for a while and then disappear, while we continue to take in our surroundings. The settlement, Haradar, is quite distinctive in this area of Palestinian villages, perched at the top of a steep hill above the village, its red-tiled roofs noticeably different from the traditional flat-roofed Palestinian architecture of its surroundings. Palestinian author Raja Shehadeh has aptly described the way in which the settlements, which "ride the hills," strategically dominating the valleys below and built with an eye to security and military advantage, stand out in contrast with the Palestinian villages that surround them—villages that "embrace the hills" rather than ride them and which, having developed slowly over time, "blend organically into the land."[1] Our instant impression of Haradar is of an alien intrusion, although settlements like this are a constantly increasing feature of the rural Palestinian landscape.

A few minutes later, the boys are back, bearing a treat—*m'tabaq*, a very thin bread, like a large crepe or sheet of filo dough drizzled

with olive oil and sprinkled with sugar. It is so delicious, and so moist and messy, that any idea of recording this moment of warm Arab hospitality on camera is quickly discarded. The boys ask if we would like to see where the *m'tabaq* is made, so we cross the street and walk a short distance to a family compound where an older woman—*Sitti*, grandmother, the boys tell us—comes out to greet us. Many more children cluster around. *Sitti* lives here with several of her six children and numerous grandchildren. They all take us to a large outdoor oven, a *taboon*, where the *m'tabaq* was made and where one of *Sitti*'s daughters stands ready to bake more bread for us. The *taboon* is a charcoal pit in the ground, enclosed in a square cinder-block structure, barely tall enough for an adult to stand in. In minutes, the young woman bakes a large piece of flat bread on hot coals in the pit and hands it to us. Perhaps because of the occasion, it seems the most delicious bread we have ever tasted.

Ahmad talks to *Sitti* in Arabic while the children mill around, alternately staring at us and horsing around with each other. We ask *Sitti* if we may take her picture and, gesturing for us to wait, she goes inside her house and emerges a moment later dressed in a long *thob*—this one dark blue with intricate embroidery in red on the bodice, in strips down the sleeves, and on the cuffs. Her head is loosely covered in a lightweight white scarf. She is happy to pose for pictures.

We ask Ahmad if we should pay for the bread, and he tells us he needs to talk to the woman first to ascertain the family's situation. After a while, he tells us some of her story. Several decades ago, her husband died while serving as a PLO diplomat in Eastern Europe, but the Israelis would not allow the family to bring his body back to Palestine for burial, so he is buried in Jordan. *Sitti* has remained here to raise the children and grandchildren. The family is prominent in

the village; some of the family land was donated for the construction of a large school, which stands adjacent to the family home. Payment for the bread is not appropriate, Ahmad decides.

Sitti talks to Ahmad about their determination to remain on the land, and he describes for us how they are able to subsist on relatively little: they have flour for bread, they raise vegetables, and they own olive trees. As we prepare to leave, someone gives us a plastic bag for the bread, and we thank everyone. We ask Ahmad to tell *Sitti* that we hope she and her family and the Palestinians will remain steadfast, *sumud*, so that ultimately the Palestinians can defeat Israel and the occupation. We have chosen the word "defeat" deliberately. Ahmad translates her response, which does not speak of anyone's defeat: "we don't mean any harm to the Israelis," she says. "We can live with them, but we just want them to leave us alone." Everyone is conscious of Haradar in the near background looking down on all of us—"riding on the houses," Ahmad calls it. He uses Shehadeh's metaphor, although he had never read Shehadeh's book. It is a common image among Palestinians.

<p style="text-align:center">☙　❧</p>

Israeli settlements in the West Bank and East Jerusalem are not only the centerpiece of Israel's occupation, but they represent as well the vanguard of Zionism's expansion throughout the West Bank, completing its advance across the entirety of Palestine. All other aspects of the occupation revolve around the settlements and are intended to enhance their permanence. The Separation Wall is routed to bring the major settlement blocs, which include almost 90 percent of the 475,000 settlers, into Israel, even where key settlements are situated deep inside the West Bank, as with Ariel (see Map 4) and

Ma'ale Adumim. The 1,000-mile settler road network that is barred to most Palestinians has been built to connect the settlements to each other and to Israel, as well as to bypass Palestinian towns and villages. The hundreds of checkpoints, terminals, and roadblocks throughout the West Bank are intended to impede free movement of Palestinians and prevent them from approaching the settlements or the Israeli-only connecting roads. Restrictions on Palestinian entry to the Jordan Valley keep Palestinians away from the network of agricultural settlements dotting this area adjacent to the Jordan River. The Israeli military presence throughout the West Bank is intended largely to protect the settlers and the settlements—a huge allocation of manpower to little more than security guard duties.

Built everywhere—on top of hills overlooking Palestinian villages, in commanding positions appearing like Crusader castles above the landscape of Palestine, burrowed into Palestinian neighborhoods in individual homes and apartment buildings expropriated from Palestinian owners in urban areas such as Hebron and some areas of East Jerusalem—the settlements are the building blocks of Zionism and of Israeli expansion. (For precisely the reason that they are the tangible symbol of Israeli expansion, and are illegal under international law, the settlements are more properly termed "colonies," but because they are so widely called "settlements" everywhere, this is the term that will be used here.) Henry Siegman, a prominent scholar of the Palestine-Israel situation and former director of the American Jewish Congress, has characterized the scale of settlement-building, without exaggeration, as a "theft of Palestinian lands" that is massive and involves "every part of Israeli society in advancing the settlement enterprise in clear and deliberate violation not only of international law but of Israel's own laws."[2] Former UN Secretary General Kofi Annan, in his final report on the

Middle East to the Security Council in 2006, stated that settlement expansion is "the single biggest impediment to realizing a viable Palestinian state with territorial contiguity."[3]

Settlement expansion continues inexorably—despite occasional objections from successive US administrations, despite Israeli government promises to cease, despite repeated peace plans since the early 1990s designed to lead to Israel's withdrawal from the occupied territories and establishment of a Palestinian state, and despite an explicit call for a freeze on further settlement construction in the 2003 Roadmap peace plan (put forth by the so-called Quartet, composed of the United States, the United Nations, the European Union, and Russia).

With little fanfare, Israel doubled the number of settlers in the West Bank and Gaza during the seven years of the Oslo peace process from 1993 to 2000.[4] From 2001 through 2007, the number of settlers increased by an additional almost 30 percent, even though approximately 9,000 settlers were withdrawn from Gaza when Israel carried out the so-called "disengagement" from that territory in 2005. During this period, Ariel Sharon, an outspoken proponent of Israeli settlement, and his like-minded successor Ehud Olmert served as Israeli prime ministers and President George W. Bush generally lent support to Israeli policies, including the settlement enterprise, despite occasional, but ultimately meaningless, statements suggesting the contrary.

In the first four months after the November 2007 Annapolis summit, which was heralded as restarting the peace process by, among other steps, ending settlement construction, Israel announced plans to build almost 2,000 new housing units in West Bank and East Jerusalem settlements, and plans for an additional 3,600 units in East Jerusalem were approved by a lower level planning

commission. As of April 2008, construction was underway in 101 West Bank settlements.[5]

Olmert justified much of this settlement construction on the basis of a letter given by Bush to Sharon in April 2004 in which Bush stipulated—contrary to past US policy and in contravention of international law, which prohibits the construction in occupied territory of colonies for the occupier—that it would be "unrealistic" to expect Israel to withdraw completely to the Green Line and that Israel could retain all or most of the "already existing major Israeli populations centers" in the occupied territories.[6] In explanation of his issuance of additional housing construction tenders in April 2008, Olmert told a group of newspaper interviewers that "it was clear from day one" that construction would continue in the areas mentioned in Bush's letter. "Beitar [Betar] Illit will be built," he asserted, "Gush Etzion will be built; there will be construction in Pisgat Ze'ev and in the Jewish neighborhoods of Jerusalem"— referring to the large settlement of Betar Illit west of Bethlehem, to the Gush Etzion bloc of several small settlements near Hebron, and to the large urban settlement of Pisgat Ze'ev in East Jerusalem.[7] (See Map 2.)

Although no settlements were specifically named in Bush's letter, these large settlement blocs are located within the concentration of settlements that have ended up on Israel's side of the Separation Wall and that Israel has assumed will remain under its control as part of any peace agreement. Israeli officials maintain that the Bush administration formally agreed in the spring of 2005, a year after the Bush letter, to accept a "line of construction" within which Israel had US consent to continue building. US officials deny any such agreement, but the United States has done nothing, beyond

occasional mild protests unaccompanied by any punitive action, to stop the Israeli actions.[8]

The massive settlement of Ma'ale Adumim, home to approximately 32,000 Israelis as of 2005 and still expanding, is a major part of the settlement blocs that Israel assumes will remain under its control, and it is indeed the jewel in the crown of Israeli settlements. In area, it is the largest by far, its sprawl covering over 11,000 acres. Situated east of Jerusalem, deep inside the West Bank, this settlement serves as a large suburb of Jerusalem and will ultimately be included on the Israeli side of the Separation Wall when this barrier is completed. Whether or not formally annexed to Jerusalem, the settlement and its surrounding infrastructure will become an integral part of Jerusalem. It already, even before the Wall is completed, effectively divides the West Bank into two sections.[9] Map 2 shows the route of the Wall around Ma'ale Adumim to the east, projecting like a fist into the West Bank. The area west of this section of the Wall includes several smaller settlements, as well as the real estate lying between Jerusalem and Ma'ale Adumim, which is slated for large-scale development. The so-called E1 Plan will include construction of a residential neighborhood, planned for a population of several thousand, along with hotels and an industrial zone.

The 232 Israeli settlements and outposts are widely dispersed throughout the West Bank and in East Jerusalem (Maps 2 and 4). So-called outposts are distinguished from settlements by being illegal even under Israeli law; although both settlements and outposts are illegal under international law, outposts are unauthorized even by the Israeli government. Most outposts, usually consisting only of several caravans, or house trailers, are offshoots of established settlements and are located within no more than a few miles, most often less than one mile, of the larger "mother" settlements.[10]

Although settlements and outposts together take up only a total of 3 percent of the land, the additional lands and infrastructure that support the settlements—including their industrial areas, their agricultural areas, and the connecting road network—along with the large areas set aside for Israeli military bases, prevent any Palestinian contiguity and undermine any possibility of Palestinian national sovereignty and viability. Yariv Oppenheimer, director general of the Israeli organization Peace Now, which closely tracks the settlements, has characterized Israel's expanding construction plans as altering the lay of the land "almost irreversibly."[11] Fully one-third of the land on which settlements are built is confiscated land taken from private Palestinian owners; most of the remainder, much of it confiscated for supposedly temporary military use, is communal land belonging to Palestinian villages under a land system passed down from Ottoman times.[12]

The settlements also take a disproportionate amount of water from West Bank aquifers, depriving Palestinians of water in a dry desert area. Allocation of water to the 475,000 Israeli settlers and the 2.2 million Palestinians in the West Bank and East Jerusalem is extremely inequitable. Israeli consumption, including that in Israel itself and in the settlements, for domestic, urban, and industrial purposes is approximately 330 liters per person per day (l/p/d), whereas Palestinian consumption in the West Bank and East Jerusalem stands at only 60 l/p/d—a ratio of more than five to one. According to some estimates, water usage for settlers versus Palestinians stands at a seven-to-one ratio. Both the World Health Organization and the US Agency for International Development place the recommended minimum consumption level at 100 l/p/d, almost twice what is available to the Palestinians. Approximately 10 percent of the Palestinian population is not connected to sources

of running water and must obtain water from cisterns or springs, where available, or through purchase from tanker trucks.[13] All Israeli settlements are connected to a running water system and are subject to few if any restrictions on usage.

Settlements are a clear Israeli attempt to assert dominion over Palestine. Henry Siegman notes that Israel's settlement expansion is part of a deliberate strategy to destroy "the possibility of a peace agreement" and ultimately to nullify altogether any partition of Palestine. He describes the persistent international attempts, by Europe as well as by the United States, to revive a peace process as a "massive hoax" for precisely the reason that Israel has made clear its intention to thwart the formation of any viable, sovereign Palestinian state. History has repeatedly shown, Siegman asserts, that uncritical Western support for Israel's policies does not lead to greater Israeli willingness to make concessions for peace but on the contrary simply spurs Israeli expansionism. "The less opposition Israel encounters from its friends in the West for its dispossession of the Palestinians," Siegman observes, "the more uncompromising its behavior."[14] The United States and the rest of the international community, by winking at Israel's aggressively expansionist policies, have given Israel virtual total impunity to do whatever it likes with Palestinian land and lives.

<p style="text-align:center">ᬀ ᬁ</p>

Because it envelops the major settlement blocs, and with them over 85 percent of the settler population,[15] effectively incorporating them into Israel, the Separation Wall in the West Bank stands as a clear symbol of Israel's intention to absorb as much of this territory as possible into itself, separating itself from as much of the Palestinian

population as possible and squeezing this population into ever smaller fragments of the territory. Although the Wall is in some measure a security barrier, intended to prevent Palestinian suicide bombers from entering Israel, its primary purpose is territorial aggrandizement. John Dugard, a UN human rights official with long experience in the occupied territories, observed in 2003, when the Wall had been completed only in the north and northwest of the West Bank, that "what we are presently witnessing in the West Bank is a visible and clear act of territorial annexation under the guise of security."[16] Even Israeli officials have acknowledged that the Wall has political implications beyond security. Among others, Tzipi Livni, who served as Israeli justice minister and foreign minister before assuming the leadership of the Kadima party in 2008, has referred frankly to the Wall as a political border for Israel.[17]

Any doubts that Israel has always intended to retain control over almost all of the West Bank, any expectation that it ever intended to withdraw from the territory and relinquish control over the settlements, any hope that Israel ever meant to allow the Palestinians to establish a truly independent, sovereign state in a contiguous body of territory large enough and economically independent enough to be taken seriously as a member of the international community of nations, were conclusively erased when Israelis began construction on the Wall in 2002.

The very concept of separation, of physically separating Jews in Israel and the West Bank from Palestinians, says much about Israel's image of itself as an exclusivist Jewish state, eventually containing no or almost no non-Jews, encompassing not only the land inside the 1967 borders but all or most of the occupied territories as well. Graham Usher, a British journalist long based in Jerusalem, has observed that the idea of an ethnically based physical

separation began to grow in the minds of Israeli leaders in the late 1980s, when the PLO, which had already galvanized a national consciousness among Palestinians, was able to mould a broad Palestinian consensus in support of fulfilling national aspirations through an independent state limited to the West Bank and Gaza, with a capital in East Jerusalem, which would exist alongside an Israeli state confined to its 1967 borders, the Green Line. From this point on, Usher explains, moves toward ethnic separation replaced the partial integration of Palestinians—who in these years were able to work inside Israel—that had heretofore characterized Israel's control over the occupied territories.[18]

This separation was formalized step by step throughout the Oslo peace process. The establishment of the Palestinian Authority in 1994 gave the Palestinians some of the non-political civilian functions of an autonomy government, without altering Israel's overall control or requiring Israel to surrender territorial, political, or military domination. Although Palestinians in the occupied territories had previously enjoyed freedom of movement inside Israel and worked in Israel in substantial numbers, their entry was now greatly restricted. Under Israeli Prime Minister Yitzhak Rabin—who is, ironically, widely but mistakenly believed to have been the architect of the effort to construct a two-state solution for Palestine-Israel—separation began to be more concrete. Rabin imposed a "general closure" on the occupied territories that further limited Palestinian movement and prevented movement even into East Jerusalem without a permit. Interim Oslo agreements in the mid 1990s established areas of differing Palestinian and Israeli civilian and security control in disconnected sections of the West Bank—forming, in Usher's words, an "even more Kafkaesque and racially stratified" system. The system was reinforced in 1996 with the

institution of a regime of "internal closure" marked by checkpoints outside Palestinian towns and bypass roads limited to cars with Israeli license plates.[19]

The notion of actual barriers to confine Palestinians and separate them from Israelis originated under Rabin. In Gaza, at the beginning of the peace process, the Rabin government built an electronic fence that still surrounds and walls in the entire territory. Rabin also commissioned the design of a "security fence" for the West Bank to parallel the Green Line, but the plan was shelved in the mid 1990s by Likud Prime Minister Binyamin Netanyahu, who believed at the time, along with most of Israel's right wing, which opposed limiting Israel's territorial options, that such a structure might be mistaken for a limiting border that would prevent Israel's further consolidation of and permanent control over all of the West Bank.[20]

The idea of a barrier, and of what was to become the Separation Wall, was revived by Prime Minister Ehud Barak in the fall of 2000, as the Palestinian *intifada* began—the second uprising, often called the al-Aqsa *intifada*, after the al-Aqsa Mosque in Jerusalem—and suicide bombings inside Israel increased. According to a "Security Separation Plan" proposed by the Barak government, a "barrier" would be built to provide physical security to Israeli citizens. But the plan, according to Jeff Halper, had "two other objectives—political objectives—as well: preventing Palestinians from achieving any territorial, infrastructural or political gains outside of negotiations and exacting from the Palestinians a high economic price, through closures, trade restrictions, sanctions and other means, as a way of pressuring them to submit."[21] Or to leave.

Although, like Netanyahu, Ariel Sharon was initially opposed to any such structure for fear that it would become a limiting territorial border, demographic realities—specifically the fear that

Palestinians would soon become the majority population in all of Palestine-Israel—along with the upsurge in Palestinian suicide bombings in 2001 and early 2002, ultimately led him to accept the limitations imposed by a physical barrier, and construction on the Separation Wall began in June 2002. Sharon's expectation was that Israel could maintain mastery by laying down the route of the Wall unilaterally, in ways that suited its own needs. Part of these "needs" involved forcing the departure of large numbers of Palestinians. In the words of a retired Israeli military commander, the Wall would "create the conditions for voluntary transfer"—meaning squeeze and confine the Palestinians in "a horrid, stifling jail"—"so that the Palestinians will abandon their homes and go [eastward] to the big Palestinian cities," and finally out of Palestine altogether. This displacement of the Palestinians, the commander foresaw, would make it "possible to expand the borders of Israel without paying the demographic price [that is, without accepting Palestinians inside Israel's 'borders'], because if you change the demography, you change the geography."[22]

The Wall, the restrictions on movement that confine Palestinians in narrow enclaves, the bypass roads that enable Israelis to move around the West Bank without encountering Palestinians are all part of a system that, in the words of author Joel Kovel, "gives Israelis the illusion that their Other does not exist."[23] In many areas, the Israeli side of the ugly concrete Wall is carefully landscaped so that its 26-foot height almost completely disappears behind attractive plantings and sculpted inclines. Although the effort is quite conscious on the part of Israeli leaders and planners, the effect on the Israeli people is to enforce denial, rendering Palestinians invisible and giving the leadership a shield behind which to carry out the unsavory aspects of oppression without being observed.

Ↄ҉ ҉ↄ

The Wall plants a monstrous footprint on the small territory of the West Bank. Longer by several times than the Berlin Wall and twice as high, the Wall when it is completed will be 448 miles long, more than twice the 195-mile length of the Green Line that forms the actual border between Israel and the West Bank. The route of the Wall when completed will put slightly over 10 percent of the 2,200-square-mile West Bank on Israel's side, effectively annexing this substantial territory and its natural resources to Israel. Approximately 80 percent of the Wall is to be built not on the Green Line but well to the east of it, jutting deeply inside the West Bank in several places. Because Palestinians are excluded as well from most of the Jordan Valley in the eastern West Bank, this means that the territory is split into several almost completely isolated pieces.

Map 4, showing the completed and projected route of the Wall as of mid 2007, illustrates this breakup of the West Bank into smaller, non-viable chunks of land, both in the Jerusalem area—where the extension of the Wall far to the east cuts the southern West Bank off from the northern two-thirds—and in two areas in the northern West Bank that again cut this northern territory almost in two. The more northerly of the two salients accommodates a string of small but strategically placed settlements that dominate the middle of the West Bank; the southern salient extends 13 miles into the West Bank to encompass the large settlement of Ariel and a swath of smaller settlements.

Political controversy has swirled around the issue of what to call the Wall—whether a "fence," because for much of its length it is indeed an electronic fence bordered by patrol roads, trenches, and coils of razor wire, or a "wall," because in urban areas it is a

massive concrete wall at least 26 feet high with round guard towers at periodic intervals, or a "barrier," thought to be a neutral choice between the other two now highly politicized terms. Palestinians, feeling very directly the effects of this impenetrable obstacle to freedom and freedom of movement, call it a wall—often "separation wall," more often "apartheid wall." Initially, even President Bush used the terms "wall" and "fence" interchangeably, until Sharon and other Israeli officials specifically asked him to use the word "fence."[24] For public relations purposes, this is the term the Israelis prefer; concrete walls inside and around cities clearly do not present a good image of Israel's relations with its Palestinian subjects. Human rights organizations, such as the Israeli organization B'Tselem and the UN's OCHA, favor the supposedly neutral term "barrier."

But there are multiple reasons for naming this structure the Separation Wall. Its stated purpose is separation, and its impenetrability gives it all the aspects of a wall. Definitions of the word "wall" are obviously not limited to the literal meaning of a material structure, but also include anything that functions like a wall, whether the sense is literal or psychological. Impenetrability is the principal criterion for labeling any structure that encloses and confines, and the Separation Wall is as impenetrable where it is a fortified fence as it is where it is a concrete wall.

Many of those most familiar with the Wall and its impact call it a "wall." Throughout its 2004 legal opinion on the Wall, the International Court of Justice referred to it as a wall. Israeli activist and anthropologist Jeff Halper, although personally referring to it as "the Barrier," points out that the Berlin Wall, to which the Separation Wall is often compared, was also a mix of concrete walls and fortified fences but was never referred to as a fence.[25] Ray Dolphin, a longtime employee of various UN agencies and an

expert on the Wall and its implications, uses the term "wall" and titled his 2006 book on the structure *The West Bank Wall.*

Dolphin points out that the non-concrete sections of the Wall are so heavily fortified and take up so much wider a swath of Palestinian land than the concrete sections that using the benign word "fence" is disingenuous and fails to convey the magnitude of a structure that carves such a long path through the West Bank landscape. The "fence" segment, he notes, is "equally effective—and destructive—in terms of its security and its humanitarian impact." Dolphin also objects to the term "barrier" because this implies that the principal purpose of the Wall is to provide security for Israelis, when in fact the structure is chiefly intended "to create a new border deeper within West Bank territory, in the process annexing major settlements, territory and water resources to Israel."[26]

One principal indication that the Wall is not intended primarily as a security barrier is that construction was halted in 2007 for an extended period, with the structure only two-thirds complete. If the Wall were intended chiefly as a security barrier rather than as a means of annexing territory, the urgency of the security situation would have dictated that construction not be so slow in the first instance, covering a five-year time span, and that it not be halted for any period with one-third of its length uncompleted. Were security the major consideration, the Wall could have been built on the Green Line rather than well inside it, or a physical barrier could have been forgone entirely and checkpoints and other security measures along the Green Line strengthened. Official Israeli reports indicate that at least through mid 2002—the year of heaviest suicide attacks inside Israel—most bombers entered Israel from the West Bank via border checkpoints where inspections were said to be "faulty and even shoddy." B'Tselem has pointed out that international law enshrines

the principle that the infringement of human rights—which the Wall clearly causes—is not justified if other courses of action are available to achieve a particular objective, in this case Israeli security against suicide bombings. This security could clearly have been achieved by improving procedures at checkpoints and strengthening military deployment along the Green Line.[27]

It is self-evident that the Wall would impede some terrorism, and the number of suicide bombings did drop dramatically after construction on the Wall began. But there were also reasons other than the Wall for this drop-off. While access to Israel from the northern West Bank became more difficult with completion of the Wall in that area in 2003, the large gaps where construction remained incomplete would have provided access for suicide bombers, but there were relatively few such attacks after 2003. The drop in attacks is partly attributable to better Israeli intelligence, as well as to the intimidation factor resulting from Israel's assassination of key leaders of Hamas and other militant Islamic organizations.[28] In addition, there is some reason to believe that a general desire to diminish the level of violence took hold in Palestinian society at this time. Palestinian physician and political activist Mustafa Barghouti noted in September 2004, on the occasion of the fourth anniversary of the start of the al-Aqsa *intifada*, that there had been a "serious rise in mass popular support for non-violent resistance" and that this, rather than the Wall, was the cause of the drop in suicide attacks against Israel.[29] Other Palestinian leaders pointed out at the same time that Palestinian society no longer supported suicide operations because the punishment from Israel was too great and the desire for some kind of normalcy was too strong.[30]

The Wall is also not a temporary structure, erected only until the security situation eases, as Israel and its defenders have claimed

in a further attempt to minimize its negative image. One Israeli commentator wrote in 2003 that "you have to be almost insane to think that somebody uprooted mountains, leveled hills and poured billions here in order to build some temporary security barrier 'until the permanent borders are decided.'" The huge cost involved, as much as the large construction effort, also indicates permanence. As of 2005, cost estimates stood at approximately US$1.3 billion for the structure, plus an additional approximately US$20 million annually for maintenance.[31] A later estimate put the cost of the Wall through mid 2008 at US$3.9 billion.[32] The structure is clearly intended mainly as part of an expanded, unilaterally imposed Israeli border.

The effect of the Wall on West Bank and East Jerusalem Palestinians has been disastrous. By the estimate of B'Tselem, almost half a million Palestinians, more than 20 percent of the population of the West Bank and East Jerusalem, are directly affected by the Wall—either because their communities or their land have ended up on the Israeli side of the Wall in the so-called "seam zone" between the Green Line and the Wall, or because they live in communities that are surrounded completely or on three sides by the Wall, or because they live in East Jerusalem, where the Wall winds in and out of neighborhoods and places most of the city's 200,000-plus Palestinian residents on the Israeli side.[33]

Homes standing on the route of the Wall have been demolished to make way for the structure. Many agricultural villages have been split by the Wall, their land lying on one side and the populated centers on the other. If land lying on the Israeli side is not immediately confiscated for construction or expansion of a settlement, farmers may farm the land but only if they obtain Israeli-issued permits, which must be renewed at frequent intervals and may be denied for

no particular reason. Access is through gates in the Wall manned by Israeli soldiers; these are opened only a few hours a day, are occasionally closed for extended periods during Israeli national and religious holidays, and ultimately depend on the whim and goodwill of individual Israeli soldiers. Farmers may not drive through the gates and must often travel for hours on foot or by donkey cart to get to the gate on one side and then backtrack more miles on the other side to reach their land. As of mid 2006, UN reports indicated that only 40 percent of farming families owning land on the Israeli side of the Wall were able to reach their land at all.[34]

The Wall's confiscation of Palestinian freshwater wells and fertile agricultural land is one of the most serious long-term effects of this terrain-changing, geography-altering structure. The West Bank's richest agricultural land, with some of the territory's most abundant water reserves, lies in the northwest—where, not coincidentally, a large concentration of Israeli settlements has been planted amidst multiple Palestinian farming villages. The Wall is particularly intrusive in this area, for the very reason that many of the settlements are situated so deep inside the West Bank, interspersed with Palestinian villages. Because in many instances settlements actually lie farther to the east and deeper inside the West Bank than Palestinian villages, the Wall winds back and forth in a bizarre effort to include the settlements on Israel's side and ensure that Palestinian communities are on the West Bank side. Enabled by this appropriation of land and water resources to expand unimpeded onto more Palestinian land, several of the settlements here began building thousands of new housing units as soon as construction on the Wall was completed in this area in 2003.

Although in 2005 the Israeli High Court of Justice ordered that an alternative route be devised after deciding that the Wall created

a "chokehold" around several Palestinian villages, by mid 2008 no changes had yet been made.[35] In July 2008, after resisting the changes for several years, the Israel Defense Force (IDF) finally agreed to alter the route in one area northeast of the city of Qalqilya near Jayyus village (see Map 1), but Palestinian activists point out that this change would return only 30 percent of Jayyus land now on Israel's side of the Wall, leaving the remaining 70 percent permanently in Israeli hands.[36]

A Palestinian hydrologist has estimated that as much as 90 percent of the available water in the West Bank has fallen on Israel's side of the Wall. The village of Jayyus, a farming village with a population of 3,200, has seen all six of its freshwater wells end up in Israeli hands and, because of the lack of water and the difficulties in reaching village farmland west of the Wall, has lost entire fruit and vegetable harvests. Vegetables grown in an extensive system of greenhouses, which require daily irrigation and care, have often had to be left to rot. A year after the Wall was completed, agricultural production from Jayyus had dropped by almost half. Villagers must now obtain water from a well in another village, which is itself affected by Israeli restrictions, or purchase expensive water from tankers, and domestic consumption per capita has fallen to one-quarter of the World Health Organization's recommended 100 liters per person per day.[37] Israeli authorities do not allow West Bankers to drill new wells without permission, and this is usually denied.

Villagers gain access to their land through a permit system regulated by Israeli authorities. A Jayyus village official regularly applies for three-month permits on behalf of multiple residents, but almost always most are denied. In one instance in mid 2008 when a British correspondent happened to be present, the village's application was returned with permits granted for only four of 32

applicants. The reason for denial is always given as "security," without further elaboration. The permit application process is particularly onerous, requiring at least six substantiating documents, including copies of an Israeli-issued identity card and of the previous permit, a map of the land, municipal certification that the land has not been sold, and documents proving inheritance of the land and original land ownership dating to pre-occupation times, often back to the Ottoman period.[38] All other Palestinians in villages along the length of the Wall face similar permit requirements. Any Israeli, on the other hand, and anyone "entitled to immigrate to Israel according to the Law of Return"—meaning any Jew in the world—may, according to Israel's racist regulations, freely enter the area west of the Wall without a permit.[39]

These effects of the Wall have been so severe in Jayyus and other farming villages that rural livelihoods and lifestyles have been dramatically affected. The UN's OCHA has concluded that the long-term fate of these communities "is uncertain, as they lose contact with the land on which they depend both for their present livelihood and for their future survival."[40] The UN estimates that 15,000 people from this farming area have been displaced because of hardships caused by the Wall.[41]

This direct impact on farmers—and Israel's ultimate intent in building the Wall—is dramatically described by a Jayyus farmer in a 2005 film entitled *Wall*. "The truth is," this farmer says, "they want to expropriate our land. It is an indirect way to try to get us to abandon our villages." How will this happen, he asks rhetorically? "Because if they take our land and leave us with nothing to make a living, to feed our children and grandchildren, we will have to leave to look for work elsewhere. In practice, it is an expulsion operation

in disguise, so that the world can continue to praise Israel or be silent and treat us like terrorists."[42]

<center> C3 80</center>

In East Jerusalem, the Wall follows a labyrinthine path around and through residential and commercial neighborhoods that has had a massive disruptive effect on life in the city both for its 200,000 Palestinian residents and for the estimated 100,000 who reside in immediately adjacent suburbs that before the Wall were an integral part of the city. Major suburbs such as Ram and Hizma northeast of the city and Anata, Abu Dis, and Azarya (Bethany) on the east, although just outside the municipal limits of Jerusalem, were barely distinguishable from neighborhoods inside the city boundary until the Wall cut them off from the city and its services. The portion of the Wall surrounding what the Israelis call the "Jerusalem envelope"—that is, the area surrounding the city on the north, east, and south and including the large area around the settlement of Ma'ale Adumim—is slightly over 100 miles in length, almost one-quarter of the entire span of the Wall.[43] These suburbs and their relationship to the Wall are clearly defined on Map 2.

A total of 13 checkpoints and terminals in the Wall around Jerusalem control movement into and out of the city for Palestinians. Most of those who have established residency inside the municipal limits have Jerusalem identity cards, which give them access through any of the checkpoints, although they must often wait in long lines to pass through. Those with West Bank identity cards may enter the city only through four of the checkpoints, only on foot, and only if they have permits, which are usually issued for limited purposes— work or medical treatment—and are good for limited periods. Three more checkpoints are planned.[44]

The Wall, the onerous checkpoints and terminals, and the need for hard-to-obtain permits in order to enter East Jerusalem have essentially cut the Palestinian capital off from its West Bank hinterland and severed the West Bank's more than two million Palestinians from their capital. Jerusalem has always, despite Israel's annexation of East Jerusalem in 1967, been the economic center of Palestine and its religious heart, for both Muslims and Christians. It is also the political center for Palestinians, even though Ramallah was established during the Oslo peace process as the headquarters of the Palestinian Authority, pending resolution of the status of Jerusalem in a final peace agreement. The Wall has essentially emasculated the Palestinian polity by physically severing its head from its population base.

In metropolitan Jerusalem, the Wall's separation of city neighborhoods from the near suburbs has had an even more direct impact, "completely ignor[ing] the fabric of life that has evolved over the years, and threaten[ing] to destroy it altogether," according to B'Tselem. Thousands of residents live outside the city but work inside or vice versa; equal thousands of school children and university students live on one side of the Wall but attend schools on the other side; families living dispersed in near neighborhoods or even across the street from each other have been separated by the Wall; Muslims and Christians who wish to worship at major religious sites such as the al-Aqsa Mosque or the Church of the Holy Sepulcher inside the city are barred, even during religious holy days, except in the rare circumstance that they obtain permits; businesses and their customers live and shop on both sides of the Wall. All of these connections have been severely disrupted or cut altogether. Many businesses have had to close because the Wall, running down the middle of a major street or through a mixed residential-commercial neighborhood, has eliminated their customer base.

Some suburbs, such as Bir Nabala and three neighboring villages north of the city and Walaja on the southwest, are completely enclosed by the Wall, with only one way out through an Israeli-manned gate.[45] (See Map 2.) In most suburbs—particularly on the north and east, in the Bir Nabala area, in Ram, as well as in Abu Dis, Azarya, and Jabal Mukhaber/Sawahra—the Wall is constructed exactly on top of areas that would otherwise be the most likely locations for much-needed Palestinian residential and commercial development.[46]

Medical care has perhaps been affected most seriously. With no hospitals at all in the near suburbs and few clinics, residents of these outlying neighborhoods have depended completely on the six hospitals inside East Jerusalem for routine and emergency medical treatment, for childbirth and surgery. Because of the Wall and the system of checkpoints, reaching hospitals in Ramallah or Bethlehem is almost impossible for residents of Jerusalem's outlying neighborhoods. The Jerusalem hospitals have treated approximately 3,000 patients from outside Jerusalem annually, but since construction began on the Wall, the number of both inpatients and outpatients has dropped in half. Medical staff at these hospitals are also affected by the Wall; almost three-quarters of the approximately 1,200 employees live outside the Wall and must obtain permits to enter Jerusalem, must often wait in lines to pass through the checkpoints into Jerusalem, and are not permitted to be in the city after 7:00 p.m.[47]

ɔ3 ଚ୦

Although Israeli settlements in the West Bank are the heart of the occupation and the tangible evidence of Israel's intention to maintain control over the entire territory, the Wall puts a seal on

Israel's huge physical presence in the West Bank and East Jerusalem and gives a further aura of permanence to the spreading imprint of the settlements. While construction and expansion of the settlements have involved confiscation of large tracts of Palestinian land, the Wall has probably directly affected larger numbers of Palestinians by impeding movement, by destroying their livelihoods and often their homes, by constricting their very lives, by imposing on them a system of separation reminiscent of the worst discriminatory regimes in the world. The Wall has regimented and systematized a network of closures and movement restrictions that has been in effect on a smaller scale since at least the beginning of the Oslo peace process in the early 1990s and has intensified as Palestinian resistance has grown, as the settlements and road networks that the Wall protects have grown, and as Israeli fear of pressures to relinquish territory has grown.

But the Wall may prove to be a step too far for Israel. The Wall is many things—it is in part a security barrier, it is in large measure a unilaterally declared political border, it is a mark of apartheid—but one thing it is not is a sign of the triumph of Zionism. On the contrary, this massive Wall is an acknowledgment that Zionism has not succeeded in ridding the so-called Land of Israel, or Greater Israel, of the large and growing Palestinian population that prevents formation of a wholly Jewish state. Construction of the Wall signals Israel's intent to establish permanent dominance over all of Palestine, but it is also a clear sign that Israel is uncertain that this dominance can indeed be sustained or become permanent. It is undoubtedly an overstatement to say that the Wall is a sign of Israeli desperation, but it is no exaggeration to state that this huge barrier is an acknowledgment of great failure.

Graham Usher, discussing the Wall and its impact, has observed that Israel is not strengthened by its occupation of the West Bank and Gaza. Vietnam and South Africa, he points out, have shown that when resistance movements and anti-colonial movements succeed, they ultimately cause "a fracture in the people of the colonial power." Such a fracture is possible in Israel, Usher believes; even decades after Israel's conquest of the occupied territories there is still no consensus over their fate. The territories "remain Israel's weakest, most contested, most vulnerable possession."[48] One might add that the occupied territories and Israel's inability to separate them from the state established in 1948 make Israel itself vulnerable and fractured.

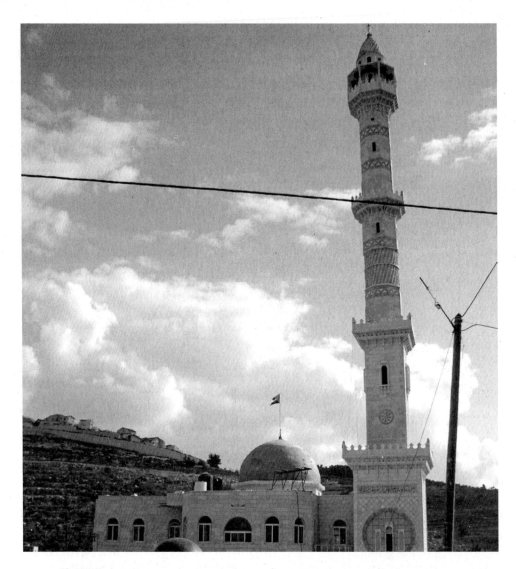

Picture 4
The settlement of Haradar, in the left background, sits on a steep hill looking down on the Palestinian village of Qatanna and its mosque, demonstrating the way in which settlements dominate the Palestinian landscape. This settlement, a relatively small one with a population of approximately 2,400, is shown on Map 2, along with Qatanna and several other Palestinian villages that sit at the foot of Haradar.

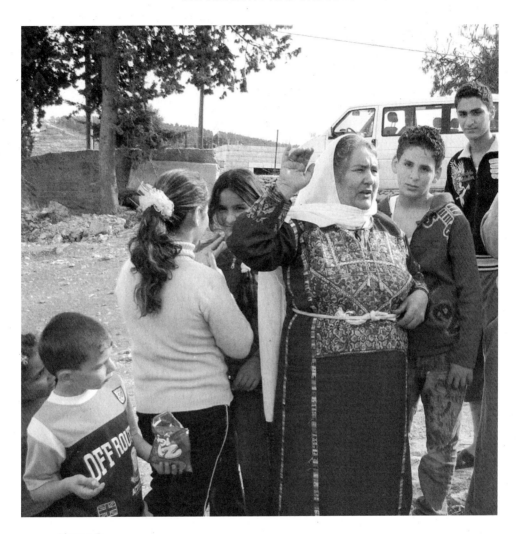

Picture 5
Children and grandchildren gather around as *Sitti* talks about life in Qatanna, in the shadow of the Israeli settlement of Haradar. The edge of the settlement is evident behind trees in the far left background.

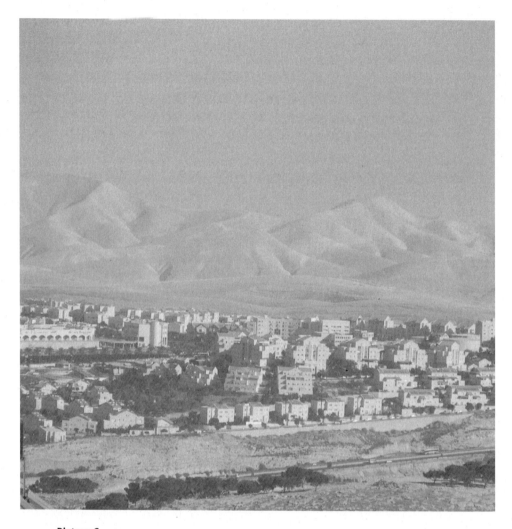

Picture 6
The hills of the Judean desert loom in the background behind the large settlement of Ma'ale Adumim, east of Jerusalem.

Picture 7
One of several community swimming pools in Ma'ale Adumim is framed by large
apartment blocs. Like the trees, flower beds, and other lush vegetation characteristic
of the entire settlement, the pool is a massive user of scarce water resources in a dry
desert area.

Picture 8

The urban settlement of Pisgat Ze'ev is situated inside the municipal limits of East Jerusalem. With a population already standing at more than 40,000 in 2005, Pisgat Ze'ev is the most heavily populated Israeli settlement in East Jerusalem or the West Bank. Settlement population grew by 13 percent between 2000 and 2005. Together with the 20,000 people in the immediately adjacent settlement of Neve Ya'akov, the two settlements form a massive bloc on the northeastern edge of East Jerusalem. Land for the two settlements, built in 1985 and 1970 respectively, has been taken from the Palestinian villages of Anata, Hizma, and Beit Hanina, as well as the refugee camp at Shu'afat. (Population figures are from the Foundation for Middle East Peace, "East Jerusalem Settlements," http://www.fmep.org/settlement_info date last accessed, 28 October 2008.)

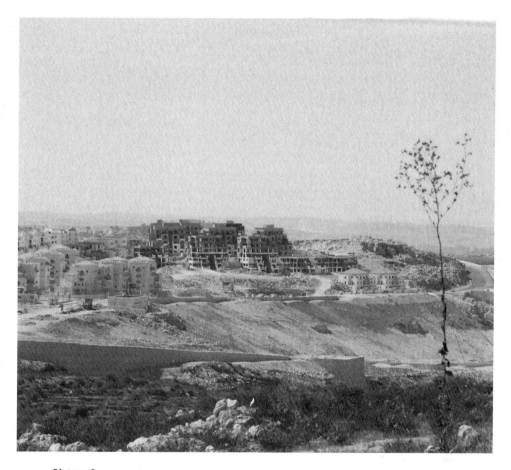

Picture 9
The settlement of Betar Illit hovers over and has taken land from at least three
Palestinian villages surrounding it—Wadi Fukin, Husan, and Nahhalin. Map 2 shows
the location of this large settlement, as well as the Palestinian villages adjacent to
it. Betar Illit, with a population—largely Orthodox Jewish—of over 29,000 in 2006,
is expanding rapidly, as this new construction indicates; population more than
doubled between 1999 and 2006, rising by 129 percent. (Population figures from the
Foundation for Middle East Peace, "West Bank Settlements," http://www.fmep.org/
settlement_info date last accessed, 28 October 2008.)

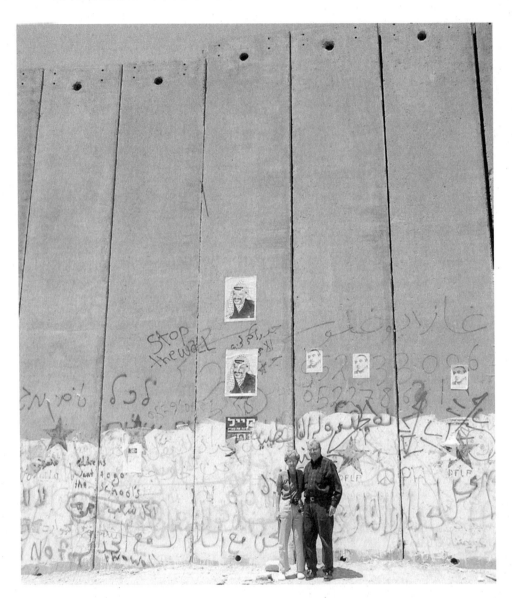

Picture 10
The Wall's enormous 26-foot height dwarfs the authors.

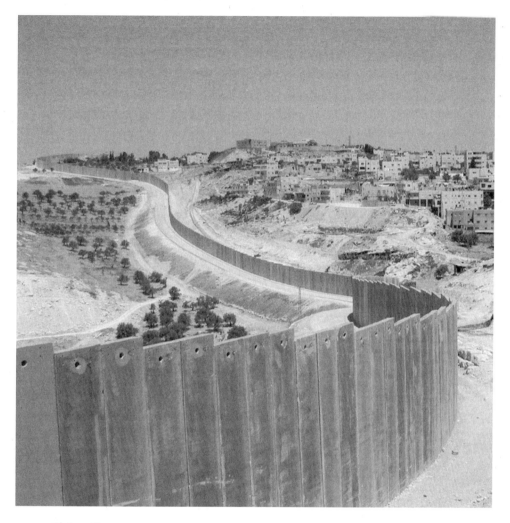

Picture 11
In Abu Dis, a suburb of East Jerusalem, the Wall runs through residential areas, cutting off locations that might be used for residential or commercial expansion. In this area, the Wall cuts through the middle of the campus of al-Quds University.

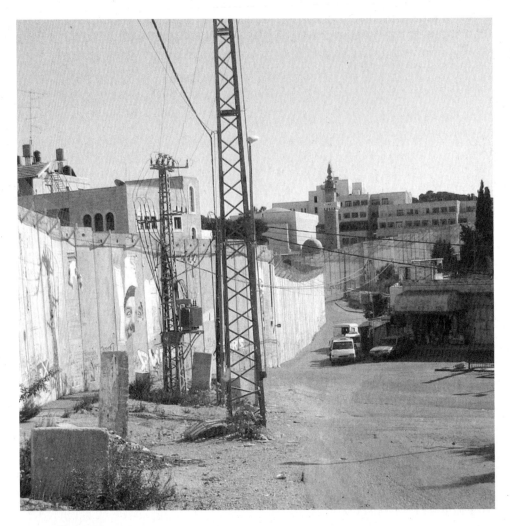

Picture 12
Because Abu Dis is contiguous with East Jerusalem and barely distinguishable from the city, the Wall slices through a busy neighborhood, leaving homes on each side, a market on one side, a mosque on the other.

Picture 13
On the northern outskirts of East Jerusalem, the Wall runs down the middle of a once busy commercial street in the suburb of Ram. In this mixed area of businesses and residential apartments, business owners have in many instances been separated from their homes by the Wall and must now traverse miles and one or more checkpoints to reach a destination that was once merely a walk across the street.

Picture 14
These homes in Bethlehem once stood on a main thoroughfare but now look out their front gates at the 26-foot-high Wall.

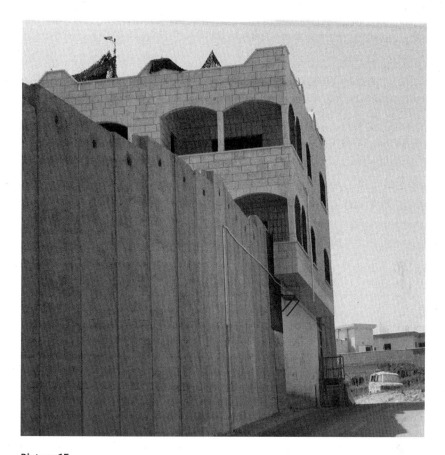

Picture 15
This home in the town of Baqa was taken over by the Israeli military and incorporated into the Wall, which continues around a corner on the other side of the house. Military paraphernalia and camouflage netting sit on the roof. Here too, the Wall runs right outside homes just across the street. Baqa, in the northwestern West Bank, is a town that lies partially inside Israel and partially in the West Bank. The town and many of its families were separated in 1949 when the armistice line was drawn through it; the two parts were named Baqa Gharbiya (West Baqa, in Israel) and Baqa Sharqiya (East Baqa, in the West Bank). (See Map 1.) When Israel captured the West Bank in 1967, the two Baqas more or less resumed their existence as a single town, but the Wall, completed here in 2003, has again split the town. To make way for the Wall, the Israelis demolished a busy market area that had run in an east-west direction, straddling the once invisible border.

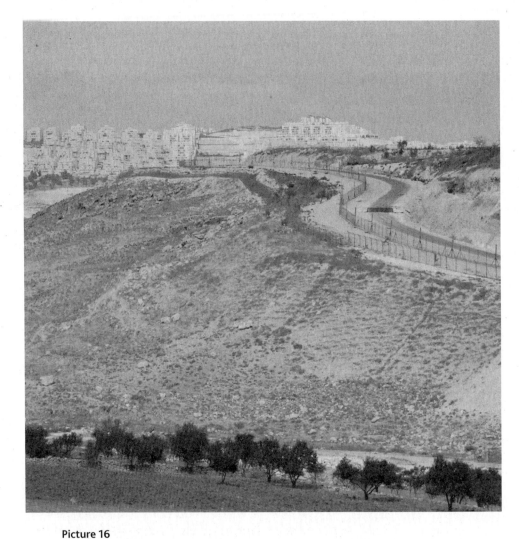

Picture 16
In rural areas, where the Wall is a series of electronic fences, patrol roads, and razor-wire coils, it cuts a wide swath through the land, often involving cutting sections out of hillsides, as here, south of the settlement of Har Homa. Coils of razor wire run along each side of the main fence, on its uphill and its downhill sides.

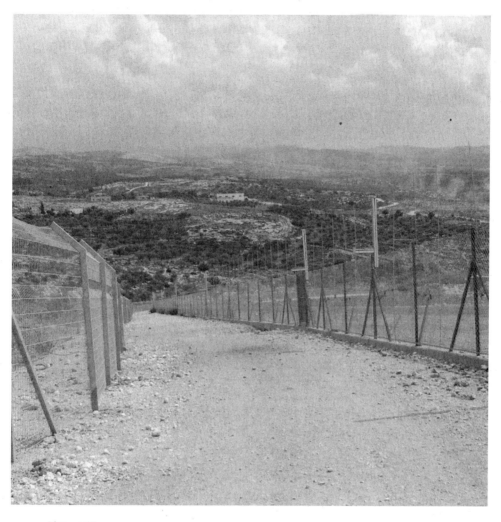

Picture 17
This patrol road is on the West Bank side of the Wall in the small town of Bil'in
northwest of Ramallah. On the other side of the small fence to the left, a large coil of
razor wire runs alongside the road. Paved and unpaved patrol roads on the other side
are evident through the electronic fence on the right. The Wall cuts through Bil'in's
agricultural land and has placed more than two-thirds of the land, primarily planted
with olive trees, on the Israeli side, where the large settlement of Modi'in Illit is
expanding eastward onto village land.

Picture 18
Nationalist graffiti is a ubiquitous feature of the Palestinian side of the Wall's concrete sections. This drawing adds a rare note of bittersweet humor to the Wall. The character is a well known figure in Palestinian lore, a ten-year-old Palestinian refugee child named Handala created by the cartoonist Naji Al-Ali, whose harsh cartoons depicted the Palestinian plight and in the process took on not only Israel and the United States, but the Arab states as well. Al-Ali, who was himself ten years old when his family were made refugees in 1948, was killed in 1987 by an unknown assassin, but his cartoons remain highly popular among Palestinians. The refugee boy Handala, who Al-Ali said was created as a symbol of bitterness, appeared in every cartoon, always scruffy looking, barefoot, wearing dirty, patched clothes, and always standing with his back to the world and hands clasped behind him. This posture, Al-Ali wrote, was "a sign of rejection at a time when solutions are presented to us the American way." In this rendition of Handala on the Wall, which appeared in 2005 but has since been covered with other graffiti, the boy stands with his hands in front of him urinating on the Wall, another act of rejection.

3
CHECKPOINTS, ROADBLOCKS, AND MOVEMENT IMPEDIMENTS

A "critically inferior" network

As we enter the terminal area of the Kalandiya checkpoint separating Jerusalem from Ramallah, a female Israeli soldier is shouting something in Hebrew over a loudspeaker, while about 50 Palestinians wait at three turnstiles. The soldier sits in a glassed-in booth from which she can remotely lock and unlock the turnstiles. She has total control over these Palestinians and anyone else who wishes to pass through to the next step in the security gauntlet, on the way out of Jerusalem. For no apparent reason, she has locked the three turnstiles and is barking orders at the waiting Palestinians. Ahmad, who speaks Hebrew, cannot understand what she is saying because of the loudspeaker's distortion; most of the waiting Palestinians undoubtedly speak no Hebrew at all. When the soldier sees us with a camera, she shakes her finger at us, but we have already taken several pictures and do not put the camera away.

At this point, she unlocks the turnstiles, and the waiting area almost immediately empties out. After passing through the turnstiles, those who have been waiting must still navigate other security checks, including electronic monitors, x-rays and, for

those coming in the other direction toward Jerusalem, permit checks, before emerging on the other side. It is mid-morning, and the terminal is not crowded. At morning and evening rush hours, however, it is packed with thousands of people moving into and out of Jerusalem to and from work. They often wait hours, usually depending on nothing more than the whim of the Israeli soldiers on duty. Because few Palestinians—only those who are Jerusalem residents or Palestinian citizens of Israel and therefore have yellow Israeli license plates—are allowed to drive through this or any of the other terminals surrounding Jerusalem, the only way through is on foot. Taxis wait on each side of the terminal to drive passengers into Jerusalem or to Ramallah. The cities are no more than ten miles apart, but the days of easy travel are long gone.

The terminals around Jerusalem are part of the network of hundreds—the number changes constantly, usually since 2007 reaching over 600—of checkpoints and roadblocks throughout the West Bank.[1] Located at several entry points to Jerusalem and at other key points in the West Bank, the terminals are elaborate security checkpoints, more highly structured and more permanent than the rest of the checkpoint system. They resemble, in fact, international border crossings, except that here the "border guards" are Israeli on both sides. The terminals went into operation in 2005 and 2006, replacing the makeshift checkpoints of concrete blocks and razor wire that had controlled movement at these locations for years previously and still do elsewhere in the West Bank. They are permanent installations, institutionalizing Israel's control over Palestinian movement and Palestinian lives.

The Israelis have made a concerted effort to hide the onerous impingement on freedom that these installations represent by dressing them up; the bars are painted a bright blue, there are

benches in waiting areas, the walls and walkways are often lined with attractive stonework, cheerful signs are often posted. The terminal between Bethlehem and Jerusalem, which is used heavily not only by Palestinians but by religious pilgrims and many other international visitors, was described by the *New York Times* when it opened as "grand, built to be a permanent gateway for Christians visiting Jesus' birthplace as well as a crossing point for Palestinians." The lack of evident irony in this description of the terminal's supposed grandeur, its stonework, and its landscaping, when tens of thousands of Palestinians are cut off from Jerusalem and imprisoned inside the West Bank by this terminal or forced to endure long lines and often humiliation to pass through it, is striking. An Israeli official boasted to the *Times* that the terminal is "our face to the Christian world." The irony here is also striking: the terminal is not in Israel in the first place but well inside the occupied West Bank, and Christians, moreover, have been making pilgrimages to Bethlehem without benefit of a Wall or a terminal or any Israeli assistance for millennia.[2] Israel's "face to the Christian world" is marked by a large sign, covering the full height of the Wall, that greets travelers driving through the terminal toward Bethlehem. Signed by the Israeli Ministry of Tourism, the sign declares "Peace be with you" in English, Hebrew, and Arabic, in that order. Obviously addressed to Christian travelers rather than the Palestinians whom the terminal is intended to control, the sign cannot be seen from the walk-through section of the terminal that Palestinians must use.

A similar attempt has been made to disguise the terminal at Kalandiya behind bright paint and nice signs. When this terminal opened in December 2005, it was graced by a sign—placed here "with great chutzpah," in the words of *Haaretz* correspondent Gideon Levy—proclaiming "the hope of us all" alongside a drawing

of a pink anemone-like flower. "The renovated checkpoint that cuts the occupied West Bank in half," Levy noted wryly, "will be 'the hope of us all.'"[3] Many anti-occupation activists, including Israelis, were disturbed that the words recalled the hypocrisy of the German sign over the entry to the Auschwitz concentration camp—*Arbeit Macht Frei*, work makes you free—and a month later a young Jewish-American activist spray-painted the German phrase on the Kalandiya sign. The sign was removed and replaced with another cheerful one in English reading, "May you go in peace and return in peace!" The flower remains, with another sign in Arabic with a greeting usually used at the end of the Muslim holy month of Ramadan or after the Hajj to Mecca, meaning loosely "May you be well every year," along with additional small signs in Arabic incongruously promoting economic prosperity.

During our stop at the Kalandiya terminal, after passing through the turnstiles and the checks beyond, Ahmad takes us to a room on the Ramallah side where Palestinians are waiting to obtain permits to be able to enter Jerusalem. Several people stand in line; many more wait on benches for what is likely to be a long and possibly unsuccessful process. We are embarrassed at watching other people's discomfiture and misery without being able to do anything about it, and we start to leave.

But a middle-aged man in a business suit approaches us and asks in English if we will take a picture of him and the medical certificate he is carrying. The paper is from Makassad Hospital in Jerusalem certifying that this man has an appointment at the "neurology surgery" clinic at Makassad two days hence. He lives in Ramallah and first applied for a permit to enter Jerusalem six days earlier at this office. He has been waiting for days, through a three-day closure of the entire terminal because of the Jewish high holy days

and through more days of just sitting here waiting for some answer. The certificate notes that he will have to be accompanied by his wife, and he tells us she already has a permit. As he talks, he begins to cry; he is worried about his medical condition, afraid he will not receive the permit in time, and utterly frustrated at his helplessness.

We take his picture and assure him that, as he asks, we will "tell the world" about his case, and we do tell his story in later presentations. But in fact there is little we can do to help him. This is one of those frequent times when being a visitor from outside is heartbreaking. We know, and this man knows, that we can come and go almost at will, that we do not need the permits he must wait for in order to obtain possibly life-saving medical treatment, that when we are frustrated we can return home to comfortable lives in the United States. Depression silences us, and we are unable to talk, even to each other, about the reality that as Americans we bear at least partial responsibility for the situation this man is in. We have his picture in our camera, but we do not know the end of his story.

<p style="text-align:center">ᘓ ᘒ</p>

The system of checkpoints and other impediments to Palestinian movement inside the West Bank predates the September 2000 outbreak of the second Palestinian *intifada*. Although the extent of these impediments has increased markedly since the *intifada* began, the roads throughout the West Bank connecting settlements to each other and to Israel—roads limited to those with Israeli license plates—and the checkpoints and roadblocks set up to prevent Palestinian access to these roads and to the settlements were a growing phenomenon even at the height of the Oslo peace process.

As part of the interim agreements negotiated in the mid 1990s, the West Bank was divided into areas of varying control. In Areas A and B respectively, which included Palestinian urban centers and areas where the Palestinian rural population predominated, Palestinians had full security control or shared control with Israel, while in Area C, the 60 percent of the West Bank where the settlements were located, Israel had full control. Only those Palestinians whose rural villages were located here were allowed in the area. This division of the West Bank, and the road and checkpoint network that defined the division, not only severely restricted Palestinian movement, but effectively broke up the West Bank into multiple disconnected segments. Amnesty International reported in December 1999 that the various obstacles to movement, instituted ironically as part of the peace process, had created over 200 separate, non-contiguous Palestinian areas, most of them smaller than two square miles.[4]

The extensive road network for Israeli settlers throughout the West Bank now covers more than 1,000 miles, linking Israeli settlements at the expense of any Palestinian territorial contiguity. The obstacles to Palestinian movement that "protect" this road network include not only large terminals and smaller manned checkpoints, but also earth mounds, concrete roadblocks, fences, and gates across small Palestinian roads that all slow Palestinian movement or block it completely.[5] The UN's OCHA has been tracking the number of closures throughout the West Bank for several years, reporting regularly on the increase or decrease of these obstacles as Israel occasionally promises to remove several checkpoints or more often increases the numbers out of alleged security concerns. December 2003 marked a high point in the number of obstacles, at almost 750. August 2005, a quiet period when attention was focused on Israel's so-called disengagement from

Gaza, was the low point, when obstacles totaled 376. Numbers have risen steadily since then—despite a near total cessation of Palestinian suicide bombings—reaching 630 in September 2008.[6]

The Israeli-only road network has created a parallel system of Israeli and Palestinian roads—the former comprising a wide, well paved, well lighted, limited-access system, while the latter are most often potholed and rutted, extremely narrow, unlighted roads. Israel has often taken over existing Palestinian roads, improved them, and forbidden Palestinian access. This occurred with Route 60, once the main north-south road running the length of the West Bank and connecting Palestinian urban centers. The road is now limited to cars with yellow Israeli license plates and has been rerouted to bypass Palestinian cities. Other Israeli-only roads cut across and thus close down rural Palestinian roads connecting villages. Palestinians have been forced to use long, circuitous routes that dodge the Israeli-only roads, often traveling miles out of the way, often walking considerable distances, in order to get from one point to another.[7]

Enterprising Palestinians know how to circumvent the closure system, although this is possible only on a limited individual basis and cannot suffice for businesses or for provision of public services. Many Palestinians improvise cross-country routes, bumping over rocks and rough terrain and climbing steep slopes where no road or trail exists. Ahmad calls this "snaking." He talks often about how he "snaked" across country in order to avoid a checkpoint, get from one side of an Israeli-only highway to the other, or reach a destination that is inaccessible by the usual routes.

In 2005, Israeli authorities instituted what they have cynically called "transportation contiguity," intended to link Palestinian communities via tunnels and underpasses running under Israeli

roads. This provides a measure of relief by minimally linking separate Palestinian enclaves, but, as OCHA has noted, it does not give the Palestinians real territorial contiguity; it does not change the reality that the road networks and the checkpoint systems have broken the West Bank into multiple separate enclaves. "Transport contiguity may satisfy short-term humanitarian needs but cannot ultimately lead to a sustainable economy," OCHA concludes.[8] Other analysts point out that because Palestinian contiguity is residual, existing "underneath the contiguity reserved for settlers," it is "critically inferior" and inadequate for businesses and public services.[9] "Transportation contiguity" may serve to restore some services to isolated communities, but it does not ease the discriminatory system created by Israeli roads and Palestinian movement restrictions, and it does not reconnect communities to "the land and water resources on which their long-term survival depends."[10]

The Israeli-only roads, the checkpoints, and the Separation Wall, in the words of one Palestinian observer, mark "the limits of [Palestinian] existence."[11] The impact on all aspects of Palestinian lives cannot be overestimated. Workers are separated from jobs; a May 2007 survey indicated that 40 percent of West Bank Palestinians, not even including those living in East Jerusalem, had experienced difficulties getting to work during the previous six months. The most commonly cited impediment to easy commuting was physical obstacles such as checkpoints and roadblocks.[12] Workers are not alone in being dramatically affected by the obstacles. Students are separated from schools, families from each other, patients from medical care, businesses from customers. Villages that were once near neighbors are now separated by high-speed Israeli highways that cannot be crossed.

Total closure is often imposed throughout the West Bank, meaning that all movement anywhere is blocked, and no one can travel at all. At some periods in 2005 and 2006, particularly in the northern West Bank, Palestinians endured one day of total closure for every two or three days of "normal" movement.[13] Shipments of cargo, including produce, must cross one of several designated "back-to-back" checkpoints, where the merchandise is unloaded on one side, inspected by the Israelis, and reloaded on another truck on the other side, altogether resulting in long shipment delays, increased prices and, with produce, increased risk of spoilage.[14]

The economic impact of movement restrictions in the West Bank has been devastating. The World Bank concluded in a report issued in May 2007 that in economic terms, movement restrictions "have created a level of uncertainty and inefficiency which has made the normal conduct of business extremely difficult and therefore has stymied the growth and investment which is necessary to fuel economic revival."[15] The human impact has been devastating as well. Many people with medical emergencies or in need of essential medical treatment have died while waiting to pass through checkpoints.[16] Women have been forced to give birth at checkpoints; the World Health Organization reports that during the first four years of the *intifada*, between September 2000 and December 2004, 61 women delivered at checkpoints, on the ground or in cars, and 36 of their infants died at or shortly after birth because of complications that could not be attended to at the checkpoints.[17]

Haaretz correspondent Gideon Levy told the tragic story in September 2008 of a young woman in labor in the middle of the night, heading for a hospital in Nablus, accompanied by her husband and her mother, who was not allowed through the notorious Huwara checkpoint because the car, driven by her brother-in-law, did not

have a permit to cross. While she lay screaming in pain and bleeding in the back seat of the car, her husband pleaded for more than an hour with the impassive Israeli soldier on duty and his commanding officer to be allowed to pass—even, when the birth began, showing his wife to the soldiers. He told Levy he was ashamed to do this but "out of fear for my wife and child, I showed her to them." By the time a Palestinian ambulance had been called, the baby, partially delivered, was dead. The father insists that when the birth began, the baby was alive, but only he was there to hold its head. The IDF expressed regret and sentenced one of the soldiers to two weeks' imprisonment.[18] Thus does Israel wash its hands of its atrocities.

At the root of the vast matrix of roads and checkpoints that cripple the Palestinian economy and Palestinian lives is the network of Israeli settlements throughout the West Bank. Without the settlements, there would be no segregated roads, no checkpoints and, most likely, no Separation Wall. The checkpoints protect the roads; the roads protect the settlements; the settlements are a colonial implantation, relentlessly expanding, intended to grab land and keep it for Israel. Like the "critically inferior" Palestinian road system that must pass underneath Israeli roads, all Palestinian interests, all Palestinian security and viability are subordinate to this essential Israeli objective of Jewish expansion across all of Palestine.

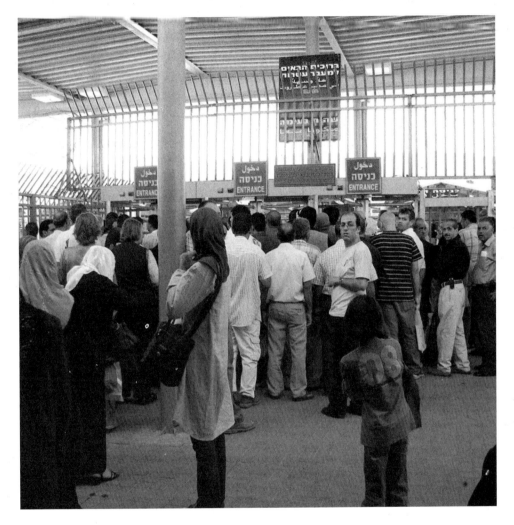

Picture 19
Palestinians attempting to leave Jerusalem through the Kalandiya terminal wait at three turnstiles, all locked by an Israeli soldier monitoring the checkpoint from a glassed-in booth.

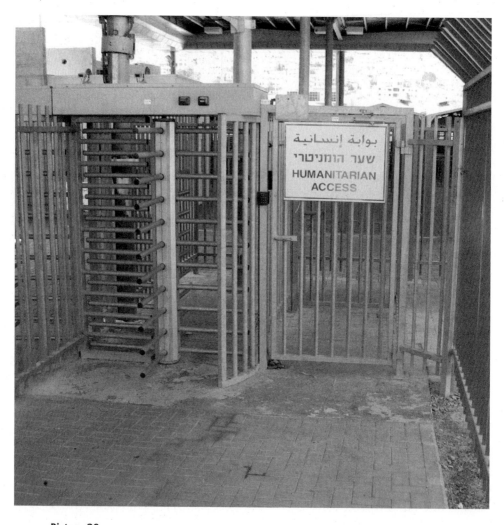

Picture 20
Bars and gates and razor wire are a principal feature of all terminals at entry points to Jerusalem. An ironically named "Humanitarian Access" gate marks this terminal at Azarya.

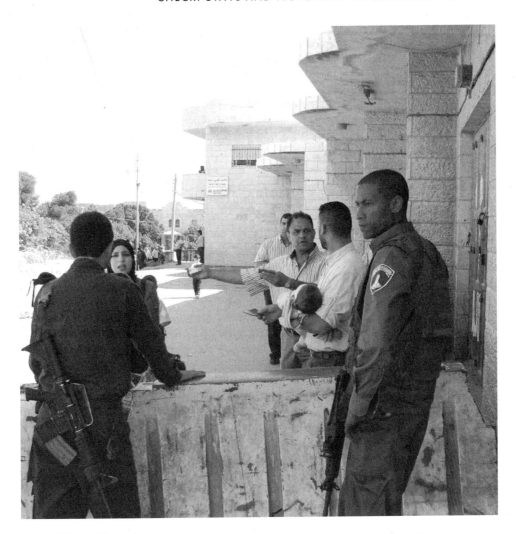

Picture 21

At a smaller makeshift checkpoint elsewhere in Azarya, Palestinians argue with Israeli Border Police manning the checkpoint, trying to persuade them to permit entry to Jerusalem at this more convenient access point. But only those Palestinians whose names are on an Israeli-maintained list may pass through this checkpoint. The small boy in the background, dressed in a tie ready to go with his father to al-Aqsa Mosque for Friday prayers during Ramadan, watches as more Palestinians begin to gather and arguments with Israeli police begin to escalate, and a few moments later he bursts into tears.

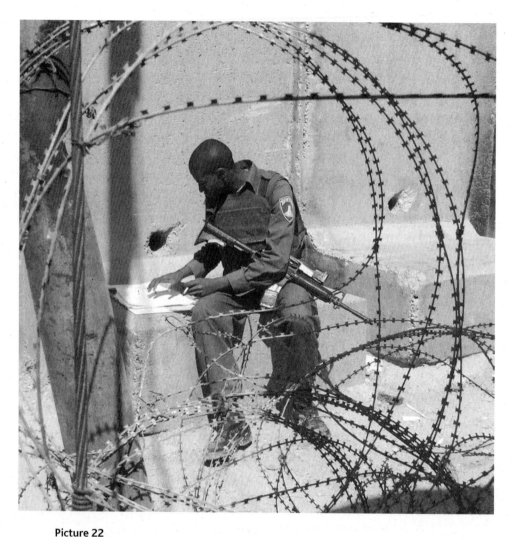

Picture 22
An Israeli Border Policeman checks a Palestinian's name on a list of the few Palestinians permitted to pass through this checkpoint. Although the checkpoints are justified by Israel as essential security measures against Palestinian terrorism, this policeman is sitting with his back to the crowd of Palestinians, unhelmeted, smoking a cigarette, his weapon unready.

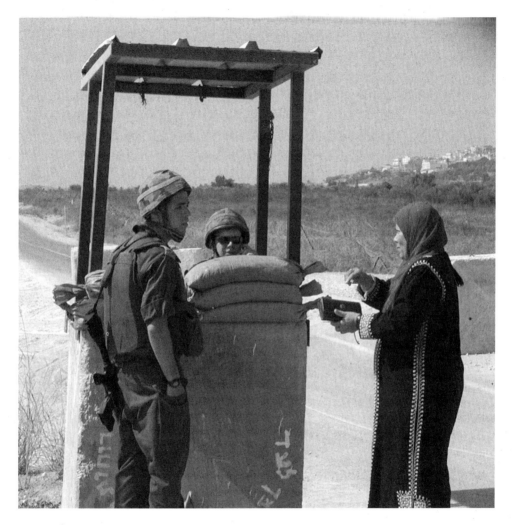

Picture 23

This Palestinian woman talks to two Israeli soldiers at a checkpoint between the Israeli town of Baqa Gharbiya and the West Bank town of Baqa Sharqiya. Baqa straddles the Green Line between Israel and the West Bank. Split by the 1949 armistice that established the Green Line, then reunited after Israel's capture of the West Bank, the town has again been split by the Separation Wall. This woman, who adopted an obviously deferential attitude with these young Israeli soldiers, was attempting to pass from the Israeli side into the West Bank. As at many other checkpoints, only those Palestinians whose names are on a list of permit holders may pass through.

Picture 24
A village leader of the small town of Bil'in, northwest of Ramallah, calls to Israeli soldiers manning a gate in the Wall to come and open the gate for himself and the authors. In rural areas like this, Palestinians whose lands are on the other side of the Wall depend on Israeli soldiers to let them through in order to tend their land. The route of the Wall in this area places more than two-thirds of Bil'in's land on the Israeli side. Although this land, planted primarily in olive trees, provides most of Bil'in's livelihood, much of it has already been confiscated for the expansion of the Israeli settlement of Modi'in Illit, which is slated to be the largest settlement in the West Bank.

Picture 25
This narrow, poorly paved road, running between the villages of Biddu and Qatanna northwest of Jerusalem, is typical of the type of rural road that Palestinians must travel, while Israelis traveling between settlements are able to use wide, well paved roads. Typically, this road is so narrow that when two cars traveling in opposite directions meet, one must leave the road for the other to pass.

4

HOUSE DEMOLITIONS AS SLOW ETHNIC CLEANSING

"Cruelty beyond words"

Ahmad gets lost in Anata, a small town of narrow, torn-up streets where everyone knows the name of Salim Shawamreh, whose house it is we are to rebuild, but not everyone quite knows where his property is. Finally, Ahmad asks two boys where the place is where the houses have been destroyed. They immediately point in the right direction. "You need to know how to ask the right question," Ahmad comments. It turns out the house is down this narrow alley, through this open field in which stand the remains of a demolished house, and down a badly rutted and extremely steep road. Reluctant to drive down the last steep section, Ahmad leads us on a walk down, a bit tentatively, until we find a house under construction and a small clutch of people—Palestinians, Israelis, and a few Westerners—sitting around on carpets placed on the ground under a canopy, having a Palestinian breakfast of humus, falafel, yogurt, hard-boiled eggs, pita, and a variety of other dishes, all laid out on a carpet in the middle. Having seen us there safely, Ahmad leaves, promising to return whenever we call him on the cell phone he has lent us.

It is August 2003, the height of the Jerusalem summer, and we are about to join a two-week work camp for volunteers, sponsored by the Israeli Committee Against House Demolitions (ICAHD), to rebuild a Palestinian home demolished a few months earlier by Israeli authorities. This is the first of what will become an annual series of rebuilding work camps sponsored by ICAHD. This rebuilt house and the land on which it will stand belong to Salim Shawamreh, a Palestinian refugee educated as an engineer who after working for several years in Saudi Arabia returned to Palestine in 1990, bought a small plot of land in Anata, on the outskirts of Jerusalem, and applied to Israeli authorities for a building permit. Refused three times, each time for a different, obviously specious reason (the area was zoned for agriculture, the slope of the land was too steep, Shawamreh could not prove ownership of the land—none true), Shawamreh went ahead after waiting for three years and built a small home anyway for his wife and then six, now seven, children. This is a common phenomenon. More than 94 percent of Palestinian applications made between January 2000 and September 2007 for building permits in Area C—which encompasses the approximately 60 percent of the West Bank that is under total Israeli security and administrative control according to the Oslo agreements—were denied. During that same period, approximately 5,000 demolition orders were issued against structures, primarily residences, with no permits.[1] Demolitions were actually carried out against almost 1,700 homes in the West Bank during this period; slightly over 600 were demolished in East Jerusalem.[2]

After Shawamreh completed his house in 1993, the Israeli Civil Administration, an ironically misnamed branch of the IDF that administers Palestinian affairs in the West Bank, immediately issued a demolition order, but the family was able to remain in the home

unmolested for five years before a bulldozer appeared with no notice one day in 1998 while the family was eating lunch and brought the house down.

With the help of ICAHD and its coordinator, Israeli anthropologist and activist Jeff Halper, Shawamreh rebuilt his home three times over the next five years and saw it demolished three more times, most recently in April 2003, just four months before the first ICAHD work camp. By this time, Shawamreh's wife Arabiyah has been so traumatized that she cannot live in any house at that location, and so the small one-room house to be built by the work camp volunteers, dubbed Beit Arabiyah—the House of Arabiyah—will function as a meeting house for peace activists and, in later years, as a headquarters for the annual work camps. In addition to honoring Arabiyah, the house is dedicated to the memories of Rachel Corrie, a young American run over and killed by an Israeli bulldozer in March 2003 while trying to prevent the demolition of a home in Gaza, and of Nuha Sweidan, a Palestinian woman, nine months pregnant and the mother of ten children, who was killed in the same month in Gaza when her house collapsed as Israeli bulldozers demolished the home next door.[3]

After we arrive at the building site, we do introductions all around. Not all the volunteers have arrived yet, but there are about six here now, who have already spent the first night at the camp. The Palestinian workers are also here, essential laborers who do the skilled work and who guide us volunteers in the unskilled work we do—passing cement blocks and stacks of tiles, clearing endless rocks from the site, passing buckets of sand for mixing cement, cleaning latrines. The Palestinian laborers have already laid the foundation of the house and are ready to start erecting the walls. We are greeted and immediately made to feel at home. Salim Shawamreh himself

offers cups of tea. Within half an hour, Jeff Halper arrives with a few more volunteers in tow, and we begin to get down to business. After a brief discussion of what to do if Israeli authorities arrive at the camp—a word on how to behave if arrested, guidance on where to hide for those who choose not to be arrested—we begin to work. It is already hot, but the camaraderie keeps all of us going, and we know there will be a substantial meal, cooked by Arabiyah with some help from one or two volunteers, in the early afternoon.

Over the two weeks of the work camp, nearly 100 volunteers will help to build this house. Those staying the full two weeks include a young Pakistani-British woman (whose sister is simultaneously working with the International Solidarity Movement in a Palestinian village), an Anglican priest from a small English town who has visited Palestine often and walked its biblical pathways, an Israeli *refusenik* who has just refused to do his military service out of opposition to the occupation, a German woman, a young Frenchman, a British teenager whose father is a Palestinian citizen of Israel, and quite a few Americans, including Jewish Americans who oppose Israel's policies and including a woman whose husband is in Palestine working on a construction contract and whose seven-year-old daughter plays with the several Palestinian children from the neighborhood who always cluster around the camp.

On several days, other activists—from Japan, Canada, Belgium, the United States—working elsewhere in Palestine join the camp for a day of hard work. On other days, local Israeli and Palestinian organizations—including Peace Now, a woman's organization called Bat Shalom, and Tayyush, an Israeli organization with both Jewish and Palestinian-Israeli members—send groups to help. During tea breaks and lunch breaks, the organizations describe their activities, and Halper frequently gives briefings on aspects of the occupation.

Palestinians from the neighborhood, including the *mukhtar* of the nearby Jahalin Bedouin encampment, visit frequently, joining in the work, and there are always children around. The public relations ripple effect among Palestinians of seeing so many Israelis, other Palestinians, and people from around the world working together to rebuild a Palestinian home is immeasurable.

House demolition has been a weapon in Israel's arsenal since the state was established in 1948. Halper has observed that the advance of Zionism from the beginning has been a process of displacement of the Palestinian population, and house demolitions have been a central aspect of this process. In the first decade and more of its existence, Israel systematically razed an estimated 400 to 500 Palestinian villages inside the Israeli state "in an attempt to 'cleanse' the country of the Arabs and their presence," according to Halper. The campaign extended well after the residents of these villages had fled or been driven out. "[T]his massive campaign to de-Arabize Palestine was initiated not in the heat of battle, not for security reasons, but as a proactive policy to create 'facts on the ground.'" Both Israeli and Palestinian historians have documented this campaign of ethnic cleansing. The assault on homes, on the very center of Palestinians' existence, has continued in the wake of the 1967 war. Since the occupation began, Israel has demolished more than 18,000 homes, according to statistics gathered by ICAHD. Only an estimated 5 percent of the demolitions have had anything to do with security or terrorism; as with the Shawamreh family, the vast majority of the demolitions were not of homes owned by terrorists or their families. The demolition policy is clearly, Halper asserts, "part and parcel of *nishul*, dispossession; turning the Land of Israel into an exclusively Jewish space."[4]

In Jerusalem, from the beginning of the occupation of the eastern sector of the city in 1967, Israeli authorities have designed zoning plans specifically to prevent the growth of the Palestinian population. In an attempt to maintain the "Jewish character" of the city at the level existing in 1967 (72 percent Jewish, 28 percent Palestinian), Israel has drawn zoning boundaries to prevent Palestinian expansion beyond existing neighborhoods, expropriated Palestinian-owned lands (one-third confiscated for Israeli settlements and other Israeli facilities), confiscated the Jerusalem residency permits of any Palestinian who cannot prove that Jerusalem is his "center of life," limited city services in Palestinian areas, limited development in Palestinian neighborhoods, refused to issue residential building permits to Palestinians, and demolished Palestinian homes that are built without permits. None of these strictures is imposed on Jews. Only 11 percent of the land in East Jerusalem is now available for Palestinian housing, even though all of this land was Palestinian before 1967 and although the Palestinian population has grown dramatically since that year, despite Israeli efforts to rein it in. As a result, the housing shortage in Palestinian neighborhoods of the city is approximately 25,000 units. Thousands of demolition orders are pending.[5]

You can drive through Palestinian towns and particularly through Palestinian neighborhoods in and near Jerusalem and see evidence everywhere of this cruel policy. Virtually every street has a house or houses reduced to rubble, one floor pancaked onto another or simply a pile of broken concrete bulldozed into an incoherent heap. We witnessed a demolition during the first work camp. Halper, having been informed that Israeli authorities were conducting several house demolitions in the Beit Hanina section of East Jerusalem (see Map 2), collected several volunteers to go to the area to give support

to the Palestinian families. Israeli and international activists had been staying overnight at several houses where it was expected that the Israelis would soon carry out demolition orders, and we joined some activists in one small house still under construction. The activists' hope, usually forlorn, is that their presence will deter or at least delay demolitions. Our presence on this day was of little help. Within minutes of our arrival, a convoy of Israeli military and police vehicles drove up, followed closely behind by two pieces of heavy equipment. These were not bulldozers but large pneumatic drills, large enough to destroy a small home and, as Halper explained, useful not only for demolishing the house but for digging up the foundation as well.

As the Israelis approached, the young owner of the house asked all activists to leave, in an apparent effort to avoid a confrontation. Halper nonetheless remained inside, hoping somehow to impede the demolition. We activists initially stood in front of the house and watched as a demolition crew, incongruously, carefully removed what little furniture was inside, but when the demolition was about to begin, Israeli soldiers moved us away, across an open expanse where we could watch but not interfere. Halper was dragged out of the house and arrested, to be released several hours later.

Because the house was small, the entire demolition took no more than about 20 minutes—20 minutes to watch two large dinosaur-like machines poke holes in the front of the house and collapse its walls, to watch as the home's water tanks on the roof were burst, sending out a spray of water, to watch as the house came down and the pneumatic drills battered at the pile of rubble and the foundation underneath. The machinery and the soldiers left as quickly as they had arrived, and we all returned to the site, to see the center of a young family's life destroyed.

The personal stories of those whose homes have been demolished are heartbreaking. Salim Shawamreh's story, and his resilience, are remarkable. Although he had invested much of his savings in his land purchase, he paid another US$5,000 for each of the permit applications that were denied before he decided in 1993 that, with a growing family and rents in Jerusalem rapidly increasing, he had to proceed with building a home. Seeing that investment and that shelter destroyed five years later was devastating to the family, and each subsequent demolition added to the devastation.

People react differently to demolition—men often feeling humiliation, women frequently experiencing depression as the center of their lives is removed, children often losing faith in their parents' ability to protect them.[6] The Shawamreh family experienced all of these traumas. It was clear at the first work camp that Arabiyah was severely depressed. Although she cooked meals for the volunteers every day, she was quiet, almost sullen, and withdrawn. When on one of the first evenings Shawamreh showed some slides of the earlier demolitions of their home and described their situation, Arabiyah sat crying with her head on her arms. As Shawamreh told the volunteers, "This is not only a home demolition, but a family demolition also." Years later, he told a British journalist that demolishing someone's house is "cruelty beyond words."[7]

This family has been able for the most part to recover by working closely with ICAHD and coming to know that they have not been abandoned. By the end of the first work camp, Arabiyah had brightened and, after several Israeli Civil Administration authorities visited the camp one day, threatening to demolish the house, she came out to confront them, later telling Halper that this was the first time in years she had not been afraid.

But the thousands of other Palestinian families with similar experiences of demolition have not been so lucky. Halper has written that the human suffering involved in the destruction of a family home is incalculable. A home "is the center of your life, the site of your most intimate personal relations.... It is a refuge ... your sacred space." For Palestinians, a home also maintains continuity with ancestral land, something of particular importance after decades of displacement and dispossession. Because the home is the physical representation of the family and land is so very important in Palestinian society, the home demolitions and land expropriation that are such a regular feature of Israeli expansion become "an attack on one's very being and identity."[8]

This assault on Palestinian identity has always been part of the animating force behind Zionism. After the blatant ethnic cleansing conducted in the wake of Israel's establishment in 1948, the attack on Palestinian identity has taken more subtle but no less cruel forms, involving not only house demolitions but varying bureaucratic schemes that result in revocation of Palestinians' right to continue living in Palestine. For instance, to remain in Jerusalem, Palestinians must prove that it is their "center of life"—meaning that going abroad temporarily to study or work, or even moving to a suburb to locate more affordable housing can result in revocation of a Jerusalem identity card. Estimates of the number of Palestinians displaced in this way since 1967 reach 25,000.[9]

In 2006, the Israelis also began a campaign to deny even temporary visas to Palestinians who live in the West Bank but hold foreign passports. Large numbers of Palestinians who were born abroad or lost residency permits while overseas returned to the West Bank in the 1990s in the belief that peace was impending, and then settled down to permanent residence, usually marrying

local Palestinians and often starting businesses. Denied permanent residence by Israel, these foreign passport holders, usually from the United States or Europe, have lived as "tourists," existing from tourist visa to tourist visa and traveling regularly to Jordan or Egypt in order to re-enter the West Bank and obtain a new three-month visa. Many did this for years until Israeli authorities began in early 2006 refusing even tourist visas. The Israeli plan is obviously to force these Palestinians into permanent exile, moving their families out and abandoning their businesses and, with them, most prospects for Palestinian economic recovery. Many affected Palestinians have successfully fought what British journalist Jonathan Cook has called this "bureaucratic obscenity," but thousands have been separated from families or have succumbed to Israel's designs and taken their families into exile.[10]

Picture 26
A very international group of volunteers work to rebuild a house in Anata, on the outskirts of East Jerusalem, at a two-week work camp sponsored by the Israeli Committee Against House Demolitions. This house, owned by Salim Shawamreh and named Beit Arabiyah after his wife, replaces a home demolished four times by Israeli authorities as part of an effort to minimize the Palestinian population of Jerusalem. The volunteers seen here include people from France, the United States, and Israel, including a Palestinian citizen of Israel.

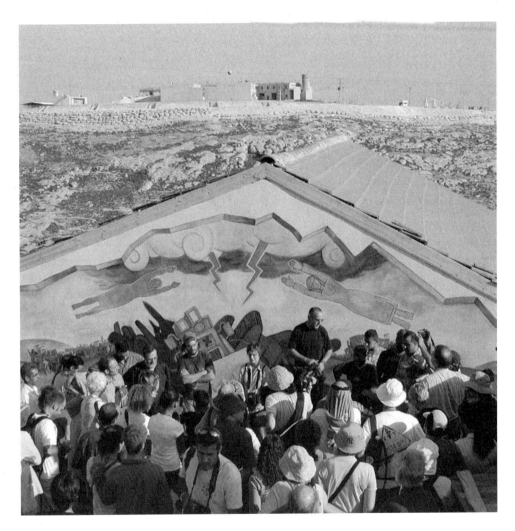

Picture 27
Beit Arabiyah sits on the rocky eastern hills of Jerusalem, in the shadow of a newly
built headquarters of the Israeli internal security service, the Shin Bet, across the *wadi*
on the next hilltop. At the dedication of the just-completed Beit Arabiyah in August
2003, Mike Alewitz, a muralist and US labor activist, speaks in front of the mural he
drew on the house, depicting the spirits of Rachel Corrie and Nuha Sweidan, two
young women killed in house demolition operations, hovering over a bulldozer
disabled by crowds of peace activists. Beit Arabiyah serves as a peace center and
meeting place for activists.

Picture 28
A Palestinian girl, a *khaffiyah* around her head and a red, black, white, and green
Palestinian flag pinned to the front of her dress, recites a nationalistic poem at the
closing celebration marking the completion in 2004 of the second annual ICAHD
work camp to rebuild a demolished Palestinian home. The girl lives in Shu'afat refugee
camp in Jerusalem, which is adjacent to the town of Anata, where this house, home to
an extended family of 23 people from the Jahalin Bedouin tribe, is located.

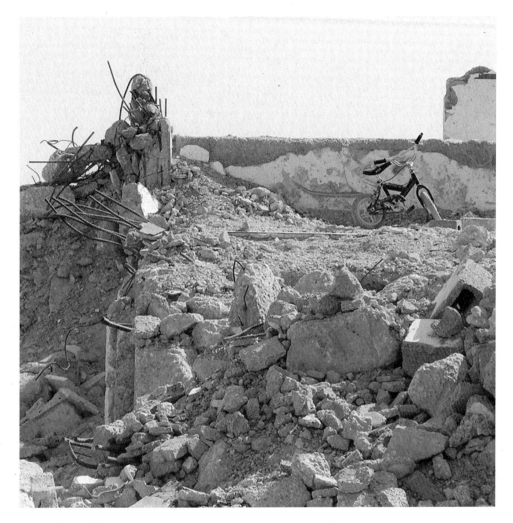

Picture 29
A small child's bicycle sits in the ruins of a demolished Palestinian home. The home, immediately adjacent to the home rebuilt by ICAHD in the summer of 2004, housed a large extended family of Jahalin Bedouin. It was demolished in November 2004.

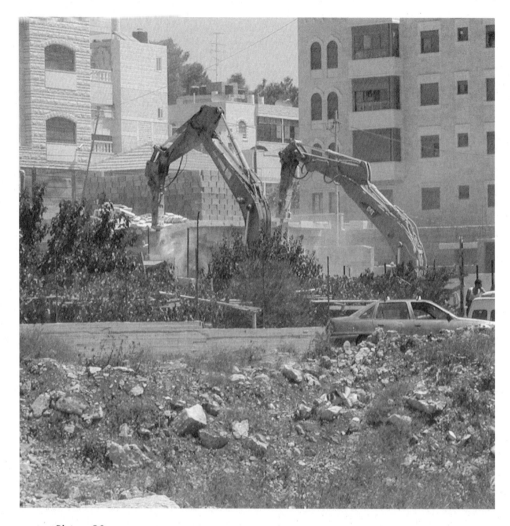

Picture 30
Two pneumatic drills break through the roof of a small house in the Beit Hanina section of Jerusalem. The house, a one-story structure surrounded by large apartment buildings, was still under construction when Israeli authorities ordered it demolished.

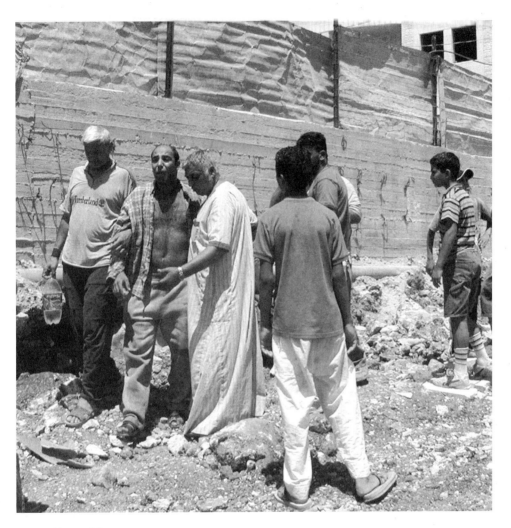

Picture 31
The owner of the house, sobbing loudly after seeing the destruction of his home, is comforted by neighbors, who immediately begin to help him erect a canopy over his belongings and build a temporary shelter for his family.

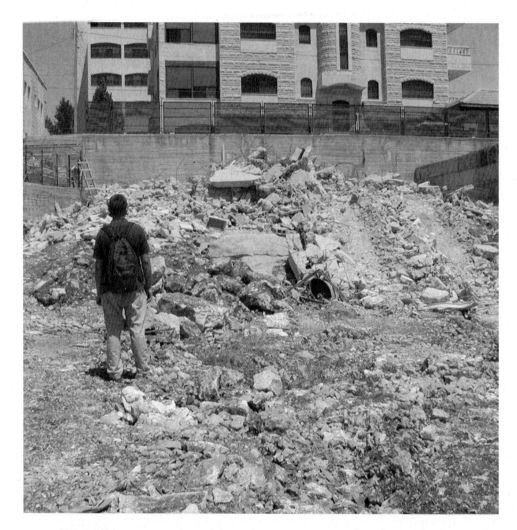

Picture 32
A pile of rubble, unrecognizable as a house, is all that remains of the home after the Israelis and their bulldozers leave.

5
TOWNS AND VILLAGES UNDER SIEGE

"Your shit in my salon"

Approaching the little village of Wadi Fukin (Map 2) west of Bethlehem, driving from the north along the ridge above the village, the scene is breathtaking. At first glance, the small village of only 1,200 people, along with its agricultural lands lying stretched out over two miles in a narrow fertile valley between ridge lines, present an idyllic pastoral scene. In summer, bougainvillea bloom everywhere, draped over fences in profuse clusters. Olive groves cover much of the hill up to the ridge line in the west; small orchards dot the valley, ripe with a late summer produce of pomegranates and figs; patches of eggplant, cucumber, cabbages, and cauliflower cover the valley floor. At intervals along the center of the village, irrigation pools filled from five natural springs dating back to Roman times provide water for the village's essential agriculture.

But on closer inspection and after talking to Wadi Fukin's villagers, it comes clear that there is trouble in this paradise. The Green Line marking the border with Israel runs along the ridge top on the western side—Wadi Fukin, in fact, is so close to the border that much of its land was lost to Israel in 1948—and Israeli plans call for building a section of the Separation Wall on this ridge. Not

only would this construction, if it is carried out, destroy more of the village's land, including many of its olive groves, but it would place Wadi Fukin and some neighboring villages in an enclave almost totally surrounded by the Wall, separated from the rest of the West Bank and with few ways out.

In addition to looking forward to a future squeezed on the west, the village is now being squeezed on the east as well by one of the largest Israeli settlements in the West Bank. The rapidly growing settlement of Betar Illit (Picture 9) perches on the ridge line to the east and has poured tons of construction dirt and rocks, shaved from the hilltop to make room for the settlement's large apartment blocs, down onto Wadi Fukin's agricultural fields. The contours of the ridge line have changed dramatically over the years, encroaching substantially on the village and its fields, as the settlement has expanded. Begun in 1985, the largely Orthodox Jewish settlement had a population of over 29,000 in 2006 and has grown exponentially in the last decade, more than doubling between 1999 and 2006 and growing by 10 percent or more in many years.

Not only is the settlement encroaching on Wadi Fukin's land, but almost unbelievably, it occasionally—some sources say regularly, as often as twice a week—dumps sewage onto the village lands. This is sewage from a settlement of more than 29,000 people, dumped on a village of 1,200. Although it is not immediately evident, if you know where to look, it is possible to see the large-diameter opening of a pipe near the top of the ridge line, from which the sewage pours. Activists have posted a seven-minute video of one spillage on YouTube, showing a torrent of sewage and a gradually increasing pool on Wadi Fukin's land as the sewage spreads out.[1]

After we first visited Wadi Fukin, Ahmad, who is usually even-tempered, erupted in an angry tirade about the Israeli settlements

and what they have done to the Palestinian landscape. "Why you want to put your shit in my salon?" he wondered pointedly. And in fact sewage dumping from Israeli settlements is not unique to Betar Illit. Palestinian author Raja Shehadeh writes of hiking with a friend in the hills northwest of Ramallah and stepping right into a field of sewage from the Israeli settlement of Talmon (Map 2). The settlement had no system for treating sewage, "which was just disposed of down the valley into land owned by Palestinian farmers."[2] Some sources indicate that only 6 percent of Israeli settlements adequately treat their sewage,[3] others that West Bank settlers, although constituting only 10 percent of the territory's population, generate one-quarter of its untreated sewage.[4]

British journalist Johann Hari, a columnist for the London *Independent*, wrote a dramatic description of the sewage problem as a counterpoint to the acclaim Israel was winning internationally on the occasion of its sixtieth anniversary in April and May 2008. He wrote that he could not participate in the praise.

Whenever I try to mouth these words, a remembered smell fills my nostrils. It is the smell of shit. Across the occupied West Bank, raw untreated sewage is pumped every day out of the Jewish settlements, along large metal pipes, straight onto Palestinian land. From there, it can enter the groundwater and the reservoirs, and become a poison.[5]

The ecological damage from Israel's sewage dumping, trash dumping, and industrial pollution is grave and growing. Dissident Israeli environmentalist Ethan Ganor wrote in 2005 of a worsening crisis. "Destructive actions by settlers and soldiers, waste from factories and settlements, land confiscations to expand settlements and roads, the plunder of water, the mass uprooting or burning of trees, and the snaking, sunset-eclipsing structure known to

Palestinians as the 'Apartheid Wall,'" he concluded, "are causing the West Bank's once-lush ecology to deteriorate. The cumulative impact on the land's hydrology, topsoil, biodiversity, food security and natural beauty is severe."[6]

The besieged villagers of Wadi Fukin would be the first to agree.

<p style="text-align:center">CB BO</p>

The small town of Bil'in—1,800 strong, its population swelled weekly by scores and sometimes hundreds of Palestinian, Israeli, and international activists protesting the construction of the Separation Wall on village land—has become a symbol of non-violent resistance to the occupation and to Israel's absorption of Palestinian land. The village, nestled in the steep hills of central Palestine northwest of Ramallah (see Map 1), lies in the path of the huge Israeli settlement of Modi'in Illit, which straddles the Green Line, now houses 35,000 settlers, and is slated to grow fourfold by 2020. (See Map 4.) When construction on the Wall began in this area in early 2005, Bil'in's farmers found that more than two-thirds of their land, planted primarily in olive trees, was to lie on the other side, ready for Modi'in Illit's picking. Hundreds of olive trees were bulldozed. Many others were cut down and taken to Israel to be sold; olive trees can be transplanted easily, and trees removed from the West Bank are often taken to Israel to be sold to landscapers. Another uncompensated loss to Palestinians. Bil'in's residents can harvest the remaining trees, but only by negotiating their way through the Israeli-manned gate in the Wall (see Picture 24) and only by transporting the harvest on foot or by donkey cart. No cars are allowed through.

Since February 2005, Bil'in has been the scene of weekly anti-Wall protests—always non-violent except for occasional stone-throwing by teenagers—led by village residents and Israeli and international activists. Every Friday, after noon prayers at the village mosque, protesters head for the Wall. Occasionally someone will attempt to scale the electronic fence; often the protesters try some imaginative twist, as when a piano was brought to the construction site and a Dutch pianist, a Holocaust survivor who opposed Israel's nationalism, played for the assembled. When on occasion, particularly in the early months of the protests, Israeli soldiers blocked all access by road to Bil'in, activists—sometimes hundreds strong—walked miles across country, up and down steep hills and over rocky terrain, to reach the village.

The response from Israeli soldiers and police is always harsh. Despite the non-violence of the protests, Israeli soldiers use violence almost every week, firing rubber bullets (which have a rubber coating over a metal core) and occasionally live ammunition, sometimes using bullets made of a compacted substance like salt or sand that adheres to the skin, firing teargas and percussion grenades, and beating protesters. Although no protesters have been killed, several have been seriously injured by rubber bullets over the years, and large numbers have been hospitalized for minor injuries and teargas inhalation. Many villagers, including young teenage boys, have been arrested in middle-of-the-night raids and held in detention for months at a time.

The Bil'in organizers have held an annual conference since 2006 to discuss the occupation and non-violent resistance to it, with speakers including Nobel Peace Prize laureates, Israeli peace activists and scholars, and other prominent anti-occupation activists and writers. Irish Nobel Peace Prize laureate Mairead Corrigan Maguire

has spoken at the conference twice and has twice been injured in accompanying peaceful protest marches.

In early 2006, protesters established an outpost or, as they call it, a "settlement" of their own on Bil'in land lying on Israel's side of the Wall, in order to stake a claim for the village. Israeli soldiers initially dismantled the outpost, which consists of a tiny building and a tent, but activists rebuilt it, and it remains. During our visit to the site with the head of Bil'in's village council, late one weekday morning when no protests are planned, we find the outpost manned by a Palestinian resident of Bil'in and a young British man, both sleeping soundly. It is Ramadan, a month in which Muslims fast from sunrise to sunset, and these two young people feasted until late the night before, in an extended *iftar*, the evening meal that breaks the fast. Ashraf and Sam, two of the many activists who man this outpost around the clock, greet us sleepily and talk for a while about their "settlement." Throughout our walk to the "settlement" and our talk with Ashraf and Sam, we can hear heavy construction equipment working in Modi'in Illit, only a short distance away. At the outpost, a small open area around the building and the tent, much of it cleared of its olive trees by the Israelis, is used as a soccer field. In one spot near the edge, the village leader points with considerable pleasure to a young olive shoot growing from the stump of a destroyed tree. It is a sign of renewal and resistance, he thinks.[7]

Bil'in felt a moment of triumph in September 2007, when the Israeli High Court of Justice ruled that one section of the Wall would have to be rerouted to give back a portion of the village land that ended up on Israel's side of the barrier. Ruling on a suit brought by an Israeli human rights lawyer on behalf of Bil'in, the court judged that one portion of the Wall was not necessary for "security-military

reasons." Israel's Defense Ministry was ordered to alter the route, bringing the Wall closer to the Green Line, within a "reasonable period of time." The rerouting would return approximately 250 acres of Bil'in's land, roughly half of the total expropriated.[8]

But the moment of triumph was short-lived. The court's injunction had no impact on the Defense Ministry. Nine months later, in May 2008, contractors in Modi'in Illit began laying the foundations for buildings in the area in question, and shortly thereafter Israeli settlers under the protection of the Israeli army began to install several mobile homes for settlers—usually the first step in establishing a new settlement or a new section of a settlement. No plans had been made for an alternate route for the Wall as mandated by the High Court, and apparently none was even being considered.[9]

Bil'in's anti-Wall protests are the most prominent and the most prolonged of several actions that have been staged over the years in villages near the Green Line whose lands have been expropriated or in some way separated from the main village by the Wall. Activists from Israel and around the world have joined with Palestinian villagers and protesters in extended protests in villages up and down the length of the West Bank, including, since Wall construction in this area began in mid 2008, Ni'lin northwest of Ramallah (see Map 1). Almost continual demonstrations in Ni'lin, a village of about 5,000, since mid 2008 have been met by a particularly harsh Israeli response. Two Palestinian boys, a ten-year-old and a teenager, were shot in the head and killed on successive days in July; scores of protesters have been injured; and Israelis have occasionally totally blockaded the village and imposed a round-the-clock curfew. Days before the Palestinian boys were killed, an Israeli soldier was videotaped shooting a blindfolded and handcuffed Palestinian protester (a man who happened to be a veteran of the Bil'in protests)

in the foot with a rubber-coated metal bullet while an Israeli officer held the Palestinian by the arm.[10] Despite the protests, construction on the Wall proceeds with at most minor disruptions.

<div align="center">⋈ ⋈</div>

In March 2003 it seems to rain almost every day, a fitting atmosphere for the destruction we see all around us, in small villages and large West Bank cities. Where the destruction and siege of small Palestinian villages are insidious, involving the slow but devastating encroachment of Israeli settlements and Israeli infrastructure on village lands, the destruction in larger towns and cities is blatant and explicit, involving demolished homes, bulldozed businesses, bombed apartment buildings. Destruction is everywhere. Much of the damage was done during Israel's massive Operation Defensive Shield in April 2002, a month-long operation that assaulted and laid siege to Palestinian cities throughout the West Bank in retaliation for the killing in late March 2002 of 29 Israelis in a suicide bombing at a Passover seder in Israel.

But small Israeli incursions throughout the West Bank were occurring before Defensive Shield and have continued steadily in the years since. Indeed, even though international attention has been focused on Gaza in recent years as a presumed security threat to Israel, the IDF has continued, virtually unannounced, to conduct almost daily raids on West Bank cities, arresting people, primarily young men, accused of but rarely formally charged with being terrorists. During the first six months of 2007, as one of many examples, Israelis conducted 3,144 raids—an average of 17 every day—throughout the West Bank and captured and detained 3,101 Palestinians.[11] According to Mustafa Barghouti, a physician,

independent politician, and member of the Palestinian Legislative Council, Israel conducted over 2,500 raids on Palestinian towns and villages in the eight months following the Annapolis summit in late November 2007. Ninety percent of these were in the West Bank, and many came in the immediate wake of a ceasefire in Gaza between Israel and Hamas that went into effect in June 2008. The fact that peace summits and ceasefires appear simply to give Israel free rein to continue assaults in the West Bank has not been lost on the Palestinians. Wondering why the ceasefire applied only to Gaza and not to the West Bank, Barghouti asked, "Do they want us to develop missiles and rockets here [similar to those fired from Gaza before the ceasefire there] before we can have a ceasefire?"[12]

As we drive into Nablus on a grim day in 2003, fog hanging low over this city laid out in a bowl in the hills of the northern West Bank, Ahmad points out flattened buildings along the side of the road, the tracks of Israeli tanks gouged into the paving of the road. On the main thoroughfare into town, we encounter the first roadblock that we have seen, an ugly pile of rubble and debris planted right across the street. The crushed, burned-out hulk of a car sits on the median strip. Ahmad takes a detour around this mess, and we are facing the destroyed former government and security headquarters for the city and the region of Nablus. In the first few years of the second *intifada*, Israel destroyed almost every Palestinian security headquarters in the West Bank and Gaza—at a time when Israel and the United States were insisting that Palestinian security authorities gain control over the security situation in Palestinian areas and stop terrorist attacks. This building was one of several security and government compounds called Tegart forts built by British Mandate authorities in the 1920s and 1930s and used over the years by Jordanian and Israeli occupiers as well. After the Palestinian

Authority assumed security control over West Bank cities during the Oslo peace process, these compounds usually functioned as Palestinian police and security headquarters and housed a regional governor's offices, municipal offices, a court, a jail, and often a medical clinic and food distribution center for the poor. This building in Nablus appears to have been bombed from the air, judging by the caved-in sections in the center of the large structure.

We park at the edge of the *suq* and Nablus's Old City, and the first thing that greets us is a destroyed building. Across the narrow street, Ahmad talks to a man running a small, one-room metalworks shop, and he tells us the destroyed building opposite had once housed his shop and residential apartment. Around the corner in this warren of tightly packed homes, shops and, unique to Nablus, centuries-old soap factories that manufacture Nablus's characteristic square bars of olive oil soap, we walk through the ruins of one soap factory and of an ancient *khan*, or caravanserai, the arches of its destroyed rooms still outlined against the now-exposed interior walls. Down the next street, there is more destruction—a second story collapsed here, an interior staircase exposed by a collapsed wall there. There is bustling activity in the streets nonetheless; business goes on.

Israelis regularly conduct raids in this area in search of so-called terrorists and frequently send tanks into the narrow streets, demolishing homes and other buildings at random. The buildings we are seeing were destroyed in 2002 or early 2003 during a series of Israeli incursions that began with Operation Defensive Shield. Hundreds were killed in Nablus during that attack, and the siege was followed immediately by a months-long curfew imposed on the city. We are seeing Nablus at a low point, and the future holds little prospect of improvement.

Nablus is an economic hub in the West Bank but has been severely constricted by checkpoints, Israeli settlements, and the movement restrictions that go with these. A city of about 130,000, the economic and service center of a region of 350,000, Nablus has a university and six hospitals serving the region and is a market and manufacturing center, but it is ringed by a total of 40 Israeli settlements and outposts, all served by a series of Israeli-only roads and seven checkpoints, including the notorious Huwara terminal, that hem Nablus in and severely restrict movement into and out of the city and around the region. Unemployment is high, businesses have closed or relocated for lack of customers, medical patients cannot reach hospitals, students are separated from schools.[13]

Since the beginning of the *intifada* in September 2000, Nablus has been targeted by the IDF as a principal breeding ground for Palestinian militants and as a result has been a target for regular, almost daily IDF search and arrest raids. According to one report, a total of almost 600 Palestinians have been killed in Nablus since the start of the *intifada*. This is 28 percent of the total Palestinian death toll in the West Bank, although the Nablus governorate comprises only about 16 percent of the West Bank population.[14] OCHA reports that the IDF conducted over 1,000 raids in the Nablus governorate between June 2005 and April 2007, an average of more than ten per week.[15]

Israel has continued these raids despite a cooperative PA-Israeli-US effort to train and strengthen a Palestinian security force that was introduced into Nablus in 2008. Although Israeli authorities have allowed PA security forces to function during the day, the IDF has ruled at night, continuing the middle-of-the-night raids, assassinations, and arrests at a high level. In July 2008, as a ceasefire was taking effect in Gaza, Israeli forces launched a crackdown on Hamas

in the West Bank, assisted by Fatah-controlled PA security forces. Israelis conducted provocative raids on businesses and institutions that they claimed were affiliated with Hamas in several West Bank cities, hitting Nablus hardest. In raids running over several nights, numerous offices and institutions were vandalized, including Nablus's municipal offices, several mosques, a girls' school, a medical center, several charities, a sports club, and an entire five-story shopping mall that housed stores and business offices. The mall and every establishment in it were ordered permanently shut down, on pain of a five-year imprisonment for any owner who reopened. Following considerable publicity and protests from the PA, Israeli authorities rescinded the closure order against the shopping mall and its stores, but not against the other establishments. *Haaretz* correspondent Gideon Levy concluded in a biting commentary that the raids demonstrate once again that "there is no place in Palestinians' lives that [the occupation] cannot reach." The Israeli actions also show, Levy wrote, that the occupation "has no boundaries."[16]

Within a few months after these raids, calm had been restored, and Nablus was being advertised as a showcase for the cooperative security arrangements forged by the PA with Israel and the United States—arrangements that the Palestinian people widely recognized as PA collaboration with Israel's occupation army. During the month of Ramadan in September 2008, for the first time since the second *intifada* began in September 2000, Israel allowed Palestinian citizens of Israel to enter the West Bank to shop in Nablus and Jenin, and talk began about trade "blossoming" after "eight years of commercial drought." In fact, far from an indication that Israel intended to allow these cities greater independence or significant economic development, this seemingly hopeful development was merely part of Israel's effort to put a good face on the occupation

and bolster the position of so-called Palestinian "moderates" in the PA in the struggle against Hamas. Ultimately, Israel continues to control the PA security forces that patrol Nablus. This is what one analyst has called a "controlled experiment" designed to keep Palestinian society politically and socially divided so that Israel can continue to claim that it has no Palestinian partner for peace capable of maintaining true security.[17] Nablus is merely another pawn in Israel's effort to maintain its domination, and there continues to be, as Gideon Levy notes, no place in Palestinian lives that the occupation cannot reach.

<div align="center"> CS ৪০</div>

When we visit Yasir Arafat the next evening, it is still gloomy and overcast, and the fog that hangs over Ramallah as we drive into Arafat's compound, the *Muqata*, is so thick it is literally impossible to see more than a foot in front of Ahmad's headlights. We have seen the large compound earlier, in the daylight, and the overall impression is of total destruction. Israeli fighter jets and tanks destroyed the compound, except for one building where an imprisoned Arafat lives and works, a year ago during Operation Defensive Shield. It is an oddly familiar sight, since much of the destruction was televised throughout the world as it happened. The world watched in real time as Israeli tanks tore down buildings and crushed automobiles.

As we approach in the early evening, the gates to the *Muqata* are wide open. Ahmad knows the compound and drives in confidently, but in the fog even he has to creep ahead slowly, across a large open square, until he stops at a sandbag emplacement and announces our arrival to a guard. We weave our way through a winding entry

formed by sandbags and earthen berms, passing a pile of crushed and burned cars left from last year. We are met at the entrance to the one undestroyed building in the compound and led past curious guards to an upstairs office where an adviser to Arafat greets us.

Our visit has been arranged by the friend of a friend, who has known Arafat for years. As we were preparing to leave for Jerusalem a few days ago, this man asked us unexpectedly if we would like to meet the *Rais*, the chairman, and, unaccustomed to such high-level meetings, we of course said yes, without actually expecting anything to result. But shortly thereafter, he gave us the phone number of an Arafat adviser to call when we arrived in Jerusalem, and the meeting was arranged as easily as that.

The building and the rooms we see are dingy and sparsely furnished. Arafat himself, who has been unable to leave this complex for over a year, since months before Operation Defensive Shield, is small and frail and is quite subdued throughout our almost hour-long meeting. When we are first ushered into the room where he works, he is alone, sitting at the end of a long conference table reading and signing papers stacked on a reading stand. He rises to greet us and offers us chairs next to him, passing a plate of sweets and crackers. Two of his advisers sit across the table from us, and a third is later summoned. The conversation never lags, but the advisers participate more than Arafat, who occasionally seems to check out, returning to his papers and once or twice having to be reminded of what is being discussed.

As soon as we sit down, Arafat shows us a series of pictures of Rachel Corrie's death three days ago. The pictures, taken by her colleagues from the International Solidarity Movement as she was first standing in front of and then was run over by an Israeli bulldozer as she tried to protect a Palestinian home in Gaza from demolition,

are horrifying. In the first picture, she is standing in front of the bulldozer, holding a megaphone. The scene is strangely peaceful, almost pastoral. The day is sunny—the rains of the following week have not yet begun—and she is standing on a bright green patch of grass in front of the targeted house. The scene is so disorienting it is difficult at first to recognize what we are seeing. The next picture shows the bulldozer closer to her; the next two show her lying in the sand bleeding. The pictures later appear on the Internet, and we will see them in Palestinian newspapers, but this is the first time we have seen them. Arafat's advisers tell us that earlier in the day he telephoned Corrie's father to express his condolences. Corrie has become a hero to the Palestinians. She was honored with a symbolic funeral in Gaza before her body was sent back to the United States. Palestinians carried her aloft, lying on a stretcher, draped in a Palestinian flag like a Palestinian martyr. Arafat regards her as a hero.

The conversation turns to the impending war with Iraq, which will start only hours after the conclusion of our meeting. One adviser charges that Israel has dragged the United States against its interests into initiating the war. Arafat himself, asked what he sees ahead for the Palestinians, says it is hard to know what lies ahead because the war could change everything. "It's a new Sykes-Picot agreement," he declares, likening the Bush administration's plans for "transforming" the Middle East to the secret 1916 agreement, named after the diplomats who signed it, by which Britain and France arranged to draw new borders throughout the Middle East and carve up the area between themselves in the aftermath of World War I. On the eve of this major aggressive US war, the analogy between the old colonial era and the Bush-era neo-colonialism is particularly apt.

The rest of the conversation revolves around the obvious hopelessness of the peace process. Arafat angrily denounces Ariel Sharon and his refusal to pursue any of the several peace proposals put forth in the last few years, and he laments that President Bush has been so ineffective in opposing Sharon's intransigence. When the conversation turns to a rehash of the Camp David summit in July 2000, when the Oslo peace process essentially collapsed, Arafat also has harsh words for then Israeli Prime Minister Ehud Barak, who he says planned from the beginning to "destroy everything." But when his advisers criticize President Bill Clinton for having blamed Arafat for the collapse, Arafat refuses to be drawn into criticism of the former president. Clinton "did his best," Arafat says, and that silences further discussion.

We leave the meeting with a mix of emotions: some undeniable excitement at having met Arafat; sadness about his obvious decline, both physically and in political stature; considerable depression about what this decline says about the vulnerability of all Palestinians in the face of Israel's efforts, with total US support and facilitation, to smother the Palestinians and their aspirations to freedom and independence; a sense that Rachel Corrie's death, virtually unnoticed by anyone but the Palestinians, similarly signifies Palestinian vulnerability; and great fear—intensified the next morning when we awake to see "shock and awe" playing out on our hotel television screen—about the coming war in Iraq and what this will mean for the people of the Middle East and the rest of the world.

We are initially a little surprised by the disinterested reaction among Palestinians to our visit with Arafat, but on further reflection we realize that, despite his undoubted role as father of the Palestinian revolution, many Palestinians are disappointed in his poor leadership and blame their vulnerability on him. "Nobody gives a damn shit

about the Palestinians," one Palestinian tells us, summing up the untenable, nearly hopeless situation of Arafat and his people.

☪ ☬

We are still in a dark mood, and it is still raining, the next day as we walk two miles into Jenin. Hoping to avoid the most difficult checkpoints, Ahmad has driven a circuitous route to Jenin from Jerusalem, traveling up through the Jordan Valley into Israel and looping back south into the West Bank, approaching Jenin from the north. But the lone soldier manning the checkpoint outside Jenin on this dismal March day absolutely refuses to let Ahmad drive his car through the checkpoint. He will let us all walk in but not drive. Ahmad argues with him in Hebrew, we argue with him in English, he phones his commanding officer, who leaves the decision to him, but in the end he will not change his mind. After half an hour, and almost certainly with greater concern than he reveals to us, Ahmad parks the car that is his livelihood on the side of the road, and we start to walk.

The area is still very rural and eerily quiet. Agricultural fields spread out on either side of the road. Yellow spring flowers are beginning to bloom on the edges of the fields and, in the near distance on one side, we can see a set of greenhouses. A short distance along, Ahmad flags down a car that has emerged from a side road. We pile in, and Ahmad tells the driver we want to go into Jenin, but the man is afraid to take us and asks us to get out. It turns out we must still walk past an Israeli guard post, and the driver is clearly frightened at this prospect. As we walk past, an Israeli soldier calls out to us, urging us sarcastically in English to "be careful in there. They're all terrorists there." We walk on and

say nothing. A minute later, we hear shooting from behind the guard post, but the shooting is not in our direction, and it appears to be just a show for our benefit. We begin to understand why the area is so quiet and seemingly empty. After we have walked what seems to be two miles, we pass an area of houses, still strangely quiet even this far away from the Israelis, but Ahmad finds some men in an auto junk yard, who appear to be the only people around, and asks for a ride the rest of the way into town.

We are dropped at a destroyed compound, what remains of Jenin's old Tegart fort, its municipal and governorate headquarters. A security official, a man obviously with little to do, who has been sitting talking to colleagues in an unfurnished garage-like structure, one of few in the compound still standing, describes Israel's destruction of the entire complex in the middle of the night in September 2001, just hours after the September 11 attacks in the United States. The Israelis obviously used the distraction of September 11 to carry out this massive destruction in Jenin, secure in the knowledge that it would attract no media attention, although they seldom have reason in any case to worry about unfavorable media treatment.

Almost every building has been flattened, destroyed with explosive charges laid throughout the compound and in bombings by F-16 fighter jets and Apache helicopters. Yellow spring flowers sprouting everywhere decorate the ruins. "We are only police here, not an army," the security official says. "We had no equipment to fight against tanks and planes, so we had to leave." On a tour of what remains of the complex, we walk through the still-standing but heavily damaged medical clinic. Medical records still lie scattered on the floor; one paper, apparently a list of clinic visitors for one day,

lists the complaints in Arabic and English: chest pain, abdominal pain, sore arm.

Moments later, we are driven to the center of the Jenin refugee camp, the scene of terrible destruction during Operation Defensive Shield a year ago. This is the place where Israeli bulldozers destroyed a huge area in the heart of the camp, the size of a large city block in a major urban center, where thousands of people had lived in closely packed, multi-story buildings. As we round a corner and gain our first glimpse of what is now, almost a year later, an empty plaza, it takes our breath away. This area housed 3,000 of the refugee camp's 13,000 residents, now homeless again. The rubble of these lives has been cleared or buried, as if nothing ever stood there, but the damage to buildings on the edges is still evident: many burned, some tilting, some partially collapsed, the corners ripped off others where bulldozers did not quite fit in the narrow alleyways. Although shortly after our visit, housing in this large area was rebuilt, thanks to funds donated by the United Arab Emirates, the demolition of such a large area remains a lasting trauma for camp residents.

The Israeli bulldozer operator who cleared this large area of houses later gave an interview to an Israeli newspaper boasting of his accomplishments—which the interviewer characterized as "far from being a regular war myth." Moshe Nissim, nicknamed "Kurdi Bear," told the interviewer that he had entered the Jenin camp "driven by madness, by desperation" over the killing of several Israeli soldiers in the Jenin battle. He worked continually in the bulldozer without a break for 75 hours, demolishing houses. Driving a large Caterpillar D-9 bulldozer, trying, as he recounted, to fight Palestinian militants who were fighting against Israeli soldiers,

I just destroyed and destroyed. The whole area. Any house that they [Palestinian fighters] fired from came down. And to knock it down, I tore down some more. They were warned by loudspeaker to get out of the house before I came, but I gave no one a chance. I didn't wait. I didn't give one blow, and wait for them to come out. I would just ram the house with full power, to bring it down as fast as possible. I wanted to get to the other houses. To get as many as possible.... Many people were inside houses we started to demolish.... I didn't see, with my own eyes, people dying under the blade of the D-9, and I didn't see houses falling down on live people. But if there were any, I wouldn't care at all. I am sure people died inside these houses.... If you knocked down a house, you buried 40 or 50 people for generations. If I am sorry for anything, it is for not tearing the whole camp down... Jenin will not return to what it used to be.[18]

"Kurdi Bear" was part of an intensive two-week Israeli siege of the refugee camp during Operation Defensive Shield, in which Israel killed over 50 Palestinians, of whom almost half were civilians, and lost 23 soldiers in fierce house-to-house battles with Palestinian fighters. Israeli forces used helicopter gunships, fighter jets, missiles, and tanks to level houses and apartment blocks. Israelis shot civilians in their homes, demolished buildings with their residents still inside, held hospitals under siege, refused to allow ambulances to transport wounded, barred the entry of humanitarian aid workers, and refused to allow the media into the camp until the siege was over. Mosques were desecrated, water and electricity were shut off for the duration of the siege, food shipments into both the city and the refugee camp were blocked. The Israelis used civilians as human shields, forcing them at gunpoint to knock on doors so that soldiers would not risk being shot trying to enter the homes.[19]

When the siege finally ended, press coverage provided a highly descriptive account of what had occurred. A *New York Times* article, for instance, described the situation in this way:

The smell of decomposing bodies hung over at least six heaps of rubble today, and weeks of excavation may be needed before an accurate death toll can be made. But it was already clear that scores, possibly hundreds, of houses were leveled by Israeli forces. Israeli army bulldozers had plowed 100-foot wide paths that crisscross the center of the camp, turning it into a pancaked field of concrete, dirt and rubble about a half-mile long, every structure flattened. Israeli officials have said the paths were created to move tanks and armored vehicles into the warren of houses where Palestinians put up fierce resistance. But the paths that were cleared were, in some areas, two to three times the breadth of a tank.[20]

As we walk around the camp a year later, tailed by several young children just coming home from school, traumatized ourselves by our long-distance perspective on these horrors, we cannot help but wonder what kind of trauma these kids have suffered, and continue to suffer. As we leave the camp and Ahmad tries to hitch a ride for us to the edge of the city, we stand looking at several "martyr posters" pasted to the wall of a downtown building. One in particular, of a dignified-looking middle-aged man, catches our eye. He was a physician, we are told, killed by the Israelis. These posters commemorate ordinary Palestinians killed by the Israelis, not only suicide bombers, as is commonly believed.

Ahmad hears a rumor that an Israeli military contingent has entered town, so we leave hastily. A taxi takes us to the outskirts and drops us off. We see no sign of Israelis, except for those at the guard post, as we walk the two miles back to the car, but the oppression of this place and of the constant Israeli presence hangs heavily over us.

By 2008, Jenin had become another showcase, like Nablus, of PA-Israeli security cooperation, and another pawn in Israel's game of domination. Once again, the media talked unrealistically of a "quiet

revolution" in this city where only Israeli security forces had reigned since the siege and destruction in 2002. As PA security forces began to patrol Jenin's streets in a shared arrangement with Israeli forces, the city was hailed by US General James Jones—then in charge of facilitating security coordination between the PA and Israel, who was later appointed President Obama's national security adviser—as a model for the rest of the West Bank, fantastically claiming that Jenin represented "a kind of dress rehearsal for statehood, a crucible where the two sides can prove things to each other."[21] Any hope that Israel ever intends to allow the Palestinians true freedom, no matter what the PA proves to Israelis, is quite forlorn.

<div align="center">CB BO</div>

The details are different in each place, but the story of one Palestinian city is essentially the story of all cities. Hebron, the largest urban area in the West Bank with a population of 165,000, has been a scene of confrontation since 1967 between Palestinian inhabitants and a small core of highly aggressive, nationalistic religious Israeli settlers who moved into the heart of the city shortly after Israel's capture of the West Bank and have succeeded in taking over multiple Palestinian residences, physically attacking Palestinians, closing down Palestinian shops, forcing Palestinians out of the Old City and *suq* area.

Statistics alone tell a dramatic story of the devastation of Hebron. The city is surrounded by 24 Israeli settlements, including four settlements established more than 20 years ago inside the Old City itself. In 1997—at a time when only approximately 450 Israeli settlers inhabited this large Palestinian city—the United States negotiated an agreement between Israel and the PLO that divided the

city unevenly. Although the agreement called for Israel's withdrawal from 80 percent of Hebron, it left a critical 20 percent, including the Old City and the Ibrahimi Mosque—which Jews revere as the Tomb of the Patriarchs or the Cave of Machpelah, believed to contain the tombs of Abraham, Isaac, and Jacob and their wives—under Israeli control. (A community of Jews lived in Hebron until 1929, when 67 Jews were massacred by Palestinian attackers in a flare-up of intercommunal violence. This original presence of Jews in the city is part of the basis for the settlers' claim to Hebron today, although few if any of the present-day settlers are descended from Hebron Jews of the 1920s.)

Because the settlers, numbering about 600 as of 2007, have free run of this Old City area at the center of Hebron, under the protection of a force of 1,500 Israeli soldiers, they have successfully forced out most Palestinians, often with the active cooperation of Israeli authorities.[22] More than 40 percent of Palestinian homes in the center of the city have been evacuated, and over three-quarters of Palestinian commercial establishments, a total of more than 1,800, have closed, many of them by military order. Although many of these evacuations and closures occurred before the start of the al-Aqsa *intifada* in September 2000, they have intensified since then. Thousands of Palestinians have moved out of the city center.[23]

Statistics, however, cannot give a full picture of Hebron's economic devastation, the Palestinians' total vulnerability, the fiercely nationalistic intent of its Israeli settlers, or the often malevolent conduct of Israeli soldiers toward the Palestinians. The movement restrictions imposed on Palestinians in the Old City, described by B'Tselem as "severe and extensive," bar all Palestinian vehicular traffic and in many areas even prevent Palestinian foot traffic. Israeli authorities have systematically failed to prevent violent settlers from

physically attacking Palestinians and have themselves frequently committed atrocities against Palestinians. B'Tselem summarizes this situation:

Over the years, settlers in the city have routinely abused the city's Palestinian residents, sometimes using extreme violence. Throughout the second intifada, settlers have committed physical assaults, including beatings, at times with clubs, stone throwing, and hurling of refuse, sand, water, chlorine, and empty bottles. Settlers have destroyed shops and doors, committed thefts, and chopped down fruit trees.... Soldiers are generally positioned on every street corner in and near the settlement points, but in most cases they do nothing to protect Palestinians from the settlers' attacks.... [T]he authorities in effect sanction the settlers' violent acts.... The increased presence of soldiers and police in the Hebron city center brings with it violence, excessive and unjustified use of force, and abuse of the powers granted them by law. Violence, arbitrary house searches, seizure of houses, harassment, detaining passersby, and humiliating treatment have become part of daily reality for Palestinians.[24]

An organization of Israeli soldiers who have served in Hebron since 2005, called Breaking the Silence, has provided substantial testimony on the military's conduct toward Palestinians. A booklet issued in 2008 asserted that "incidents of looting, infiltrating houses for no reason, harsh physical abuse towards Palestinians, and firing at Palestinians contrary to any official IDF rules of engagement" together constitute "normative" behavior and "cannot be described as 'exceptional.'"[25] Soldiers have talked about "losing the human condition" in Hebron as a result of their own behavior and about the settlers as a "pure evil" that must be removed.[26]

ᴄʒ ꙮ

Qalqilya, lying immediately adjacent to the Green Line in the most fertile agricultural area in Palestine and Israel, was a thriving

agricultural center and a commercial center for over 30 neighboring West Bank villages until the Wall, completed in this area in late 2003 and almost totally encircling the town, devastated its economy. Only one road leads out of Qalqilya, and this is controlled by an Israeli checkpoint. More than 80 percent of the town's 1,500 acres of land is either taken up by the Wall or is isolated on the Israeli side, accessible to Palestinian farmers only with great difficulty, if at all. Much of Qalqilya's thriving economy came from Israelis who shopped there regularly, from Palestinian residents who worked in Israel, and from over 40 joint business ventures between Qalqilya residents and Israelis. Although a great deal of this activity was thwarted by the *intifada*, the Wall put an end to virtually all of it. One-third of the town's commercial establishments had closed by 2005.[27]

When we meet Qalqilya's acting mayor, Hisham al-Masri, in September 2005, he has been in office for three months, elected on a Hamas ticket, most likely because of popular frustration over the dismal economic and political situation.[28] Hamas is making gains in local elections throughout the West Bank and will win a plurality in legislative elections in the West Bank and Gaza in January 2006. The newly elected mayor of Qalqilya, for whom Deputy Mayor al-Masri is acting, was elected while in an Israeli jail—an indication of the strength of popular dissatisfaction with the status quo and the rising popularity of Hamas. Al-Masri is a gracious man, socially flexible enough to shake hands with both of us—something many strong Muslim traditionalists will not do. He is eager to tell the story of Qalqilya's distress and hopes that we will publicize it.

Qalqilya once had three principal sources of income, he tells us. Whereas approximately 12,000 residents once worked inside Israel, where incomes and job opportunities are greater, now only

about 300 are able to sneak in illegally to work. The town has also lost approximately 80 percent of its agricultural market because so much of its land has ended up on the Israeli side of the Wall. Produce from the Qalqilya fields on Israel's side of the Wall is now being sold by Israelis, al-Masri charges, with the result that what Qalqilya is still able to grow and sell goes very cheaply. Finally, the town's commercial interests once gave it a business capacity more than three times what was needed for the town itself, but now less than one-quarter of that capacity is left. Al-Masri estimates that Qalqilya has lost more than two-thirds of its economy. Over 5,000 of its 45,000 inhabitants have left to move farther into the West Bank. Other sources put the unemployment rate at 75 percent.[29]

The city's distress is quite evident to us. Streets are lined with closed shops, a central market area is obviously not thriving, and in a jarring throwback to earlier times, horse and donkey carts are increasingly being used for ordinary transport by people unable any longer to afford cars.

In early 2006, shortly after the January legislative election in which Hamas came to power, Israel arrested scores of Hamas legislators and political leaders. Hisham al-Masri, still Qalqilya's acting mayor, was among those arrested. He was held for two years and released in May 2008. The longer term prospects for Qalqilya are no better than elsewhere in the West Bank.

<div align="center">Cs &</div>

There are hardly words to describe the human suffering and degradation deliberately imposed on Palestinians by Israel's occupation. The Israeli threat to Palestinian lives and livelihood, individually and collectively—indeed to Palestinian national

existence—through theft of land and the siege of towns and villages, through walls and roads and blockades that strangle, through the crippling of economic opportunity, through deliberate large-scale killing, together resemble a hunting expedition designed to cage and ultimately eliminate animals from a natural habitat. Israeli leaders, Israeli settlers, Israeli soldiers treat Palestinians not as a collective of human beings, but as trapped animals whose fate is of little or no concern.

International law scholar Richard Falk has called this a holocaust-in-the-making. Noting that the scale and the "unconcealed genocidal intent" of the Nazi Holocaust make it "as close to unconditional evil as has been revealed throughout the entire bloody history of the human species," Falk wondered in a 2007 article if it were "an irresponsible overstatement to associate the treatment of Palestinians with this criminalized Nazi record of collective atrocity?" Answering his own question, he asserted, "I think not." His attention was focused primarily on Gaza, struggling under an international embargo, and he warned that Israel's "abuse of the Palestinian people" there vividly expressed "a deliberate intention on the part of Israel and its allies to subject an entire human community to life-endangering conditions of utmost cruelty."[30]

It takes but a few visits to towns and villages around the West Bank to conclude that, although Gaza's suffering places it farther along the path toward a holocaust, conditions in the West Bank clearly constitute a "holocaust-in-the-making."

Picture 33
The agricultural fields and irrigation pools of Wadi Fukin lie between a ridge line in the west, along which runs the border with Israel, and a ridge line to the east, the site of the large and rapidly expanding Israeli settlement of Betar Illit. Israel plans to build the Separation Wall on the western ridge, shown here, and Betar Illit is squeezing the small village from the east, dumping construction debris and occasionally sewage onto Wadi Fukin's fields.

Picture 34
Looking north, the village and mosque of Wadi Fukin can be seen on the left and a part
of the settlement of Betar Illit on the right. In the right foreground is part of the wall
of dirt and rocks dumped onto Wadi Fukin's fields from construction in the settlement.

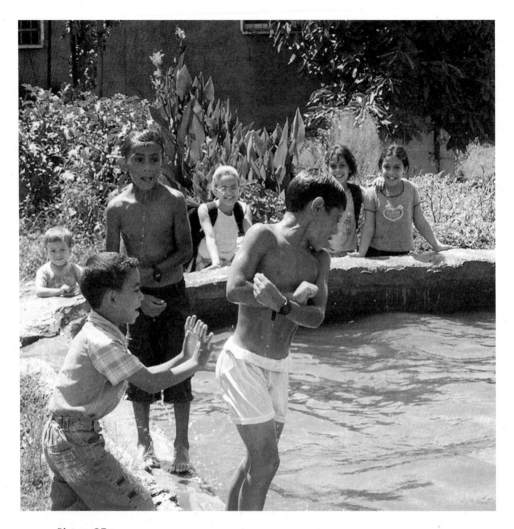

Picture 35
A group of village children on their way home from school swim in one of Wadi Fukin's irrigation pools. In recent years, groups of settlers from Betar Illit, usually armed, have begun swimming in irrigation pools more distant from the village center.

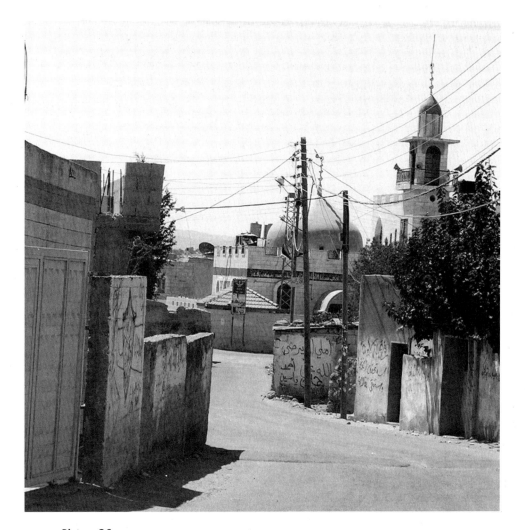

Picture 36
The mosque in the village of Bil'in is the gathering place for weekly non-violent protest demonstrations against the Separation Wall, which has been built through village land, placing more than two-thirds of it on the Israeli side, where one of the largest Israeli settlements in the West Bank, Modi'in Illit, is expanding.

Picture 37
A young Israeli soldier commands a group of eight soldiers and policemen who have established a temporary checkpoint—a so-called "flying checkpoint"—about two miles outside Bil'in on a Friday in September 2005 to keep protesters from reaching the village to join the weekly protest against the Wall. During the few hours that the checkpoint was in place, the soldiers allowed Palestinian drivers through—a striking reversal of the usual practice—but stopped all cars with Israeli license plates. A group of five women from Machsom (Checkpoint) Watch, an Israeli women's group that monitors soldier behavior at checkpoints, was held for about an hour but then allowed to proceed into Bil'in. Other Israeli drivers were turned away. Ahmad was driving us, as well as a Japanese journalist assigned to cover the protest, hoping that we would be allowed through on the basis of the journalist's press pass and his own Palestinian press pass. But the Israelis refused to let us through, despite considerable arguing and importuning by us and Ahmad. This young commander denied any responsibility for barring us, saying he was only acting on orders from above. A hauntingly familiar story. Eventually, Ahmad took the Japanese journalist into the village to cover his story and drove back and forth for two hours to keep us company as we waited and observed.

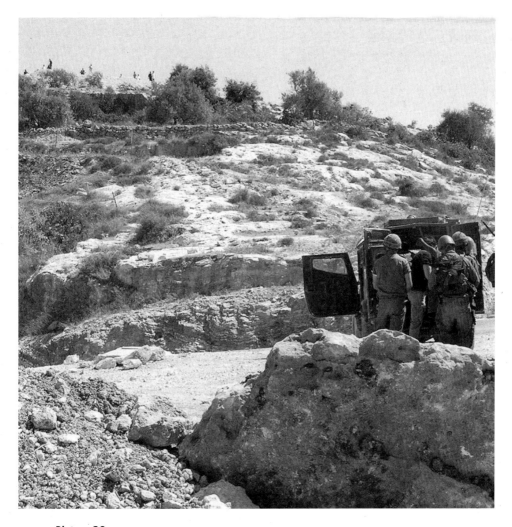

Picture 38

As the protest came to an end inside the village, a group of teenage boys began throwing stones at the soldiers and police at the checkpoint from a hilltop above the road. They were far enough away that the stones did little harm, but a few landed noisily on the roof of the police jeep. The Israelis, most of whom had been lounging around helmetless, immediately donned helmets and took refuge behind the jeep. After the Israelis had gathered their equipment, the jeep and the entire checkpoint retreated farther downhill to a bend in the road where the soldiers and policemen were out of the stone-throwers' line of fire.

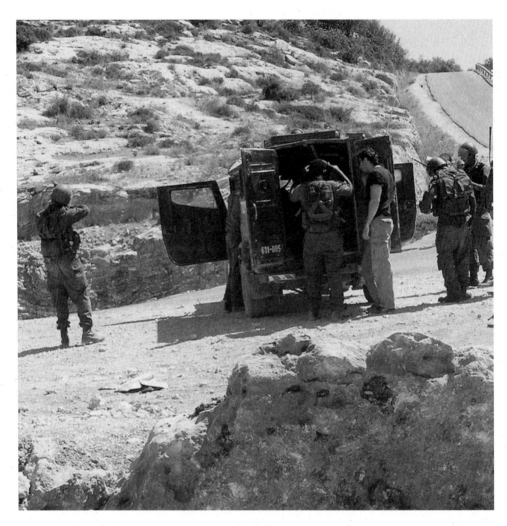

Picture 39
Before retreating downhill, an Israeli soldier aims his weapon at the boys on the hilltop but does not fire.

Picture 40
This small building is part of the mock "settlement" that Bil'in residents and
international activists have established on Bil'in's land now lying on Israel's side of the
Separation Wall. A Palestinian flag flies from the top of the building. The numbers
"242" presumably refer to UN Security Council Resolution 242, the 1967 resolution
that calls for Israel's withdrawal from the occupied territories.

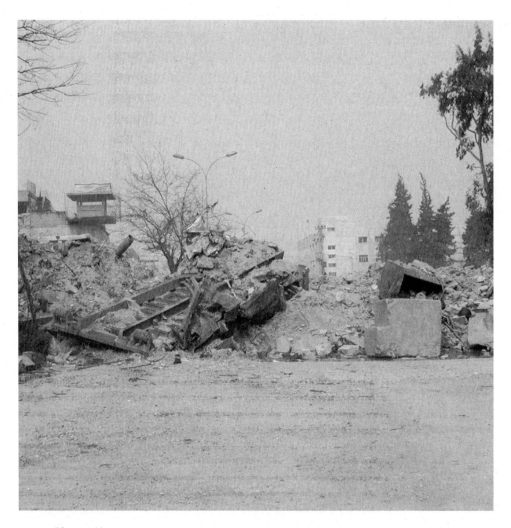

Picture 41

This roadblock stops traffic on a main street in the large city of Nablus. Composed of cement blocks, mounds of dirt, and other pieces of scrap and debris, this roadblock is typical of many established in urban areas following Israel's siege of the West Bank and reoccupation of Palestinian cities in the spring of 2002. This picture, taken a year later in March 2003, is testimony to Israel's continued presence and control everywhere in Palestinian areas, inside cities as well as in rural areas.

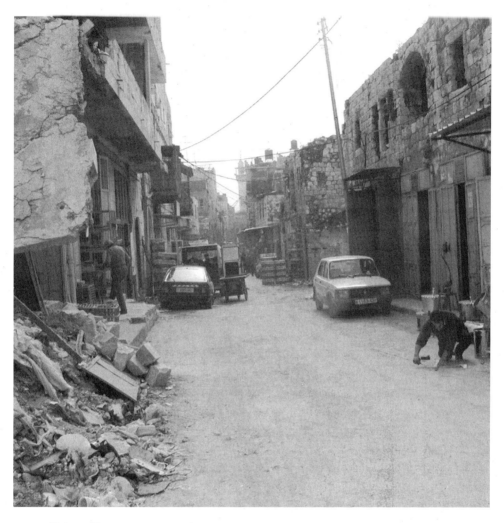

Picture 42
This 2003 scene in the Old City of Nablus is typical of the destruction wrought by Israel's attacks. The building in the left foreground, once housing a shop and an apartment above, is completely destroyed, the first floor a pile of rubble, the floor of the second story hanging down limply in a slab. Additional damage can be seen down the narrow street, including burned-out upper stories on the right and a bombed second story at the corner. The man on the right is measuring something outside his metalworks shop.

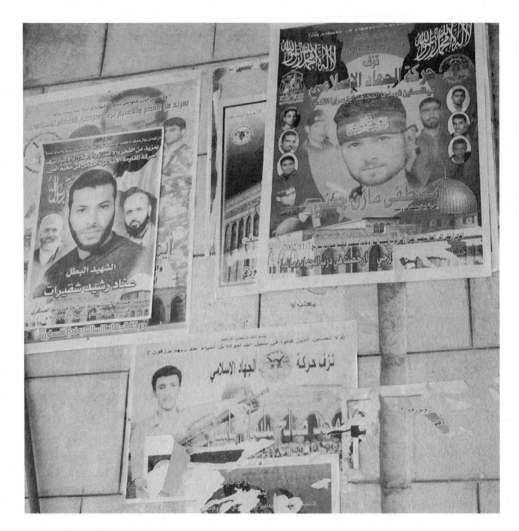

Picture 43

"Martyr posters" like these on the walls of the mosque in Nablus's Old City can be seen everywhere throughout the occupied territories. The posters show young men, children, in some cases an infant, often people in middle-age. The posters do not only depict terrorists, as is commonly believed. Some of these people are fighters, some are probably suicide bombers, but most are civilians killed because they live in the midst of warfare in their cities, and because they are Palestinian.

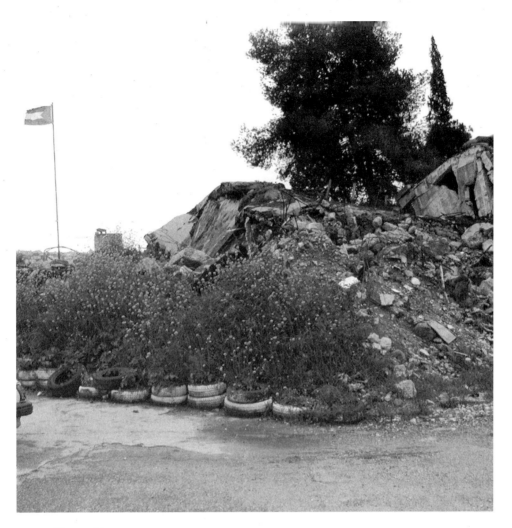

Picture 44
The Palestinian flag flies above the destroyed remains of the governorate, municipal, and security headquarters in Jenin, destroyed by Israel in September 2001.

Picture 45
In March 2003, boys on their way home from school kick a soccer ball in the open plaza at the center of the Jenin refugee camp left by Israel's bulldozing of a huge swath of the camp a year earlier, in April 2002.

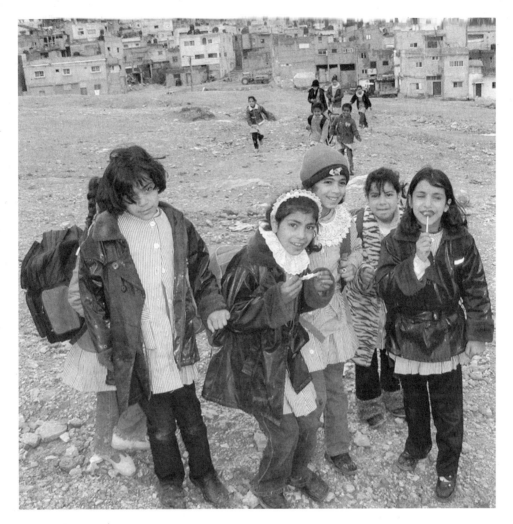

Picture 46
Young girls on their way home from school in the center of the Jenin refugee camp
gather around a pair of foreigners to have their pictures taken.

Picture 47
Because of violence from fiercely nationalistic Israeli settlers, almost no Palestinian shops remain open in the *suq* area of Hebron's Old City.

Picture 48
Israeli settlers stroll down a street in the heart of Hebron's Old City, where settlers, acting under the protection of Israeli security forces, have seized Palestinian residences, physically assaulted Palestinians, forced them out, and shut down commerce in this once vital market and commercial center. Israeli flags are evident in this once Palestinian area.

Picture 49

A Palestinian man reads the Qur'an in the Ibrahimi Mosque in Hebron. In February 1994, this mosque was the scene of a massacre by an Israeli settler, Baruch Goldstein, a physician originally from Brooklyn, who entered the mosque and shot 29 Palestinian worshippers to death, injuring more than 100 others. Goldstein was then killed by Palestinian survivors. The Israeli government responded to the incident by imposing a round-the-clock curfew on the victims, Hebron's large Palestinian population, but not on the Israeli settlers, who later built a memorial for Goldstein at his gravesite. The massacre was followed, 40 days later, by the first Palestinian suicide bombing. Forty days is the Muslim period of mourning. Repaired bullet holes are still visible in the marble and stonework inside the mosque.

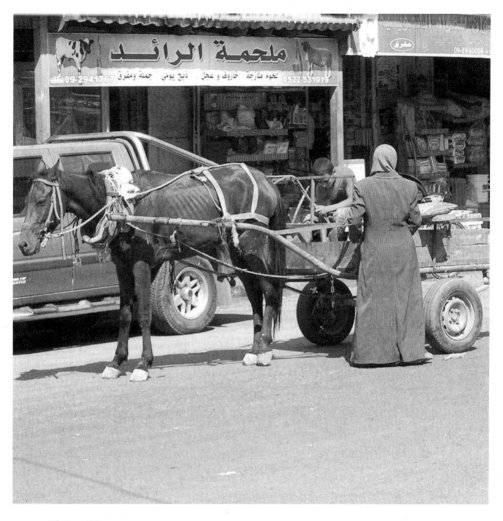

Picture 50
The economic distress caused by the Separation Wall is evident in the streets of Qalqilya, once a major agricultural market center now almost totally surrounded by a concrete wall. Multiple businesses have closed, business is down for those establishments still open, large numbers of residents have moved away to other West Bank towns, and increasing numbers of people, unable to afford cars and gas, are using horse and donkey carts for transportation. This woman and her son are on an apparent shopping trip, using a cart drawn by a horse that obviously appears to be underfed.

6
EYELESS IN GAZA

"Israel's exposed nerve"

"I couldn't even believe that a place like this existed," Rachel Corrie wrote of Gaza after she first arrived in January 2003.

As a volunteer with the International Solidarity Movement, her purpose was to stand up for Palestinians in the face of Israeli bulldozers, tanks, and snipers. Two weeks later—just over a month before she was run over and killed by an Israeli soldier driving one of those massive bulldozers as she stood in front of a Palestinian home about to be demolished—she wrote that she still had "very few words to describe what I see.... [N]o amount of reading, attendance at conferences, documentary viewing, and word of mouth could have prepared me for the reality of the situation here. You just can't imagine it unless you see it."[1]

Gaza has that effect, tending to leave observers hopelessly inarticulate in the face of so much Palestinian misery, so much Israeli oppression. If the West Bank's horrible situation is difficult to fathom and describe, the anguish of Gaza is unspeakable. We observed it, all too briefly, in March 2003, coincidentally just days after Corrie's death. It is the poverty that hits you in the face, although that is only the surface: donkey carts everywhere, children

in bare feet or only plastic flip-flops walking through cold puddles in the winter rain, flea markets on many corners selling old clothes and run-down shoes—and the walls covered everywhere with endless graffiti in Arabic. We gained some sense of Gaza's situation from our brief visit but could not do more than glimpse the margins of its distress. All of our subsequent attempts to enter Gaza have been refused by Israeli authorities, who still, despite the 2005 so-called "disengagement," control all entry to and exit from this territory, for Palestinians as well as foreign visitors.

The Gaza Strip is one of the most densely populated places on earth, its population of almost 1.5 million people packed into an area of only 147 square miles. Gaza is less than one-tenth the size of Rhode Island, the smallest state in the United States, yet has a population one and a half times as large. Two-thirds of Gazans— slightly over one million people—are refugees, the outgrowth of about 250,000 Palestinians who fled or were expelled from their homes in what became Israel in 1948. Gaza has never thrived and has grown dramatically more crowded over the years. The already destitute refugees crowded in with an original population of 80,000 Gazans and, when the 1949 armistice lines were drawn, all found themselves more or less confined to this small strip of land, under Egyptian control.[2]

After Israel captured the territory in 1967 and began building settlements there in the 1970s, Gazans were able to enter Israel freely to find work—as much as 70 percent of the labor force worked in Israel until the late 1980s[3]—but the Israeli settlements made more than 20 percent of Gaza's small territory unavailable for Palestinians. In the early 1990s, Israel imposed an increasingly tight closure on Gaza, eventually building an actual wall around it, and began requiring permits for entry to Israel. Unemployment skyrocketed

as the percentage of the labor force working in Israel dropped to one-quarter in the wake of the first *intifada* in the late 1980s and later to a mere 11 percent after the Israelis imposed closure.[4] Israeli journalist Amira Hass, who lived in Gaza for several years in the 1990s, wrote in mid-decade, at the height of the Oslo peace process, that for Gazans the words "Oslo" and "peace process" had "become synonymous with mass internment and suffocating constriction.... For most Gazans, most of the time, there is no exit, not to Israel, not to Egypt, and not to the West Bank."[5]

Sara Roy, a political economist at Harvard who has studied Gaza closely since the early 1980s, has enunciated a theory of "de-development" to explain Israel's deliberate effort to suppress the growth of an independent Palestinian economy, particularly in Gaza. Defining de-development as "the deliberate, systematic and progressive dismemberment of an indigenous economy by a dominant one, where economic—and by extension, societal—potential is not only distorted but denied," Roy concluded from years of observation that Israel has not only exploited Palestinians economically, as has occurred in most colonial situations, but has positively deprived Palestinians of developmental potential and, through its efforts to advance Jewish sovereignty over the whole of Palestine, even of national identity. Rather than allow for some limited, albeit dependent or distorted, economic development, as in most colonized societies, Israel's de-development strategy has ensured that Palestinians are able to develop no economic base at all—that they are actively deprived of the economic resources and the institutional development capabilities needed to create and sustain productive capacity and a vigorous economy.[6]

Because of this Israeli strategy, the Oslo peace process brought not economic prosperity or any kind of economic revival to Gaza,

but a severe downturn, as Israeli policies worked to ensure that any future peace agreement would not result in true Palestinian independence. Early in the peace process, Roy wrote that the prolonged closure and other economic restrictions imposed on both Gaza and the West Bank should be understood not only for their economic implications but as indicators of Israel's longer term political intention of guaranteeing continued Israeli control over Palestinian land and water by ensuring continued integration of the occupied territories with Israel, and the continued dependence of the Palestinians.[7] Amira Hass has been even more blunt in her description of Israel's intent. One motive for "the obstruction of development" in Gaza, she wrote in the mid 1990s, "was the none-too-secret political objective of encouraging a mass exodus: Gazans who left the Strip would subsequently lose their residence rights. Israel's control over the Palestinians' right to work was a blatant political device whose calculated long-term aim was their ultimate economic, national, and geographic displacement."[8]

In the decade and a half since these assessments were written—a period that has seen the collapse of the peace process, the start of the second *intifada*, a total closure of Gaza, the political rise and election victory of Hamas, the eruption of armed conflict between Hamas and the principal Palestinian faction, Fatah, and a crippling international embargo of Gaza led by Israel and the United States—Gaza has sunk to unutterable levels of misery. For years even before the embargo, unemployment continued to rise; real wages fell; increasing numbers lived below the poverty level; children suffered rising levels of malnutrition; families gradually bought and consumed less food; an increasing proportion of the population was subsisting on food donations from welfare organizations such as the UN's refugee agency, the UN Relief and Works Administration

(UNRWA); increasing salinity levels in drinking water as a result of overpumping of wells by Israeli settlers in Gaza were causing severe health problems. Thousands of houses were demolished—more than 4,000 between the start of the second *intifada* and the end of 2007[9]—primarily in Israeli clearing operations to create open "secure" areas along the length of Gaza's fenced border with Israel and along the southern border with Egypt. All but a few hundred of the demolitions took place in the years before the Israeli "disengagement" in September 2005. The catalog is endless.

Despite Israel's so-called "disengagement" from Gaza in 2005, which saw the dismantlement of all settlements and the withdrawal of Israeli military forces, the plight of Gazans has only grown worse. Although Israel contends that the occupation of Gaza ended with the disengagement, in fact Israel remains in total control of the territory; it continues to control all Gaza's borders, including the Mediterranean coastline and the border with Egypt, and controls the entry and exit of all people and all cargo. Ostensibly in response to Palestinian rocket attacks on civilian areas of Israel, the Israelis regularly block shipments of food, fuel, healthcare supplies and equipment, and vital equipment such as spare parts for sewage treatment plants. Despite an agreement negotiated by the United States in November 2005 regulating the passage of goods through several crossing points, Israel opens the crossing points only on a limited basis; the number of trucks carrying commercial and humanitarian cargo has dropped to a fraction of pre-embargo levels.[10]

The international embargo imposed on Gaza in the wake of Hamas's legislative election victory in January 2006, led by the United States, has markedly intensified Gaza's grinding poverty. Eighty percent of the population now depends on food aid from humanitarian organizations, a steep rise from a horrendous 63

percent in 2006. Hospitals lack adequate supplies of fuel to run generators during electric power cuts that usually run for eight to twelve hours a day. Unemployment in the private business sector stands at almost 70 percent, and 95 percent of private industrial operations have been suspended; lack of imports and the inability to export cripple business. Because of a lack of spare parts for treatment plants, sewage occasionally backs up and runs in the street, and virtually the entire coastline is polluted by massive quantities of raw sewage that pour into the sea every day because of inadequate treatment facilities.[11] Israeli military operations in Gaza, including many incursions since the withdrawal of Israeli military forces, have inflicted massive damage on Palestinian infrastructure and agriculture. Between June and November 2006, damage amounted to US$75 million; in the preceding four years, the damage came to almost US$2 billion. More than half of this latter damage was to agricultural land razed by Israeli bulldozers; the remaining damage was to homes, public buildings, roads, water and sewage systems, electricity infrastructure, and telephone lines.[12]

In early 2008, UNRWA Commissioner General Karen Koning AbuZayd harshly condemned the international embargo and blockade of Gaza. The territory, she said, "is on the threshold of becoming the first territory to be internationally reduced to a state of abject destitution, with the knowledge, acquiescence and—some would say—encouragement of the international community."[13] Throughout this devastation, the killing in Gaza has been relentless. Against a total of 13 Israeli civilians killed in Palestinian Qassam rocket attacks from Gaza in the three and one-half years between mid 2004 and the end of 2007,[14] the number of Palestinians killed in a much shorter period—from the beginning of 2006, when Hamas was elected and Israel began to concentrate its force on

Gaza, through September 2008—was over 1,400, the vast majority in Gaza. This is a kill ratio of more than 100 Palestinians to every one Israeli. Approximately 20 percent of the Palestinians killed were children.[15]

Few understand the full extent of Gaza's profound distress, or care. Fewer still understand that this distress is almost totally a deliberate creation. The "grinding daily ramifications," as journalist Amira Hass puts it,[16] of Gaza's misery—not only the economic and political ramifications but, more critically, the social and psychological implications—are so disastrous as to be impossible to fathom. In explaining the particular poignancy of Gaza's destitution, Hass described Gaza as "a profoundly Israeli creation," a small piece of land, filled with people who were forced from their own villages in 1948, that starkly demonstrates the "central contradiction of the State of Israel—democracy for some, dispossession for others." Gaza, she remarked, "is our exposed nerve."[17] Although written a dozen years ago, Hass's words are even more apt today.

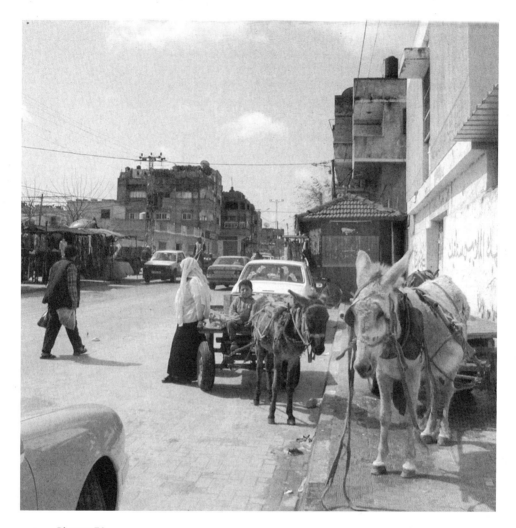

Picture 51
Donkey carts are ubiquitous throughout Gaza. In 2003, before the international
embargo imposed on Gaza as a result of Hamas's victory in legislative elections in
2006 dramatically worsened the situation, Gaza was already sunk in poverty.
Donkey carts were only slightly less numerous than cars, and outdoor flea markets
such as this one in the Jabalya refugee camp selling old clothing were common.

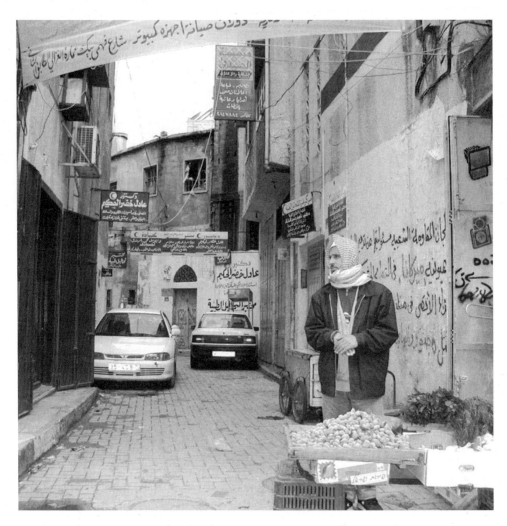

Picture 52
Graffiti adorns walls everywhere in Gaza. This man sells almonds, garlic, and parsley from a stand in a colorful alleyway on a windy, overcast day.

7

"It's a pity I don't have a stepladder"

Throughout the travels in Palestine described here, we have only touched the surface of Palestinian suffering. Gaza is sunk in unbelievable misery, but we have seen very little of it. Israel holds over 9,000 Palestinian political prisoners—11,000 by some calculations[1]—but we have not visited them or seen the conditions in which they languish. *Haaretz* correspondent Gideon Levy has for years written heartbreaking stories of the wretched circumstances of Palestinians besieged and assaulted by Israeli settlers, of Palestinians shot and paralyzed by Israeli soldiers, of Palestinian residential areas bombed and shelled with heavy civilian deaths, of bereaved Palestinian families mourning the murder of children, but we have seen only a fraction of what he describes. And the killing goes on relentlessly, at an overall ratio of almost five Palestinians killed for every one Israeli killed since the start of the second *intifada* in September 2000 and at markedly higher ratios, sometimes approaching 100 to one, during the last several years,[2] but we have witnessed none of this killing.

Nonetheless, we have seen enough to recognize severe oppression. Everywhere we have gone, we have run up against clear evidence of Israel's intention never to let go, never willingly to relinquish

Jewish control, never to allow the Palestinians real independence and sovereignty. Indeed, although political intentions and long-range political strategies are not usually so clearly laid out that one can see them in tangible ways, Zionism's long-term goal of ultimately bringing all of Palestine's land and resources under Jewish dominion is so transparent that it is possible to see it in concrete form during one intensive visit. When you have seen the vast extent and the permanence of Israeli settlements throughout the West Bank and East Jerusalem; when you have watched the Separation Wall (an artifact of occupation that is concrete in both the literal and the figurative sense) tear Palestine apart and slash through Palestinian land and lives; when you have endured the checkpoints that squeeze and confine Palestinians and stop any hope of Palestinian economic development in its tracks; when you have watched homes, the very center of people's lives, being demolished for no other reason than that their owners are not Jews; when even inside Israel you have seen the homes and villages of Palestinians and Palestinian Bedouin who are citizens of Israel being destroyed because they stand in the way of Jewish development and expansion—when you have seen all these things, it is crystal clear that Zionism's design is absolute Jewish control over the entirety of a Palestine swept clean of Palestinians.

The analogy is often made between the Israeli occupation and South Africa's apartheid regime. This comparison is apt in a great many respects, particularly in the personal degradation and near helplessness of each of the oppressed populations. During hearings of the post-apartheid Truth and Reconciliation Commission in South Africa in the mid 1990s, an illiterate shepherd gave a poignant account of what he considered the destruction of his life following the invasion of his home, his space, by white police.

The vivid picture he painted provides a near-perfect analogy to the overall Palestinian situation, particularly to Zionism's invasion and vandalization of Palestine, and to the personal vulnerability of Palestinians living under Israeli occupation. South African journalist Antjie Krog recorded the shepherd's account in her searing book on the commission proceedings, *Country of My Skull*. Unable adequately to convey a sense of the loss he felt at the ransacking of his home and the injury to his family and its humiliation, the shepherd lamented that "it's a pity I don't have a stepladder" so that the commission could get a bird's-eye view of his house and understand what he had endured. A ladder, Krog interpreted, would give the commission "a perspective on the impossible." It would "give the Truth Commission insight; it would raise his story from one plane to another, from the unreal to the real, from incomprehension to full understanding."[3]

This story is a metaphor for all oppression and the misery under which all oppressed peoples live, so often in silence and isolation, away from the view and the comprehension of a world at best indifferent, at worst allied with the oppressor. This is nowhere more true than with respect to the oppression Palestinians experience and have been experiencing for 60 years and more, since Zionism set its sights on their land and determined to empty it of Palestinians. Like the shepherd, Palestinians strive to give the world "a perspective on the impossible," to show the world that the Israel it sees is not the tiny country or the innocent or the benign Western democracy of popular propaganda, but an oppressive occupier bent on destroying the Palestinians as a nation.

As the journalist Jonathan Cook has concluded, "the gradual ethnic cleansing of the Palestinians from their homeland, on both sides of today's Green Line," has been "the consistent goal of Israeli

policy towards the Palestinians over several decades," not just since 1967 but since 1948. Israel "has turned the increasingly confined spaces left to the Palestinians not only into open-air cages but also into laboratories where experiments to encourage Palestinian despair, and ultimately emigration, are being refined."[4] Because these experiments and strategies are hidden behind Israel's image as a plucky little Western democracy fighting for its survival and because the United States supports and ultimately enables Israel's actions with its massive provision of aid and its unquestioning political support, there will be nothing to stop the ethnic cleansing—and, as Cook notes, it will take place "with few witnesses to record it"[5]—unless the Palestinians have a stepladder that will "raise their story from the unreal to the real" and bring its horrors home to the comprehension of the world.

<div align="center">଼ ଼</div>

The occupation—an illegal, oppressive system intended from the beginning to extend Israel's dominion over all of Palestine by enfolding the occupied territories under its permanent control—has grown even more oppressive, and increasingly so, over the two decades since the Palestinians, Israel, and the United States began the more or less serious pursuit of a peace process meant to lead to some kind of permanent solution. Indeed, it is ironic—although, in light of Israel's long-term intentions, not surprising—that Israel has stepped up its oppressive actions in direct relation to the perceived likelihood that it might be forced, by US pressure or the pressure of Palestinian concessions, to relinquish territory.

As is now widely known but was virtually unnoticed at the time, Israel almost doubled the number of settlers in the West Bank, Gaza,

and East Jerusalem in the seven years between the September 1993 signing of the Oslo Accords and the collapse of the peace process at the Camp David summit in July 2000. During this same period, while Israel and the United States led the world to believe that progress was being made toward a just resolution of the conflict, construction began on the network of Israeli-only roads throughout the West Bank, and the pervasive system of permits and checkpoints that severely restrict Palestinian freedom of movement and confine Palestinians to small, disconnected segments of territory was established. As historian Rashid Khalidi has observed, during the administrations of Presidents George Bush the elder and Bill Clinton, the United States allowed Israel "to help itself to huge bites of the pie that the two sides were supposed to be negotiating about."[6]

The expansion of settlements and the movement restrictions were not measures to enhance Israeli security but a concerted effort to stake out as much of the occupied territories for permanent Israeli control as possible in anticipation of a peace agreement that might demand a substantial Israeli withdrawal. For the first 20 years of the occupation—from June 1967 until the start of the first *intifada* in late 1987 and the peace process that followed—Israel ran the occupied territories with a relatively unobtrusive military presence and only nominal control of Palestinian infrastructure. During these years, Palestinian resistance was minimal and pressures on Israel to withdraw were all but non-existent, so that Israel could expand its own presence virtually unimpeded but had no thought of restricting Palestinians' freedom of movement because it was thought that they posed no direct threat to continued Israeli domination.

It was not until the first *intifada* that Palestinians began to experience, in direct response to their engagement in non-violent resistance, what one commentator has called a "hovering occupation,"

and only during the Oslo peace process did the oppressive, specifically military occupation of the territories begin. At the very time that it was supposed to begin negotiating a withdrawal from the occupied territories, Israel not only vastly expanded settlement construction but also ringed Palestinian towns with bypass roads, checkpoints, and military observation posts, instituted a regime of permits and closures, and established Israeli tank emplacements and other forward positions outside Israeli West Bank military bases, primarily in settlements throughout the territory.[7]

Israeli scholar Neve Gordon, studying Israel's modes of control throughout the 40 years of the occupation, has observed that during the first two decades, Israel actually introduced measures to improve the Palestinian population's standard of living—all in an effort specifically to "normalize" the occupation and undermine any Palestinian national impulses and any progress toward economic self-sufficiency. By contrast, Gordon demonstrates, in the second two decades, since the first *intifada* and particularly since the second, Israel has lost interest in controlling the Palestinian population—as opposed to Palestinian land—and has deliberately suspended application of law in the occupied territories, deliberately enhancing the circumstances in which Palestinians can be killed, through extrajudicial executions and wanton shooting by Israeli security forces. Whereas formerly Israel managed the population by bringing it some measure of security and Palestinian civilian deaths were considered inimical to Israel's interests, in recent years Israel has deliberately made insecurity prevalent and Palestinians have been rendered expendable.[8]

It was clearly no accident that the occupation's increased severity, and Israel's moves to consolidate its control and render Palestinian political and economic development impossible, began at precisely

the moment, at the start of the peace process, when the serious possibility arose that Israel might lose total control. Although the first *intifada* convinced Israeli Prime Minister Yitzhak Rabin that continued total occupation of the Palestinian territories was untenable and persuaded him to engage in negotiations to devise new ways of managing the occupation, neither Rabin nor anyone else in the Israeli leadership was prepared to grant the Palestinians real independence in a truly sovereign, viable, and contiguous state or to give up the Israeli settlements or the system of control that had turned the Palestinian territories into an Israeli domain. Neither did the United States, acting as a mediator and so-called honest broker in the peace process, press for Palestinian statehood. No part of the Oslo agreements committed Israel to withdraw from the occupied territories or to permit establishment of a Palestinian state, and every Israeli move throughout the Oslo years was designed to enhance its control rather than prepare the way for relinquishment of that control. Indeed, it was in this period, with the delineation of areas of Palestinian semi-autonomy and areas of differing levels of Israeli control, that the occupied territories—what remained of pre-1948 Palestine—were shattered into a myriad of small pieces in order to accommodate Israel's long-term intention to retain dominion over all of Palestine.

It was also during this period, heralded as ushering in a new era of peace and coexistence, that Israeli officials, led by Ehud Barak, who served initially as IDF chief of staff and later as prime minister, began to think about and design the Separation Wall as a further means of cordoning off the Palestinians and limiting the amount of territory Israel might ever have to relinquish. During the entire 15 years beginning with the Oslo process through 2008, "peace" in Israeli terms came to mean not an equitable solution to

the conflict or meaningful compromise with the Palestinians and coexistence but, plain and simply, security for Israel's system of total control and impunity for every Israeli action toward that end. The United States willingly complied, looking away as Israel met each demand for concessions to the Palestinians with greater violations of Palestinian freedoms and rights.

Each step toward total, unchallenged Israeli domination over Palestinian territory has been enabled and facilitated by US acquiescence and international silence, so that human rights violations that would not have been possible a decade or two decades ago are accepted today as commonplace, or are simply not noticed by an uncaring world. Each step makes the next, more brutal step easier. Settlement expansion begun when the Oslo process began in 1993—and made possible because the United States chose to acquiesce—gave Israel an impunity it had never previously enjoyed. Thus, by the administration of the younger President Bush, Israel enjoyed virtual total license to continue its expansion and step up its oppressive actions and had gained almost total US support for moves that would never have been possible even during the permissive era of President Ronald Reagan.

Impunity is its own perpetuator. A mindset has been created in which Israel is increasingly seen as part of "us" and Palestinians are increasingly seen as barbaric terrorists—an image further enhanced on both sides by the events of September 11, 2001 and the so-called "clash of civilizations" that the United States and Israel have promoted since then. This mindset creates a situation in which every Israeli action is automatically sanctioned or at least winked at, which makes acceptance of each additional Israeli step that much easier—the geopolitical equivalent of the usually rueful lament that

if you give this bully or that obstreperous child an inch, he will take a mile.

Israel has taken a mile and more. Impunity means that Israeli settlers rampage through Palestinian villages—assaulting farmers in their fields, burning olive groves, poisoning sheep herds—while Israeli security forces stand by and do nothing.[9] Impunity means that soldiers can shoot Palestinians without provocation, humiliate and abuse Palestinians at checkpoints, terrorize Palestinians in their homes with little fear of being prosecuted or disciplined.[10] Impunity means that Israeli leaders feel free to thumb their noses at US demands and initiatives. Such is the continuing power of the Israel lobby in US politics.

Indeed, despite continued talk by US leaders of "two states living side by side in peace" and despite continued negotiations by Israeli and Palestinian leaders, Israel no longer feels the need, and is not required by the United States, even to play the charade of seeking two states. Recent Israeli prime ministers, including particularly Ehud Olmert, have talked loosely of two states, but they have made no effort to hide the reality that the Palestinian "state" they might be persuaded to concede would be no state at all—an entity with no capital, no territorial contiguity, no international borders, and no sovereignty or independence, something akin to the collection of enclaves depicted in Map 3. Ultimately, like most Israeli leaders, Olmert believed, and trumpeted the belief, that all of Palestine belongs to Israel. Shortly after his election in March 2006, Olmert announced to a joint session of the US Congress that he had always strongly believed in the Jewish people's "eternal and historic right to this entire land."[11] Throughout his term, he went out of his way to snub demands that settlement expansion cease. Construction of housing units in settlements increased dramatically in the months

immediately following the November 2007 Annapolis summit, in a direct and unabashed affront to specific requests by the Bush administration for a settlement freeze. Dror Etkes, a veteran Israeli settlement monitor, who tracked settlements for Peace Now for years and now works for the human rights group Yesh Din, stated bluntly in mid 2008 that the settlements are deliberately intended to be "the nail in the coffin of any future peace agreement with the Palestinians. Their purpose is to make a Palestinian state unviable."[12]

Other Israeli officials have been even blunter than Olmert in making known their disdain for Palestinian rights and for any possibility of permitting genuine Palestinian independence and sovereignty. Dov Weisglass, adviser to former Prime Minister Ariel Sharon, famously remarked in October 2004 that he and Sharon had worked together with the United States to use the Gaza "disengagement"—eventually completed unilaterally in September 2005—to place the peace process and negotiations with the Palestinians in "formaldehyde." What he had agreed to with US officials, he said, was

the freezing of the political process. And when you freeze that process you prevent the establishment of a Palestinian state and you prevent a discussion about the refugees, the borders and Jerusalem. Effectively, this whole package that is called the Palestinian state, with all that it entails, has been removed from our agenda indefinitely.

The United States was fully aware of and cooperated in Weisglass's schemes and in general has always sympathized with Israel's long-term agenda. The freezing of the peace process and all that this entailed was accomplished, Weisglass gloated, "with a [US] presidential blessing and the ratification of both houses of Congress."[13]

Moshe Ya'alon, who served as IDF chief of staff for three critical years during the al-Aqsa *intifada* and had once referred

to Palestinians as a cancer posing an existential threat to Israel, graphically described what is Zionism's bottom line—its ultimate intent for the Palestinians and the end result of six decades of ethnic cleansing, land confiscation, settlement building, and other brutalities. "The Palestinians," Ya'alon decreed, "must be made to understand in the deepest recesses of their consciousness that they are a defeated people."[14]

The US-Israeli partnership, forged over the decades of Israel's existence and greatly consolidated during the administration of the younger President Bush, has actively sought to destroy Palestinian society and culture, as well as Palestinian national aspirations— in short, to impress on the Palestinians that they are a "defeated people." The basic Israeli intent, as described by Dror Etkes, to make any Palestinian state unviable is clearly known to and supported by US officials. Indeed, as Weisglass makes clear, this goal has been actively encouraged by the most prominent neoconservative policymakers of the Bush administration, who have long advocated overturning any peace process that would necessitate Israeli territorial concessions.

Elliott Abrams, who served as principal Middle East adviser on the National Security Council staff throughout the administration of the younger Bush, has long been on record as opposing any Israeli concessions to Palestinian independence and statehood and was one of Dov Weisglass's principal US cohorts in placing the peace process with the Palestinians in "formaldehyde." Other prominent neoconservatives came into the Bush administration with a similar clear anti-Palestinian agenda, including a paper trail of advice to Israeli leaders urging that the peace process be terminated, that Israel avoid making territorial concessions and, in broader terms, that Israel and the United States cooperate to "transform" the entire

Middle East by pursuing any states, such as Iraq, Syria, and Iran, that might pose a military threat to Israel. The fact that the United States ultimately carried out most of these policies, launching wars in Iraq and Afghanistan and totally undermining any prospect of a just and equitable solution to the Palestinian-Israeli conflict, is testimony to the strength of the US-Israeli partnership and the strong influence of the Israel lobby in the United States.[15]

The United States has a dark history of brutality with its own native population to match Israel's oppression of the Palestinians—a history in which successive US governments sought to destroy, and ultimately succeeded in destroying, the independent societies and cultures of Native Americans. This history has not been lost on Israel and its supporters. In response to criticism of Israel and its treatment of the Palestinians, strong friends of Israel in the United States frequently recall this US history as a means of justifying Israeli actions. We have often had this experience, as have others who defend Palestinian rights. One acquaintance, a strong supporter of Israel, expressed the view that Israel ought to be able easily to "take care of" the Palestinians the way the United States "took care of" the Indians. Another, writing a letter to the editor complaining about those who speak out for Palestinians and defending Israel's actions because it is a "tiny, vulnerable" nation, observed that many peoples in history, including the Native Americans, have been dispossessed— an historical phenomenon so common as to be banal, in the words of yet another friend of Israel. Many Israelis themselves take the fate of Native Americans as a model for Israel's behavior. Israeli historian Benny Morris, in a highly publicized interview in 2004 in which he explicitly justified the 1948 ethnic cleansing of the Palestinian population, contended that "the great American democracy could not have been created without the annihilation of the Indians."[16]

Terms like "annihilation," "ethnic cleansing," "genocide," "holocaust" are increasingly being used by serious scholars to describe the fate Israel and its US enabler envision for the Palestinians. Indeed, the history over the last almost century of domination by successive colonial administrations—including British, Jordanian, and particularly Israeli—that were bent at their most benign on suppressing any Palestinian impulse toward independence and most ominously on actively expelling the Palestinians and destroying their society would not seem to bode well for the Palestinians' future. Israel and the United States enjoy what can only be called, in the context of the Palestinians' own impotence, overwhelming power. It is also clear that the Palestinians can expect little help in their struggle for independence—no intercession and certainly no justice—from any other external source. European and Arab government leaders are so eager to accommodate the United States that no help will come from the so-called international community or even from the Arab world. European and Arab *peoples* may display more sympathy for Palestinians than do their governments, but the sympathy is unlikely to translate into meaningful action.

But if there is little prospect that Palestinians will find significant help from others, there is also little prospect that they will surrender or disperse. As the journalist Khalid Amayreh told us, the Palestinians "have existed despite history, despite everything Zionism has done to us and despite Zionism's goals." And they will continue to exist—on the land this time, refusing to be scattered as they were in 1948. Ultimately, as Hanan Ashrawi also told us, the land is the Palestinians' source of self-value, and they will not abandon it or surrender. Zionism can shatter Palestine itself into pieces, and has, but the land will survive. There is little likelihood that Zionism can shatter the Palestinian people by scattering them again. They know

that they would not survive another scattering, and they will resist this to the end. They also know that they hold a significant long-term advantage, by the mere fact of their numbers—an advantage, it must be noted, that many other indigenous peoples preyed upon by colonial settlers, including the Native Americans, never had.

There are increasing signs, however, that the Palestinians will no longer be content, as has so often been the case in the past, simply to wait for a new stage of history to roll around. Palestinian civil society is increasingly speaking out, to express in clear, well thought out language and actions their refusal to continue submitting to Israeli and international terms of discourse and to Israeli schemes for domination. Several grassroots organizations have sprung up in the last few years to oppose the Separation Wall, to organize non-violent protests against the Wall and other Israeli human rights violations, to promote boycott-divestment-sanctions actions against Israel and Israeli products, to insist on the Palestinians' right of return, and in particular to oppose the PA's continued accommodation to Israel and its continued willingness to manage the occupation on Israel's behalf—always "negotiating" with Israel, always working to ensure Israel's security, but never achieving independence for the Palestinians or any progress toward freedom from Israeli domination.

After 20 wasted years of adherence to the two-state formula, thoughtful Palestinians are increasingly debating the wisdom and practicalities of alternative options, particularly a one-state option that could take the form of either a binational state or a democratic, non-sectarian state in which both Palestinians and Jews would live as equal citizens with equal rights and equal access to the reins of government. These discussions have begun to flourish both inside Palestine and in the Palestinian diaspora in online forums and in

discussion groups among academics, activists, and others across the spectrum of Palestinian society.[17]

A leading example of Palestinian strategic thinking is a lengthy paper published in August 2008 that outlines a proposed strategic reorientation by Palestinians and a new path toward ending the occupation and forcing Israel to stop delaying and begin negotiating seriously for an equitable solution. The paper, entitled "Regaining the Initiative: Palestinian Strategic Options to End Israeli Occupation," was published by a group of 45 Palestinian civil society activists, academics, and business people from inside the occupied territories, inside Israel, and in the Palestinian diaspora. Called the Palestine Strategy Study Group, these Palestinian thinkers declare that, after 60 years of dispossession and 20 years of fruitless negotiation for a Palestinian state based on the PLO's historic initiative in 1988 recognizing the existence of Israel inside its 1967 borders, "it is time for Palestinians to reconsider this entire strategic path to their national objectives." Stating bluntly that Israel "is not a serious negotiating partner," the paper lays down a political ultimatum, declaring that, if Israel continues to refuse to negotiate seriously for a genuine two-state solution based on withdrawal to the 1967 borders, Palestinians must make it clear that Israel bears full responsibility for the failure of negotiations. If Israel will not negotiate seriously for two states, Palestinians "can and will" change course and shift their focus to pursuing a single-state option.[18]

The particular significance of this paper and other emerging strategic debates among Palestinians is that the Palestinian authors have shown the assertiveness to speak out in frank language that challenges the assumptions of the usual Israeli-US discourse and challenges their own leadership to stand up to that discourse. They have taken the political offensive, asserting Palestinian rights rather

than simply going along with demands to accommodate Jewish/
Israeli rights. By defining a Palestinian discourse and affirming the
necessity of dealing with Palestinians in terms of this discourse,
and by challenging Israel to negotiate now on reasonable terms or
finally forfeit the chance—a chance it has had for 20 years—for
a genuine two-state solution that would preserve the existence
of a "Jewish" state while giving the Palestinians a decent state
of their own, these Palestinians have taken the initiative as few
Palestinians ever have in the long and thus far failed struggle for
national self determination.

The Palestinians know that justice is on their side. This is not an
automatic guarantee of success or even of survival, but it provides
a great advantage in the national struggle. An open letter written in
2008 by one bereaved Palestinian father to another clearly showed
in which direction the scales of justice tip in this conflict. Bassam
Aramin, whose ten-year-old daughter Abir was shot in the head
and killed by IDF soldiers as she left school in the village of Anata
in January 2007 and who later co-founded a Palestinian-Israeli
organization of former combatants called Combatants for Peace,
wrote to Hisam Musa, whose ten-year-old son Ahmad was shot in
the head in the village of Ni'lin in August 2008 as he attempted to
move a coil of razor wire during an anti-Wall protest. Noting that
when he heard of Ahmad's death he experienced "that relentless
feeling of powerlessness that I know too well," Aramin wrote to
Musa that ultimately the Palestinians have a powerful weapon on
their side.

We Palestinians cannot protect our children from being killed.... [But] we will
never lay down our arms. For despite the advanced military technology and
deadly force that we face, it is we who possess the most dangerous weapons

of all. These are the weapons of morality and justice. We will not surrender these in the face of brutality.... We do not seek revenge. Justice for our beloved, dead children will not be served by the murder of a young Israeli girl in front of her school, or by the murder of a young Israeli boy by a bullet to the head. We will refuse to mirror the violent means of the occupation. You and I, and every Palestinian, must let our morals and our humanity and the teachings of our great faith be our guides.[19]

This is a credo for Palestinian survival. And, as Aramin told Musa, there are "thousands" of Israelis "who feel it is their moral, and human, duty to stand with us." These Israelis and some few anti-war, anti-occupation activists from around the world can provide the stepladder that will ultimately bring the rest of the world from incomprehension to full understanding of what is happening in Palestine.

The alternative is an outbreak of that "frozen rage" that Khalid Amayreh speaks of. A decade and a half ago, after Israel had partially withdrawn its military forces from the Palestinian towns and refugee camps of Gaza as the first step in the Oslo process, a Palestinian refugee living in one of those Gaza camps told British journalist Graham Usher that he felt like a man who had lost a million dollars—meaning the home and land he and his family had when he was forced out by Israel in 1948—and had just been given ten dollars. "But, you see," he explained, "I lost the million dollars a long time ago. So I will keep the ten. We cannot go on the way we are. I accept, I accept, I accept. After so much bloodshed, I accept. But, please don't ask me how I feel." Usher recounted this conversation in an essay entitled, significantly, "Why Gaza Says Yes, Mostly."[20]

As this man explained, after decades of exile and bloodshed, most Palestinians were willing, if reluctantly, to accept the

monumental compromise represented by Oslo. But now, 15 years later, Palestinians are increasingly coming to realize that they are unlikely even to receive ten dollars, that Israel intends, and has always intended, to keep all that it has taken—all of Palestine. More and more Palestinians—frustrated, enraged, knowing that justice is on their side and, indeed, aware that demographics are on their side—are unwilling to settle for whatever coins Israel and the United States might give them and are demanding to live as free, equal citizens in the entirety of their own land.

NOTES

PREFACE

1. Jeffrey Goldberg, "Obama on Zionism and Hamas," *The Atlantic* (12 May 2008), http://jeffreygoldberg.theatlantic.com/archives/2008/05/obama_on_zionism_and_hamas.php (date last accessed, 23 November 2008).
2. Gideon Levy, "Born in Sin," *Haaretz* (21 November 2008).
3. Tony Karon, "Waltzing With Ariel: Will Obama, Too, Indulge Israeli Rejectionism?" *Rootless Cosmopolitan* blog (4 February 2009), http://tonykaron.com/2009/02/04/waltzing-with-ariel-will-obama-too-indulge-israeli-rejectionism (date last accessed, 14 February 2009).

INTRODUCTION

1. Cited in Office of the Special Envoy to Monitor and Combat Anti-Semitism, US Department of State, *Contemporary Global Anti-Semitism: A Report Provided to the United States Congress* (Washington, DC: US Department of State, March 2008), p. 38. The statement was made as part of a podcast series entitled "Voices on Anti-Semitism."
2. See Ilan Pappe, *The Ethnic Cleansing of Palestine* (Oxford: One World, 2006). The book, in Pappe's words, explores "both the mechanism of the 1948 ethnic cleansing, and the cognitive system that allowed the world to forget, and enabled the perpetrators to deny, the crime the Zionist movement committed against the Palestinian people in 1948." See p. xvi.
3. Ilan Pappe, "State of Denial: Israel, 1948–2008," *The Link* (April–May 2008), p. 3.
4. *Sunday Times* (of London) (15 June 1969).
5. See, for instance, Tanya Reinhart, *Israel/Palestine: How to End the War of 1948* (New York: Seven Stories Press, 2002); Jeff Halper, *An Israeli in Palestine: Resisting Dispossession, Redeeming Israel* (London: Pluto Press,

2008); and Jonathan Cook, *Disappearing Palestine: Israel's Experiments in Human Despair* (London: Zed Books, 2008).

6. For a detailed study of the way in which the Palestinians' situation has been dealt with, and largely ignored, in US policymaking circles from the mid nineteenth century through the twentieth century, see Kathleen Christison, *Perceptions of Palestine: Their Influence on U.S. Middle East Policy* (Berkeley, CA: University of California Press, 2001).

7. Walid Khalidi, "Introduction," in Walid Khalidi, ed., *From Haven to Conquest: Readings in Zionism and the Palestine Problem Until 1948* (Washington, DC: Institute for Palestine Studies, 1987), pp. xxi, xxiii–xxiv.

8. Gershom Gorenberg, *The Accidental Empire: Israel and the Birth of the Settlements, 1967–1977* (New York: Times Books, 2006), p. 124.

9. The so-called autonomous areas marked on this Carta map appear to coincide approximately with the land designated as Area A under the Oslo agreements of the 1990s. For a few years before the Oslo process collapsed, Palestinians enjoyed administrative and security control in Area A, which was largely limited to Palestinian cities and included only approximately 12 percent of the West Bank. This Carta map nowhere marks the border between Israel and the West Bank and labels several Palestinian localities by their Hebrew names. Neither, among all of the roads and terrain features marked on the map, does the massive Separation Wall appear.

10. Halper, *An Israeli in Palestine*, pp. 164–5.

11. Yariv Oppenheimer, "Settlement Bloc Expansion is the Most Destructive," *Bitterlemons.org* (7 April 2008), http://www.bitterlemons.org/previous/bl070408ed14.html (date last accessed, 27 October 2008).

12. Jean Zaru, "Theologising, Truth and Peacemaking in the Palestinian Experience," in Michael Prior, ed., *Speaking the Truth: Zionism, Israel, and Occupation* (Northampton, MA: Olive Branch Press, 2005), p. 168.

13. See Greg Philo, Mike Berry, and the Glasgow University Media Group, *Bad News From Israel* (London: Pluto Press, 2004). The poll result among British students appears on pp. 217–18.

14. Howard Friel and Richard Falk, *Israel-Palestine on Record: How the* New York Times *Misreports Conflict in the Middle East* (London: Verso, 2007). Quotes are from pp. 2 and 4. Analyst and commentator Alison Weir has also produced several short-term studies of media coverage in the United States, which can be viewed on her website, www.ifamericansknew.com. One of Weir's studies, detailing significant disparities in reporting Palestinian versus

Israeli casualties by several media organs during the first few years of the second *intifada*, is "The Coverage—and Non-Coverage—of Israel-Palestine," *The Link* (July–August 2005).

15. Raja Shehadeh, *Palestinian Walks: Forays into a Vanishing Landscape* (New York: Scribners, 2008), pp. 100, 103, 108.

16. Kathleen and Bill Christison, "Palestinians: Long-Term Hopefulness Still Dominates: An Interview with Hanan Ashrawi," *Counterpunch* (25 March 2003), http://www.counterpunch.org/christison03252003.html (date last accessed, 27 October 2008).

17. Linda Mamoun, "A Conversation with Richard Falk," *The Nation* (17 June 2008), http://www.thenation.com/doc/20080630/mamoun (date last accessed, 12 September 2008).

1 THE OCCUPATION IN MICROCOSM: AN OVERVIEW

1. The Israeli human rights organization, B'Tselem, puts the population at 170. It is likely that some residents left in the years after confiscations, home demolitions, and construction of the Separation Wall began. For a B'Tselem report on the village situation, see "Israel Isolates Numan Village from Both Jerusalem and the West Bank," B'Tselem (22 February 2008), http://www. btselem.org/english/jerusalem/20080222_numan.asp (date last accessed, 27 October 2008).

2. Following its capture of East Jerusalem and the West Bank from Jordan in the June 1967 war, Israel annexed East Jerusalem and expanded its municipal boundaries by incorporating 72,000 dunams (72 square kilometers or approximately 28 square miles) of West Bank territory on the north, east, and south of the city. This boundary expansion increased the area of Arab East Jerusalem more than tenfold. To the south, the expansion reached to the city limits of Bethlehem and in the process placed Numan inside the Jerusalem city limits. See Michael R. Fischbach, "Jerusalem," in Philip Mattar, ed., *Encyclopedia of the Palestinians* (New York: Facts on File, 2000), p. 214, and B'Tselem, "Israel isolates Numan."

3. B'Tselem, "Israel Isolates Numan."

4. Foundation for Middle East Peace, *Report on Israeli Settlement in the Occupied Territories* (July–August 2007), p. 6. Housing units totaling 1,500

would accommodate an estimated 6,000 people; another 3,700 units would accommodate an estimated additional 15,000.

5. Isabel Kershner, "Israel Rejects Hamas Overture, and Presses Housing Construction," *New York Times* (24 December 2007).

6. Akiva Eldar, "The Har Homa Test," *Haaretz* (10 December 2007).

7. B'Tselem, "Israel Isolates Numan."

8. John Quigley, *The Case for Palestine: An International Law Perspective* (Durham, NC: Duke University Press, 2005), pp. 178, 205. Although Israel is a signatory to this Geneva Convention, it has argued that the convention does not apply to occupied Palestinian territory because the territory was captured from Jordan and Egypt, which, as occupiers themselves, did not in Israel's view have proper de jure control over the West Bank and Gaza. The United Nations and various individual states have rejected this Israeli position.

9. International Court of Justice, "Advisory Opinion: Legal Consequences of the Construction of a Wall in the Occupied Palestinian Territory," Press Release 2004/28 (9 July 2004), http://www.icj-cij.org/docket/index.php?pr=71&code=mwp&p1=3&p2=4&p3=6&case=131&k=5a (date last accessed, 27 October 2008). For a thorough analysis of the ICJ ruling, see Norman Finkelstein, *Beyond Chutzpah: On the Misuse of Anti-Semitism and the Abuse of History* (Berkeley, CA: University of California Press, 2008), pp. 230–7. Finkelstein further analyzes the contrary view of the Wall's legality put forth by the Israeli High Court of Justice in two decisions on separate segments of the Wall. See pp. 237–70. The Israeli human rights organization B'Tselem has also analyzed the ICJ ruling. See B'Tselem, "Opinion of the International Court of Justice" (no date), http://www.btselem.org/english/Separation_Barrier/International_Court_Decision.asp (date last accessed, 27 October 2008).

10. B'Tselem, "Israel Isolates Numan," and Dan Izenberg, "High Court Ruling Keeps Palestinian Village In Limbo," *Jerusalem Post* (11 July 2008).

11. This story is recounted in Kathleen and Bill Christison, "Eyeless in Gilo: What Hillary Clinton Doesn't Know About Palestine," *Counterpunch* (5 January 2006), http://www.counterpunch.org/christison01052006.html (date last accessed, 27 October 2008).

12. Gideon Levy, "Dusty Trail to Death," *Haaretz* (23 December 2005).

13. *Ibid.*

14. Several Israeli, US, and UN organizations keep track of and issue frequent reports on Israeli settlements in the occupied territories; Israeli-only roads;

restrictions on Palestinian movement, including checkpoints, roadblocks, and travel terminals; and construction of the Separation Wall. For detailed information on the estimated 476,000 Israeli settlers and 232 settlements and outposts in the West Bank and East Jerusalem (as of late 2007), see the website of the Washington-based Foundation for Middle East Peace, http://www.fmep. org. The website of the Israeli organization Peace Now also carries extensive information on West Bank settlements, at http://www.peacenow.org.il/site/ en/peace.asp?pi=51 (date last accessed, 27 October 2008). One Peace Now report concludes that over 32 percent of land appropriated by settlements is actually privately owned by Palestinians. See Peace Now, "G-U-I-L-T-Y!: Construction of Settlements upon Private Land—Official Data" (March 2007), http://www.peacenow.org.il/data/SIP_STORAGE/files/6/2846.pdf (date last accessed, 27 October 2008). The Israeli human rights organization B'Tselem and a UN monitoring organization have issued reports on the network of limited-access, Israeli-only roads connecting settlements in the West Bank, as well as on the multitude of Israeli-imposed restrictions on Palestinian movement. See, for instance, B'Tselem, "Checkpoints, Physical Obstructions, and Forbidden Roads" (no date, c. late 2007), http://www.btselem.org/ english/Freedom_of_Movement/Checkpoints_and_Forbidden_Roads.asp (date last accessed, 28 October 2008); B'Tselem, "Ground to a Halt: Denial of Palestinians' Freedom of Movement in the West Bank" (August 2007), p. 13, http://www.btselem.org/Download/200708_Ground_to_a_Halt_Eng. pdf (date last accessed, 28 October 2008); and United Nations Office for the Coordination of Humanitarian Affairs (OCHA), *The Humanitarian Impact on Palestinians of Israeli Settlements and Other Infrastructure in the West Bank* (Jerusalem: July 2007), pp. 58–73. A B'Tselem report that contains links to pertinent international laws prohibiting restrictions on movement can be found in B'Tselem, "Restrictions on Movement" (no date), http://www. btselem.org/english/Freedom_of_Movement/ (date last accessed, 28 October 2008). With respect to the Separation Wall being constructed in the West Bank and around East Jerusalem, B'Tselem has issued a detailed report, with several subsections, on the Wall and its consequences for Palestinians. See B'Tselem, "Separation Barrier" (no date), http://www.btselem.org/english/ Separation_Barrier (date last accessed, 28 October 2008). See also OCHA, *The Humanitarian Impact on Palestinians*, pp. 46–53.

15. Amira Hass, "Israel Cuts Off Eastern West Bank from Rest of West Bank," *Haaretz* (13 February 2006), and OCHA, *The Humanitarian Impact on*

Palestinians, p. 105. Former Prime Minister Ariel Sharon initially planned to build a wall down the length of the Jordan Valley that would guarantee Israel's permanent control over this large territory and drafted a map of the planned route. Fearing a negative international reaction, the Israeli cabinet in early 2004 decided against building this section, but Sharon was reportedly still talking about the possibility of a wall in this area months later. See Ray Dolphin, *The West Bank Wall: Unmaking Palestine* (London: Pluto Press, 2006), p. 54. Jan de Jong, a geographer and land planning expert long based in Jerusalem, refers to a "security perimeter" established by Israel long ago to enclose and control the Jordan Valley. Characterizing this perimeter as more consequential than the Wall in the west of the West Bank in terms of the territory it encloses, de Jong observes that the perimeter incorporates extensive military training grounds barred to civilians, as well as agricultural areas attached to Israeli settlements, and leaves only minimal transportation corridors for the passage of people and goods. See Jan de Jong, "The End of the Two-State Solution: A Geo-Political Analysis," in Dr Mahdi Abdul Hadi, ed., *Palestinian-Israeli Impasse: Exploring Alternative Solutions to the Palestine-Israel Conflict* (Jerusalem: PASSIA—Palestinian Academic Society for the Study of International Affairs, 2005), p. 332.

16. See OCHA, *The Humanitarian Impact on Palestinians*.

17. Blair was appointed as special representative for the Quartet, made up of the United States, the United Nations, the European Union, and Russia, in July 2007. For a further report of his shocked and angry reaction to the Palestinians' situation in Hebron following a similar briefing by UN and other international representatives in that city, see Ian Black, "The Honeymoon is Ending on 'Mission Impossible,'" *Guardian* (13 October 2007).

18. These maps can be seen at OCHA, *The Humanitarian Impact on Palestinians*, pp. 19, 37, 41, 43, 45, 47, 51, 53, and 59.

19. Halper, *An Israeli in Palestine*, pp. 100, 195.

2 SETTLEMENTS AND THE SEPARATION WALL

1. Shehadeh, *Palestinian Walks*, pp. xvi, 158.

2. Henry Siegman, "Grab More Hills, Expand the Territory," *London Review of Books* (10 April 2008). In this article, Siegman reviews the following two books on the history and current status of the settlement enterprise, written

by Israelis: Gorenberg, *The Accidental Empire*, and Idith Zertal and Akiva Eldar, *Lords of the Land: The War for Israel's Settlements in the Occupied Territories, 1967–2007* (New York: Nation Books, 2007).

3. Cited in OCHA, *The Humanitarian Impact on Palestinians*, p. 124.

4. See Foundation for Middle East Peace, *Report on Israeli Settlement in the Occupied Territories* (November–December 2000), p. 2. In addition to 200,000 settlers in the West Bank and Gaza at the time the Camp David summit collapsed in July 2000, which constituted a doubling since 1993, the settler population of East Jerusalem stood at 170,000 in mid 2000.

5. Griff Witte, "Tiny Party Shows Large Clout on Settlements," *Washington Post* (2 April 2008), and Oppenheimer, "Settlement Bloc Expansion."

6. For a text of Bush's letter to Sharon, see *New York Times* (14 April 2004).

7. Glenn Kessler, "Israelis Claim Secret Agreement With U.S.," *Washington Post* (24 April 2008).

8. *Ibid.*

9. Figures for settlement population and geographic area can be found at the Foundation for Middle East Peace, "Settlements in the West Bank," http://www.fmep.org/settlement_info (date last accessed, 28 October 2008).

10. OCHA, *The Humanitarian Impact on Palestinians*, p. 36.

11. Oppenheimer, "Settlement Bloc Expansion."

12. Peace Now, "G-U-I-L-T-Y!," and Steven Erlanger, "West Bank Sites on Private Land, Data Shows [sic]," *New York Times* (14 March 2007).

13. B'Tselem, "The Water Crisis: The Gap in Water Consumption Between Palestinians and Israelis" (no date, c. 2006), http://www.btselem.org/english/Water/Consumption_Gap.asp (date last accessed, 28 October 2008); and OCHA, *The Humanitarian Impact on Palestinians*, p. 114.

14. Henry Siegman, "Tough Love for Israel," *The Nation* (5 May 2008), pp. 7–8.

15. As of late 2005, only 13 percent of all Israeli settlers lived in settlements lying east of the Separation Wall. See the "Statistics" link at B'Tselem, "Separation Barrier."

16. Cited in Dolphin, *The West Bank Wall*, p. x.

17. OCHA, *The Humanitarian Impact on Palestinians*, pp. 46 and 56 n. 33.

18. Graham Usher, "Introduction," in Dolphin, *The West Bank Wall*, pp. 9–13.

19. *Ibid.*

20. *Ibid.*

21. Halper, *An Israeli in Palestine*, p. 168.

22. Cited in Saree Makdisi, *Palestine Inside Out: An Everyday Occupation* (New York: W.W. Norton, 2008), p. 203.

23. Joel Kovel, *Overcoming Zionism: Creating a Single Democratic State in Israel/Palestine* (London: Pluto Press, 2007), p. 118.

24. Dolphin, *The West Bank Wall*, pp. 36–7.

25. Halper, *An Israeli in Palestine*, p. 169.

26. Dolphin, *The West Bank Wall*, pp. 38–9, 41.

27. B'Tselem, "Behind the Barrier: Human Rights Violations as a Result of Israel's Separation Barrier" (March 2003), pp. 26–8, http://www.btselem. org/Download/200304_Behind_The_Barrier_Eng.pdf (date last accessed, 28 October 2008). Even where the Wall has been completed, Palestinians are able to find ways around it and to avoid checkpoints in order to sneak into Israel to work. It is commonly known, according to one knowledgeable Israeli, that between 500 and 1,000 Palestinians find a way into Israel every week seeking work. Those who are caught and returned to the West Bank are reported on the radio news. Personal communication with Israeli source (14 May 2008).

28. Dolphin, *The West Bank Wall*, p. 45–6.

29. Mustafa Barghouti, "Palestinian Intifada—4th Anniversary: Summary of Press Conference," *Palestine Monitor* (27 September 2004), http://www. palestinemonitor.org.

30. Graham Usher, "Why Marwan Did Not Run," *The Nation* (10 January 2005).

31. Dolphin, *The West Bank Wall*, pp. 40–1.

32. This estimate, made in mid 2008 by the Adva Center, an independent Israeli think tank in Tel Aviv, put the cost of the Wall to that point at 13 billion Israeli shekels, the equivalent of US$3.9 billion at the June 2008 dollar-shekel exchange rate. Rory McCarthy, "Occupation Has Cost Israel Dear, Says Report," *Guardian* (4 June 2008).

33. B'Tselem, "Statistics" link at "Separation Barrier." For the population of East Jerusalem, see "PA Census: Nearly 4 Million Palestinians Live in West Bank, Gaza, East Jerusalem," *Haaretz* (10 February 2008), which reports the results of a census conducted by the Palestinian Authority and released in February 2008. The reported population figure for East Jerusalem was 208,000, a reduction of 2,000 from a census taken a decade earlier. Although many Palestinian political leaders challenged the new figure, the lower number

might be explained by the fact that large numbers of Jerusalem residents have moved outside the city in recent years because of rising living costs and are now blocked from the city by the Wall. The total population of the West Bank and East Jerusalem, according to this census, was 2.45 million.

34. OCHA, *The Humanitarian Impact on Palestinians*, p. 110.

35. Rory McCarthy, "One Wall, Two Very Different Views: Israeli Side: Alfe Menashe," *Guardian* (7 July 2008).

36. Amos Harel, "Israel Agrees to Raze Part of West Bank Separation Fence," *Haaretz* (28 July 2008), and Stop the Wall, "A Change in the Route of the Apartheid Wall Near Jayyus Sanctions the Land Confiscation," *StoptheWall. org* (28 July 2008), http://stopthewall.org/latestnews/1700.shtml (date last accessed, 28 October 2008).

37. OCHA, *The Humanitarian Impact on Palestinians*, pp. 110–12, and Abdul-Latif Khaled, "The 'Olive Branch' That Ought to Cross the Wall," *Christian Science Monitor* (21 December 2004).

38. Rory McCarthy, "West Bank: Desperate Battle for a Permit to Work Their Own Land: Palestinian Side: Jayyus," *Guardian* (7 July 2008).

39. Amira Hass, "IDF Redefines Palestinians East of the Fence," *Haaretz* (14 October 2003).

40. OCHA, *The Humanitarian Impact on Palestinians*, p. 111.

41. Makdisi, *Palestine Inside Out*, p. 25.

42. Cited in Ali Abunimah, *One Country: A Bold Proposal to End the Israeli-Palestinian Impasse* (New York: Metropolitan Books, 2006), pp. 33–4.

43. B'Tselem, "Jerusalem" link at "Separation Barrier."

44. OCHA, *The Humanitarian Impact on Palestinians*, p. 84.

45. B'Tselem, "Jerusalem" link at "Separation Barrier."

46. de Jong, "The End of the Two-State Solution," p. 331.

47. OCHA, *The Humanitarian Impact on Palestinians*, p. 86.

48. Usher, "Introduction," p. 29.

3 CHECKPOINTS, ROADBLOCKS, AND MOVEMENT IMPEDIMENTS

1. British journalist Jonathan Cook spent a day in 2007 observing several checkpoints, in the company of a woman from Machsom Watch, an organization of Israeli women who monitor the behavior of Israeli soldiers

at checkpoints. For a description of his experience, see Cook, *Disappearing Palestine*, pp. 168–79.

2. Steven Erlanger, "Israel Is Easing Barrier Burden, but Palestinians Still See a Border," *New York Times* (22 December 2005).

3. Gideon Levy, "Theater of the Absurd," *Haaretz* (16 December 2005).

4. Cited in Foundation for Middle East Peace, *Report on Israeli Settlement in the Occupied Territories* (March/April 2000).

5. For a description and pictures of the types of obstacles, see OCHA, *The Humanitarian Impact on Palestinians*, pp. 64–5.

6. See *ibid.*, p. 66, for a graph tracing the number of obstacles at periodic intervals between December 2003 and May 2007. For OCHA's report in April 2008, see OCHA, "Report No. 62: Implementation of the Agreement on Movement and Access and Update on Gaza Crossings (19 March–1 April 2008)" (30 April 2008), http://www.ochaopt.org/documents/AMA_62.pdf (date last accessed, 28 October 2008). For the total of 612 as of September 2008, see OCHA, "OCHA Closure Update (30 April—11 September 2008)" (29 September 2008), http://www.ochaopt.org/documents/ocha_opt_closure_update_2008_09_english.pdf (date last accessed, 28 October 2008).

7. OCHA, *The Humanitarian Impact on Palestinians*, pp. 57–74.

8. *Ibid.*, p. 124.

9. de Jong, "The End of the Two-State Solution," p. 333.

10. Dolphin, *The West Bank Wall*, p. 77.

11. Makdisi, *Palestine Inside Out*, p. 32. Makdisi deals extensively with the effect of the movement impediments on individual Palestinians, using stories gathered himself, as well as testimony gathered by B'Tselem. See pp. 34–57.

12. OCHA, *The Humanitarian Impact on Palestinians*, p. 104.

13. Makdisi, *Palestine Inside Out*, p. 58.

14. B'Tselem, "Ground to a Halt," p. 13.

15. Cited in Makdisi, *Palestine Inside Out*, pp. 61–2.

16. For the story, one of many, of a woman suffering a heart attack who died after Israeli soldiers refused to let a Palestinian ambulance through a checkpoint to enter her northern West Bank village, see B'Tselem, "B'Tselem Video: Heart Patient Dies After Soldiers Prevent Her Evacuation to Hospital, Feb '08" (11 June 2008), http://www.btselem.org/english/video/20080611_death_of_fawziyah_a_dark.asp (date last accessed, 28 October 2008).

17. Cited in Makdisi, *Palestine Inside Out*, p. 50.

18. Gideon Levy, "Dead on Arrival," *Haaretz* (19 September 2008).

4 HOUSE DEMOLITIONS AS SLOW ETHNIC CLEANSING

1. OCHA, "Lack of Permit Demolitions and Resultant Displacement in Area C" (May 2008), http://www.ochaopt.org/documents/Demolitions_in_Area_C_May_2008_English.pdf (date last accessed, 28 October 2008).
2. Meir Margalit, "2007 Report on House Demolitions," Israeli Committee Against House Demolitions (12 March 2008), http://www.icahd.org/eng/news.asp?menu=5&submenu=1&item=578 (date last accessed, 28 October 2008).
3. Halper, *An Israeli in Palestine*, p. 43.
4. *Ibid.*, pp. 41–53. For an enumeration of the numbers of home demolitions in each year between 1967 and 2006, see Appendix 1, "House Demolitions in the Occupied Territories since 1967," pp. 275–7. For a detailed study of the history and status of house demolitions in East Jerusalem, including the impact of the policy on individual Palestinians and their families, written by a former member of the Jerusalem City Council and former development specialist with the Jerusalem Municipality, see Meir Margalit, "No Place Like Home: House Demolitions in East Jerusalem," ICAHD (March 2007), http://www.icahd.org/eng/images/uploaded_admin_content/NoPlaceLikeHome_withCover.pdf (date last accessed, 28 October 2008).
5. Margalit, "No Place Like Home," pp. 46–51.
6. *Ibid.*, pp. 54–6.
7. Jonathan Cook, "Palestinians Face Home Demolitions Spree by Israel: The Struggle Against Jerusalem's Quiet Ethnic Cleansing," *Counterpunch* (1 August 2008), http://www.counterpunch.org/cook08012008 (date last accessed, 28 October 2008).
8. Margalit, "No Place Like Home," pp. 53–4, and Jeff Halper, *Obstacles to Peace: A Re-Framing of the Palestinian-Israeli Conflict* (Jerusalem: ICAHD, 2004), p. 38.
9. Halper, *An Israeli in Palestine*, p. 48.
10. For a description of this Israeli policy, see Cook, *Disappearing Palestine*, pp. 179–82.

5 TOWNS AND VILLAGES UNDER SIEGE

1. The video can be viewed at http://www.youtube.com/watch?v=vE3tHPwmnSQ (date last accessed, 28 October 2008).

2. Shehadeh, *Palestinian Walks*, p. 163.

3. Johann Hari, "Israel is Suppressing a Secret It Must Face," *Independent* (28 April 2008).

4. Kovel, *Overcoming Zionism*, p. 119.

5. Hari, "Israel is Suppressing a Secret." Hari was roundly criticized for this article and wrote a later commentary on the hate mail he received. "There was little attempt to dispute the facts I offered," he wrote. "Instead, some of the most high profile 'pro-Israel' writers and media monitoring groups … said I was an anti-Jewish bigot akin to Joseph Goebbels and Mahmoud Ahmadinejadh…. Any attempt to describe accurately the situation for Palestinians is met like this. If you recount the pumping of sewage onto Palestinian land, 'Honest Reporting' claims you are reviving the anti-Semitic myth of Jews 'poisoning the wells.' If you interview a woman whose baby died in 2002 because she was detained—in labour—by Israeli soldiers at a checkpoint within the West Bank, 'Honest Reporting' will say you didn't explain 'the real cause': the election of Hamas in, um, 2006. And on, and on." See Johann Hari, "The Loathsome Smearing of Israel's Critics," *Independent* (8 May 2008).

6. Ethan Ganor, "Holy Land or Living Hell: Pollution, Apartheid, and Protest in Occupied Palestine," *Earth First! Journal* (September/October 2005), http://www.earthfirstjournal.org/article.php?id=249 (date last accessed, 28 October 2008). For further information on the ecological damage in Palestine, see Kathleen and Bill Christison, "The Settlements and Their Sewage: Polluting Palestine," *Counterpunch* (24/25 September 2005), http://www.counterpunch.org/christison09242005.html (date last accessed, 28 October 2008).

7. For a further description of the situation in Bil'in, see Kathleen and Bill Christison, "Horror Story: Travels in Palestine," *Counterpunch* (19 September 2005), http://www.counterpunch.org/christison09192005.html (date last accessed, 28 October 2008). Major media organs have devoted very little attention to Bil'in and its ongoing peaceful protest against the Wall. After what is apparently only one visit to a weekly protest, *New York Times* correspondent Steven Erlanger absurdly described the protest as a bit of pleasant play-acting. "The Israeli Army and a crowd of protesters," Erlanger wrote in 2005, "squared off almost joyfully on Friday for their weekly tactical battle here over the construction of Israel's separation barrier, one of the closest spectacles the region provides to Kabuki theater." See Steven Erlanger,

"At Israeli Barrier, More Sound Than Fury," *New York Times* (8 October 2005).

8. Isabel Kershner, "Israeli Court Orders Barrier Rerouted," *New York Times* (5 September 2007).

9. Akiva Eldar, "Defense Ministry Yet to Start Court-Ordered Reroute of Bil'in Fence," *Haaretz* (24 April 2008), and Ghassan Bannoura, "Israeli Settlers and Army Started to Expand Illegal Settlement on Bil'in Land," *International Middle East Media Center* (26 May 2008), http://www.imemc. org/article/55064 (date last accessed, 28 October 2008).

10. B'Tselem, "Use of Firearms: 21 July 08: Following Exposure by B'Tselem, Military Police Investigate Shooting of Bound Palestinian" (21 July 2008), http://www.btselem.org/english/Firearms/20080721_Nilin_Shooting.asp (date last accessed, 28 October 2008).

11. Makdisi, *Palestine Inside Out*, p. 63.

12. Jonathan Steele, "Middle East: 'Almost Every Prisoner is Told to Get Money or Weapons,'" *Guardian* (29 July 2008), and Jonathan Steele, "Europe's Obama Cheers Ring Hollow in the Middle East," *Guardian* (25 July 2008).

13. OCHA, *The Humanitarian Impact on Palestinians*, p. 90.

14. "One-Room Houses in the Stories of Struggle and Hunger," *Palestine News Network* (19 July 2008), http://english.pnn.ps/index.php?option=com_conte nt&task=view&id=3202&Itemid=1 (date last accessed, 28 October 2008).

15. OCHA, *The Humanitarian Impact on Palestinians*, p. 90.

16. Gideon Levy, "The General of Onions and Garlic," *Haaretz* (13 July 2008). See also Palestine Media Center, "Israeli Troops on Rampage against Nablus Civilian Life," *Palestine Monitor* (9 July 2008), http://www. palestinemonitor.org/spip/spip.php?article514 (date last accessed, 28 October 2008), and "Israeli Forces Retreat from Decision to Close a Shopping Mall in Nablus," *Kuwait News Agency* (17 July 2008), http://www.kuna.net.kw/ NewsAgenciesPublicSite/ArticleDetails.aspx?id=1925688&Language=en (date last accessed, 28 October 2008).

17. Wafa Amr, "Trade Blossoms as Israel Eases Chokehold on Nablus," *Reuters* (17 September 2008), http://www.reuters.com/article/worldNews/idUSLF 15755420080917?sp=true (date last accessed, 28 October 2008); and Ali Jarbawi, "A Precarious Coexistence," *Bitterlemons* (22 September 2008), http://www.bitterlemons.org/previous/bl220908ed37.html (date last accessed, 28 October 2008).

18. See "I Made Them a Stadium in the Middle of the Camp," *Yediot Aharanot* (31 May 2002), translated by Israeli peace organization Gush Shalom.

19. For the personal accounts of Palestinian residents who lived through the siege of Jenin, see Ramzy Baroud, ed., *Searching Jenin: Eyewitness Accounts of the Israeli Invasion* (Seattle, WA: Cune Press, 2003). For a description of the siege, citing several media accounts, and a detailed analysis of media coverage of the siege and of Israeli conduct, see Kathleen and Bill Christison, "Confronting Israeli Myth-Making: Tempest in Santa Fe," Appendix 2, *Counterpunch* (22 June 2005), http://www.counterpunch.org/christison06222005.html (date last accessed, 28 October 2008). Additional accounts, with photographs, of Israel's Operation Defensive Shield throughout the West Bank, beyond the siege of Jenin, include Muna Hamzeh and Todd May, eds., *Operation Defensive Shield: Witnesses to Israeli War Crimes* (London: Pluto Press, 2003), and Suad Amiry and Mouhannad Hadid, eds., *Earthquake in April* (Ramallah: Riwaq—Centre for Architectural Conservation and The Institute of Jerusalem Studies, 2002).

20. David Rohde, "The Dead and the Angry Amid Jenin's Rubble," *New York Times* (16 April 2002).

21. Ethan Bronner, "A West Bank Ruin, Reborn as a Peace Beacon," *New York Times* (22 September 2008).

22. OCHA, *The Humanitarian Impact on Palestinians*, p. 96. The section on Hebron also includes several pictures and maps that further describe the situation; see pp. 95–100.

23. B'Tselem, "Hebron City Center" (no date), http://www.btselem.org/english/Hebron (date last accessed, 28 October 2008).

24. *Ibid.*

25. Foundation for Middle East Peace, "Testimonies of Soldiers on the Front Line," *Report on Israeli Settlement in the Occupied Territories* (May–June 2008), p. 6.

26. Donald Macintyre, "Our Reign of Terror, by the Israeli Army," *Independent* (19 April 2008).

27. Dolphin, *The West Bank Wall*, pp. 73, 75–6.

28. The previous mayor, Marouf Zahran, had noted that frustration with the situation was leading to social breakdown and to a rise in support for groups like Hamas and Islamic Jihad. *Ibid.*, p. 73.

29. *Ibid.*

30. Richard Falk, "Slouching toward a Palestinian Holocaust," *ZNet* (5 July 2007), http://www.zmag.org/content/showarticle.cfm?SectionID=107&ItemID=13226 (date last accessed, 28 October 2008).

6 EYELESS IN GAZA

1. Rachel Corrie, *Let Me Stand Alone: The Journals of Rachel Corrie*, edited and with an introduction by the Corrie Family (New York: W.W. Norton, 2008), pp. 234, 243.
2. Population statistics from Sara Roy, *Failing Peace: Gaza and the Palestinian-Israeli Conflict* (London: Pluto Press, 2007), p. 54.
3. *Ibid.*, p. 96.
4. *Ibid.*
5. Amira Hass, *Drinking the Sea at Gaza: Days and Nights in a Land Under Siege* (New York: Henry Holt, 2000), p. 234. The book was originally published in Hebrew in 1996.
6. For a brief description of de-development, see Roy, *Failing Peace*, pp. 32–4. Roy elaborated on this theory in far greater detail in Sara Roy, *The Gaza Strip: The Political Economy of De-development* (Washington, DC: Institute for Palestine Studies, 1995, 2001).
7. Roy, *Failing Peace*, p. 103. This is from a reprinted article originally published in 1994.
8. Hass, *Drinking the Sea at Gaza*, pp. 270–1.
9. B'Tselem, "Statistics on Houses Demolished for Alleged Military Purposes" (no date), http://www.btselem.org/english/Razing/Statistics.asp (date last accessed, 28 October 2008).
10. United Nations, "Gaza Strip Inter-Agency Humanitarian Fact Sheet" (June 2008), http://www.ochaopt.org/documents/Gaza%20Factsheet%20June%202008.pdf (date last accessed, 28 October 2008); and Care International UK, Oxfam, Trocaire, Save the Children UK, and four other humanitarian agencies, "The Gaza Strip: A Humanitarian Implosion" (March 2008), http://www.carewbg.org/Reports/Gaza-A-Humanitarian-Implosion.pdf (date last accessed, 28 October 2008).
11. *Ibid.*
12. Eyad al-Sarraj and Sara Roy, "Ending the Stranglehold on Gaza: Why is This Acceptable?" *Counterpunch* (28 January 2008), http://www.counterpunch.org/roy01282008.html (date last accessed, 28 October 2008).

13. Care et al., "The Gaza Strip."

14. B'Tselem, "Attacks on Israeli Civilians by Palestinians: Qassam Rocket Fire into Israel" (no date), http://www.btselem.org/english/Israeli_Civilians/Qassam_missiles.asp (date last accessed, 28 October 2008).

15. For Palestinian casualty statistics, see Palestine Red Crescent Society, "Total Daily Numbers of Deaths and Injuries, West Bank and Gaza, 30 September 2000–Present" (no date), http://www.palestinercs.org/modules/cjaycontent/index.php?id=15 (date last accessed, 28 October 2008). For statistics on both Palestinian and Israeli deaths, see B'Tselem, "Statistics: Fatalities, 29 September 2000–30 September 2008" (no date), http://www.btselem.org/English/Statistics/Casualties.asp (date last accessed, 28 October 2008).

16. Hass, *Drinking the Sea at Gaza*, p. 234.

17. *Ibid.*, p. 7.

7 "It's a Pity I Don't Have a Stepladder"

1. B'Tselem, "Detainees and Prisoners: Statistics on Palestinians in the Custody of the Israeli Security Forces" (no date), http://www.btselem.org/English/Statistics/Detainees_and_Prisoners.asp (date last accessed, 28 October 2008), and B'Tselem, "Administrative Detention: Statistics on Administrative Detention" (no date), http://www.btselem.org/English/Administrative_Detention/Statistics.asp (date last accessed, 28 October 2008). Data kept by the Palestinian Center for Human Rights (PCHR) show that the number of Palestinian detainees is almost 11,000. PCHR statistics put the number of Palestinians arrested between the beginning of 2008 and late August 2008 at 1,751. According to statistics maintained by Palestinian physician and legislator Mustafa Barghouti, the numbers detained are considerably higher. Although Israel released 788 Palestinian detainees between the Annapolis peace conference in late November 2007 and late August 2008, according to Barghouti, the Israelis detained more than 3,700 others, including 30 teenagers, in the same period. See Ali Waked, "Palestinians Slam Israel's 'Revolving Door Policy' on Prisoners," *YNetnews* (19 August 2008), http://www.ynetnews.com/articles/0,7340,L-3584593,00.html (date last accessed, 28 October 2008).

2. According to B'Tselem, almost 4,900 Palestinians were killed from the start of the second *intifada* through September 2008, while 1,061 Israelis were killed.

See B'Tselem, "Statistics: Fatalities." The Palestine Red Crescent Society (PRCS) carries a slightly higher total for Palestinian deaths. Listing Palestinians killed and injured every month since September 2000 through August 2008, the PRCS puts the total of Palestinians killed at 5,179, in addition to 33,034 injured. See Palestine Red Crescent Society, "Total Daily Numbers of Deaths and Injuries, West Bank and Gaza." The ratio of Palestinian to Israeli deaths in the conflict in Gaza is higher by several orders of magnitude for the years since 2005. According to Palestinian physician Mustafa Barghouti, in 2006 the ratio of Palestinians to Israelis killed rose to 30 to one, and in 2007 the ratio rose again markedly, to 45 Palestinians killed to every one Israeli killed. See Jamal Najjab, "The *Nakba* Never Ended," *Washington Report on Middle East Affairs* (September–October 2008), p. 57.

3. Antjie Krog, *Country of My Skull: Guilt, Sorrow, and the Limits of Forgiveness in the New South Africa* (New York: Three Rivers Press, 2000), pp. 282, 288.

4. Cook, *Disappearing Palestine*, pp. 7–8.

5. *Ibid.*, p. 8.

6. Rashid Khalidi, *The Iron Cage: The Story of the Palestinian Struggle for Statehood* (Boston, MA: Beacon Press, 2006), pp. 198–9.

7. Danny Rabinowitz, "Before and After Oslo," *Haaretz* (16 April 2004).

8. See Neve Gordon, *Israel's Occupation* (Berkeley, CA: University of California Press, 2008).

9. Uri Blau, "Behind Closed Doors, Police Admit 'Turning a Blind Eye' to Settler Violence," *Haaretz* (15 August 2008). Police reported a considerable increase in incidents of settler violence against Palestinians in 2008. Incidents totaled 429 in the first half of 2008, compared with 587 incidents in all of 2006 and 551 in 2007.

10. Agence France Presse, "Soldiers Seldom Punished for Attacks on Palestinians: Report," *Middle East Times* (30 July 2008). Shortly after IDF soldiers shot three Palestinians—killing two and severely injuring one—in the village of Ni'lin with rubber-coated steel bullets in August 2008, B'Tselem issued a press release stating its "grave suspicion" that soldiers and Border Police "systematically breach the Open-Fire Regulations ... often with the knowledge and approval of officers" by firing rubber bullets at Palestinians at short ranges that are potentially lethal and in situations that pose no threat to the Israeli security forces. From the start of the *intifada* in September 2000 through August 2008, according to B'Tselem, 21 Palestinians were killed by

rubber bullets, which are supposed to be non-lethal. In B'Tselem's view, the failure to prosecute offenders—an indictment was filed in only one of these cases—encourages "a trigger-happy attitude among the forces" and sends the message to soldiers and commanders that they will not be held accountable for killing or wounding Palestinians. See B'Tselem, "B'Tselem to Attorney General: Stop Reckless Use of Rubber-Coated Steel Bullets" (1 September 2008), http://www.btselem.org/English/Press_Releases/20080901.asp (date last accessed, 7 February 2009).

11. "Entire Text of Olmert Speech to Congress," *Jerusalem Post* (24 May 2006), http://www.jpost.com/servlet/Satellite?cid=1148482035571&pagename=JPost%2FJPArticle%2FShowFull (date last accessed, 29 October 2008).

12. Cited in Jonathan Cook, "Israeli Outposts Seal Death of Palestinian State: Fledgling Settlements Grow by Stealth," *Counterpunch* (25 August 2008), http://www.counterpunch.org/cook08252008.html (date last accessed, 29 October 2008).

13. Ari Shavit, "The Big Freeze," *Haaretz* (8 October 2004).

14. Cited in Makdisi, *Palestine Inside Out*, p. 90.

15. For a profile of Elliott Abrams, see Connie Bruck, "How Serious is the Bush Administration About Creating a Palestinian State?" *New Yorker* (15 December 2003), and Kathleen Christison, "The Siren Song of Elliott Abrams: Thoughts on the Attempted Murder of Palestine," *Counterpunch* (26 July 2007), http://www.counterpunch.org/christison07262007.html (date last accessed, 29 October 2008). In 1996, several US neoconservatives, including most prominently Richard Perle, Douglas Feith, and David Wurmser, wrote a paper for Israeli Prime Minister Binyamin Netanyahu, entitled "A Clean Break: A New Strategy for Securing the Realm," that laid out a strategy for thwarting the peace process with the Palestinians and ensuring Israeli hegemony throughout the Middle East. For the text of the paper, see http://www.iasps.org/strat1.htm (date last accessed, 29 October 2008). For a thorough study of the neoconservatives, their political philosophy, and their strong influence on US policymaking during the administration of George W. Bush, see Stephen J. Sniegoski, *The Transparent Cabal: The Neoconservative Agenda, War in the Middle East, and the National Interest of Israel* (Norfolk, VA: Enigma Editions, 2008).

16. Ari Shavit, "Survival of the Fittest," *Haaretz* (9 January 2004). About the ethnic cleansing of the Palestinians, Morris had this to say: "There are circumstances in history that justify ethnic cleansing.... A Jewish state would

not have come into being without the uprooting of 700,000 Palestinians. Therefore it was necessary to uproot them. There was no choice but to expel that population. It was necessary to cleanse the hinterland and cleanse the border areas and cleanse the main roads. It was necessary to cleanse the villages from which our convoys and our settlements were fired on."

17. A principal online site for debate, both pro and con, among Palestinians about establishing a single state in Palestine is www.kanaanonline.org. The site is primarily in Arabic, with occasional articles in English. Two articles in English include Adel Samara, "Why the Socialist Solution in Palestine" (11 July 2008), http://www.kanaanonline.org/articles/01592.pdf (date last accessed, 29 October 2008), and Khalil Nakhleh, "Thinking the Thinkable: The Future Palestinian Society I Aspire To: Preliminary Deliberations on Proposed Solutions to Restore Genuine Palestinian Rights" (20 August 2008), http://www.kanaanonline.org/articles/01633.pdf (date last accessed, 29 October 2008).

18. The paper can be found online at the website of the Palestine Strategy Study Group, http://www.palestinestrategygroup.ps (date last accessed, 29 October 2008). For an article describing the study group's paper, written by one of the group's participants, see Sam Bahour, "No Coexistence with Occupation," *al-Ahram* (18 September 2008), http://weekly.ahram.org.eg/2008/915/op9.htm (date last accessed, 29 October 2008).

19. Bassam Aramin, "From One Bereaved Palestinian Father to Another," open letter to Hisam Musa, circulated on the Internet (2 August 2008).

20. Graham Usher, *Dispatches from Palestine: The Rise and Fall of the Oslo Peace Process* (London: Pluto Press, 1999), p. 17.

SELECTED BIBLIOGRAPHY

Abdul Hadi, Mahdi (ed.), 2005. *Palestinian-Israeli Impasse: Exploring Alternative Solutions to the Palestine-Israel Conflict*. Jerusalem: PASSIA.

Abunimah, Ali, 2006. *One Country: A Bold Proposal to End the Israeli-Palestinian Impasse*. New York: Metropolitan Books.

Amiry, Suad and Mouhannad Hadid (eds), 2002. *Earthquake in April*. Ramallah: Riwaq—Centre for Architectural Conservation and The Institute of Jerusalem Studies.

Baltzer, Anna, 2007. *Witness in Palestine: A Jewish American Woman in the Occupied Territories*. Boulder, CO: Paradigm Publishers.

Baroud, Ramzy (ed.), 2003. *Searching Jenin: Eyewitness Accounts of the Israeli Invasion*. Seattle, WA: Cune Press.

—— 2006. *The Second Palestinian Intifada: A Chronicle of a People's Struggle*. London: Pluto Press.

Carey, Roane (ed.), 2001. *The New Intifada: Resisting Israel's Apartheid*. London: Verso.

Christison, Kathleen, 2001. *Perceptions of Palestine: Their Influence on U.S. Middle East Policy*. Berkeley, CA: University of California Press.

Cook, Jonathan, 2006. *Blood and Religion: The Unmasking of the Jewish and Democratic State*. London: Pluto Press.

—— 2008. *Disappearing Palestine: Israel's Experiments in Human Despair*. London: Zed Books.

Corrie, Rachel, 2008. *Let Me Stand Alone: The Journals of Rachel Corrie*, edited and with an introduction by the Corrie Family. New York: W.W. Norton.

Dolphin, Ray, 2006. *The West Bank Wall: Unmaking Palestine*. London: Pluto Press.

Finkelstein, Norman, 2008. *Beyond Chutzpah: On the Misuse of Anti-Semitism and the Abuse of History*. Berkeley, CA: University of California Press.

Friel, Howard and Richard Falk, 2007. *Israel-Palestine on Record: How the* New York Times *Misreports Conflict in the Middle East*. London: Verso.

Gordon, Neve, 2008. *Israel's Occupation*. Berkeley, CA: University of California Press.

Gorenberg, Gershom, 2006. *The Accidental Empire: Israel and the Birth of the Settlements, 1967–1977*. New York: Times Books.

Halper, Jeff, 2008. *An Israeli in Palestine: Resisting Dispossession, Redeeming Israel*. London: Pluto Press.

Hamzeh, Muna and Todd May (eds), 2003. *Operation Defensive Shield: Witnesses to Israeli War Crimes*. London: Pluto Press.

Hass, Amira, 2000. *Drinking the Sea at Gaza: Days and Nights in a Land Under Siege*. New York: Henry Holt.

—— 2003. *Reporting from Ramallah: An Israeli Journalist in an Occupied Land*. New York: Semiotext(e).

Hilal, Jamil (ed.), 2007. *Where Now for Palestine? The Demise of the Two-State Solution*. London: Zed Books.

Karmi, Ghada, 2007. *Married to Another Man: Israel's Dilemma in Palestine*. London: Pluto Press.

Khalidi, Rashid, 2006. *The Iron Cage: The Story of the Palestinian Struggle for Statehood*. Boston, MA: Beacon Press.

Kovel, Joel, 2007. *Overcoming Zionism: Creating a Single Democratic State in Israel/Palestine*. London: Pluto Press.

Makdisi, Saree, 2008. *Palestine Inside Out: An Everyday Occupation*. New York: W.W. Norton.

Pappe, Ilan, 2006. *The Ethnic Cleansing of Palestine*. Oxford: One World.

Philo, Greg, Mike Berry, and the Glasgow University Media Group, 2004. *Bad News From Israel*. London: Pluto Press.

Quigley, John, 2005. *The Case for Palestine: An International Law Perspective*. Durham, NC: Duke University Press.

Reinhart, Tanya, 2002. *Israel/Palestine: How to End the War of 1948*. New York: Seven Stories Press.

Roy, Sara, 1995, 2001. *The Gaza Strip: The Political Economy of De-development*. Washington, DC: Institute for Palestine Studies.

—— 2007. *Failing Peace: Gaza and the Palestinian-Israeli Conflict*. London: Pluto Press.

Shehadeh, Raja, 2008. *Palestinian Walks: Forays into a Vanishing Landscape*. New York: Scribners.

Sniegoski, Stephen J., 2008. *The Transparent Cabal: The Neoconservative Agenda, War in the Middle East, and the National Interest of Israel*. Norfolk, VA: Enigma Editions.

Tilley, Virginia, 2005. *The One-State Solution: A Breakthrough for Peace in the Israeli-Palestinian Deadlock*. Ann Arbor, MI: University of Michigan Press.

United Nations Office for the Coordination of Humanitarian Affairs, 2007. *The Humanitarian Impact on Palestinians of Israeli Settlements and Other Infrastructure in the West Bank*. Jerusalem: OCHA.

Usher, Graham, 1999. *Dispatches from Palestine: The Rise and Fall of the Oslo Peace Process*. London: Pluto Press.

Zertal, Idith and Akiva Eldar, 2007. *Lords of the Land: The War for Israel's Settlements in the Occupied Territories, 1967–2007*. New York: Nation Books.

INDEX

Also available from **Pluto**Press

An Israeli in Palestine

Resisting Dispossession, Redeeming Israel

Jeff Halper

An Israeli's passionate argument for a solution in Palestine based on respect for human rights and tolerance.

'Jeff Halper's book, like his life's work, is an inspiration. Drawing on his many years of directly challenging Israel's treatment of the Palestinians, he offers one of the most insightful analyses of the occupation I've read. His voice cries out to be heard.'
Jonathan Cook, author of *Israel and the Clash of Civilisations* (2008)

Pb 9780745322261 336pp £16.99 / $27.95

Long Time Passing

Mothers Speak about War and Terror

Susan Galleymore

'This is a heartfelt and gut-wrenching account – and a must read for anyone wanting to understand the effects of modern war.' **Andrew J. Bacevich**, author of *The Limits of Power: The End of American Exceptionalism*

'Eloquently presents the universal fear, sorrow, and suffering experienced by mothers whose lives have been profoundly affected by war.'
Mary Tillman, mother of football star Pat Tillman who was killed by friendly fire in Afghanistan

Hb 9780745328294 288pp £16.99 / $24.95

 PlutoPress www.plutobooks.com

Also available from **Pluto**Press

Married to Another Man

Israel's Dilemma in Palestine

Ghada Karmi

'Two rabbis visited Palestine in 1897 to examine its suitablity as a Jewish state and observed that the land was like a bride "beautiful but married to another man". This dilemma - the displacement of the Palestinian people — is the subject of this book, also published to mark the 40th year of occupation. ... Karmi, one of our most renowned commentators on the Israeli-Palestinian conflict, has some startling ideas and conclusions in this fascinating book.' **Hampstead and Highgate Express**

'This is a well-written book, and one of the best accounts of the Arab-Israeli narrative.' **Times Literary Supplement**

Pb 9780745320656 320pp £14.99 / $26.95

Israel's Vicious Circle

Ten Years of Writings on Israel and Palestine

Uri Avnery

'There is something about Uri Avnery's perception of Israel, Palestine and the wider world that is unique. What is it? I would say it is a humanity, wisdom and exquisite sense of history and irony that cuts through the compliant dross of so much of today's commentary and is a beacon.' **John Pilger**

Hb 9780745328232 240pp £15.99 / $29.95

 PlutoPress www.plutobooks.com

Also available from PlutoPress

Israeli Apartheid

A Beginner's Guide

Ben White

'A very strong and clear voice ... In a world confused by competing narratives, disinformation and fabrication, this book is an excellent guide for understanding the magnitude of the crimes committed against the Palestinians and the nature of their present suffering and oppression.'
Professor Ilan Pappe, University of Exeter, Israeli historian and author of *The Ethnic Cleansing of Palestine* (2007)

'This book deals rationally and cogently with a topic that almost always generates considerable heat.' **Archbishop Desmond Tutu**

Pb 9780745328874 192pp £9.99 / $15.95

Israel and the Clash of Civilisations

Iraq, Iran and the Plan to Remake the Middle East

Jonathan Cook

'American-Israeli relations have intrigued, occupied and preoccupied two generations of scholars and politicians. ... Jonathan Cook's book enriches and elevates the debate.'
Afif Safieh, Palestinian Ambassador in Washington

'A compelling account of the recent wars for Middle East oil, untangling a complex web of interests shared by the neocons, Israel and the White House.'
David Hirst, author of *The Gun and the Olive Branch* (2003)

Pb 9780745327549 192pp £14.99 / $24.95

 PlutoPress www.plutobooks.com